YOUNG ASIAN DESIGNERS

INCLUDING AUSTRALIA

daab

Introduction 5

INTRODUCTION

The Asian countries seek to dominate global markets not only in the areas of science, technology and management, but also in the area of design, which is playing an increasingly crucial role in their strategic economic plans. One of their clear trends is the conscious use of traditional themes in combination with contemporary styles. Whether kimonos or packaging, Shinto shrines or computer designs, the viewer is stimulated by a wealth of inspiring visual stimuli. The culture and heritage of Asia is defined by this equal and simultaneous incorporation of the old and the new.

Today, the Asian-Pacific realm is considered to be the next major global economic player—and design plays a crucial political-economic role in this region. This is mainly due to the close proximity of nations at very different levels of development that are interconnected in numerous ways.

In addition to Asia, this book also sheds light on Australia, a continent of extremes. This perspective is also firmly established in the consciousness of Australian art and production, featured here through a selection of young designers that apply energy and a fresh approach to reinvent objects of everyday use. The works of these designers are distinguished by the influence of the raw beauty of natural elements, the simplicity of rural open spaces, or the progressive resonance and multi-faceted culture of international cityscapes.

A speech given by the Japanese Crown Prince Fumihito in person on the importance of design ennobles not only the sector as such, but also emphasizes the high status of product styling. In the 1980s already, when Asian corporations set out to conquer global markets with their products, they started to use design as a "global tool". They strategically hired European and U.S. designers to better understand the individual mentality of the nations that were their crucial markets.

Today, at the launch of the 21st century, the exchange between Europe and the Asian-Pacific realm is taking place at breathtaking speed. The "Asian Design Community" operates globally and is familiar with Milan and New York as much as it is with Shanghai or Sydney—a development that speeds up the dynamic merger of international markets.

This book presents an overview of the current trends of the young Asian-Pacific design scene. Though the featured works, ideas and products vary very much from each other, they exemplify one thing for sure: the initiated dialogue between cultures and across national borders is increasingly gaining in importance.

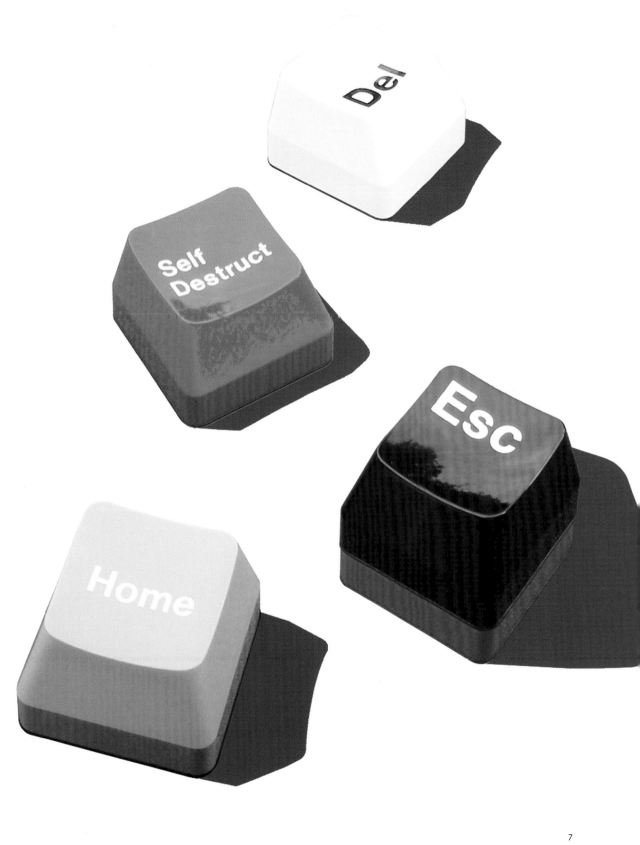

Nicht nur in Wissenschaft, Technik und Management streben die asiatischen Länder die globale Marktführerschaft an, auch das Design spielt eine entscheidende Rolle innerhalb ihrer ökonomisch-strategischen Überlegungen. Deutlich ist dabei zu erkennen, wie bewusst die eigenen Traditionen genutzt werden und in die Gegenwart mit einfließen: Von Kimonos bis zur Verpackung, von Shinto-Schreinen bis zum Computerdesign wird der Betrachter mit einer Fülle an inspirierenden visuellen Eindrücken stimuliert. Dieses gleichberechtigte Nebeneinander von Alt und Neu definiert die Kultur und das Erbe Asiens.

Der asiatisch-pazifische Raum gilt heute als der kommende Hauptdarsteller auf der wirtschaftlichen Weltbühne – und auch das Design hat dort eine große wirtschaftspolitische Bedeutung erlangt. Eine wichtige Ursache hierfür ist das räumlich enge Nebeneinander von Ländern mit sehr unterschiedlichem Entwicklungsstand, zwischen denen vielfältige Verflechtungen existieren.

Das vorliegende Buch wirft außer nach Asien auch einen Blick auf Australien, einen Kontinent voller Extreme. Eine Perspektive, die auch im Bewusstsein australischer Kunst und Produktion verankert ist und hier anhand einer Auswahl junger Designer präsentiert wird, die mit Elan und Frische Alltagsprodukte neu erfinden. Beeinflusst von der rohen Schönheit natürlicher Elemente, der Einfachheit ländlicher Freiflächen oder der progressiven Resonanz und vielschichtigen Kultur internationaler Stadtansichten zeichnen sich die Arbeiten der Designer aus.

Wenn der japanische Kronprinz Fumihito höchstpersönlich eine Ansprache über die Bedeutung von Design hält, dann adelt das nicht nur die Disziplin selbst, sondern zeigt auch den großen Stellenwert der Produktgestaltung. Asiatische Unternehmen begannen Design bereits in den 80er Jahren des vergangenen Jahrhunderts als ein „Global Tool" zu verstehen, als sie sich aufmachten, die Weltmärkte mit ihren Produkten zu erobern. Um die jeweilige Mentalität derjenigen Länder, die für sie wichtige Absatzmärkte darstellten, besser zu verstehen, engagierten sie gezielt europäische und amerikanische Designbüros.

Heute, am Beginn des 21. Jahrhunderts, entwickelt sich der Austausch zwischen Europa und dem asiatisch-pazifischen Raum atemberaubend schnell. Die „Asian Design Community" agiert inzwischen weltweit und ist in Mailand und New York ebenso wie in Shanghai oder Sydney zu Hause – eine Entwicklung, die das dynamische Zusammenwachsen der internationalen Märkte beschleunigt.

Dieses Buch ermöglicht einen Überblick über aktuelle Tendenzen der jungen asiatisch-pazifischen Designszene. So unterschiedlich die hier vorgestellten Arbeiten, Ideen und Produkte auch sind, eines ist deutlich zu spüren: Der begonnene Dialog zwischen den Kulturen und über nationale Grenzen hinweg gewinnt immer mehr an Bedeutung.

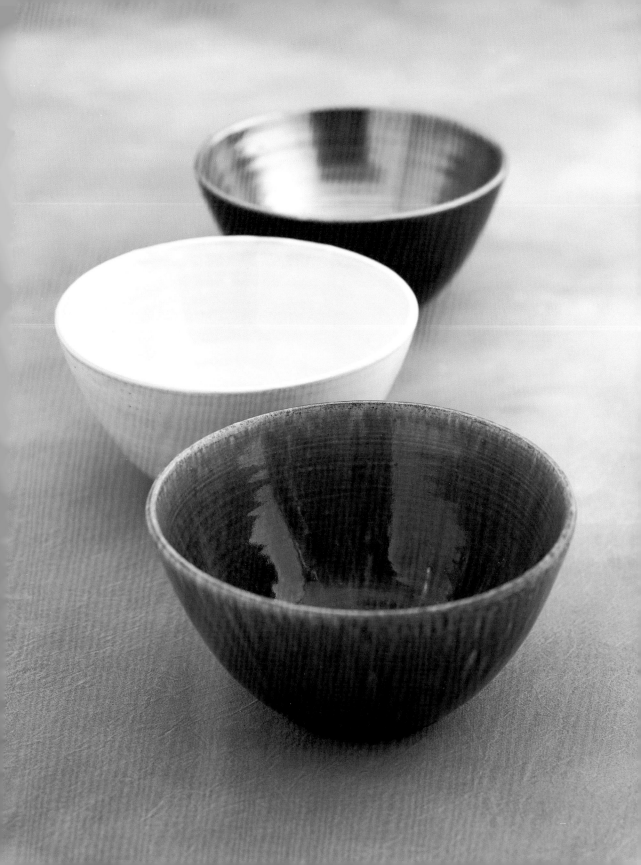

L'objectif de domination globale du marchés poursuivi par les pays asiatiques ne concerne pas seulement sur les plans scientifique, technique et management mais aussi le design qui joue un rôle décisif dans leurs perspectives économiques et stratégiques. Il en résulte une utilisation consciente de la tradition qui débouche sur une intégration dans le présent : c'est ainsi que le spectacteur est stimulé par un flot d'impressions visuelles depuis les kimonos jusqu'à l'art de l'emballage en passant par les armoires Shinto jusqu'au design de l'ordinateur. Cette coexistence de l'ancien et du neuf marque la culture et l'héritage asiatiques.

De nos jours l'espace asiatique autour du Pacifique est perçu comme l'acteur principal sur la scène de l'économie, et là aussi, le design a acquis une grande importance dans le domaine politique économique. On peut attribuer une des causes à ce phénomène à l'étroite proximité géographique de pays d'un niveau de développement disparate qui sont étroitement imbriqués les uns dans les autres.

L'Asie mise à part, le présent ouvrage pose aussi son regard sur l'Australie, continent des extrêmes. Là, une perspective ancrée dans la conscience de l'art australien et de sa production est présentée avec une sélection de jeunes designers qui ré-inventent avec beaucoup de fraîcheur et d'élan des produits de la vie quotidienne. On retrouve dans leurs œuvres l'influence de la beauté brute des éléments naturels, la simplicité des espaces agrestes ou encore la résonance progressive et la culture multistrate des vues urbaines internationales.

Quand le prince héritier japonais Fumihito fait un discours sur la signification du design, il n'anoblit pas seulement cette discipline en soi, mais il démontre aussi l'importance de la place accordée à la forme de produits. Dès les années 80 les entreprises asiatiques ont commencèrent à apposer au design cette touche de « Global Tool » qui devait mener à la conquête des marchés mondiaux par leurs produits. Ces mêmes entreprises engagèrent des bureaux de design européens ou américains soigneusement sélectionnés, ceci afin de mieux comprendre la mentalité de chaque pays susceptible de leur offrir d'importants débouchés sur le marché.

Aujourd'hui, au début du 21ème siècle, les échanges entre l'Europe et l'espace asiatique autour de l'océan Pacifique se développent à un rythme stupéfiant. L' « Asian Design Community » est entre-temps active dans le monde entier, son domaine se trouve aussi bien à Milan qu'à New York, à Shangaï qu'à Sydney. Cette évolution accélère la croisssance dynamique des marchés internationaux.

Cet ouvrage donne un aperçu des tendances actuelles de la jeune scène du design en Asie et dans l'espace du Pacifique. En dépit de sensibles différences entre les œuvres, les idées et les produits présentés, on perçoit clairement à quel point le dialogue entamé entre les cultures et les frontières nationales gagne de plus en plus d'importance.

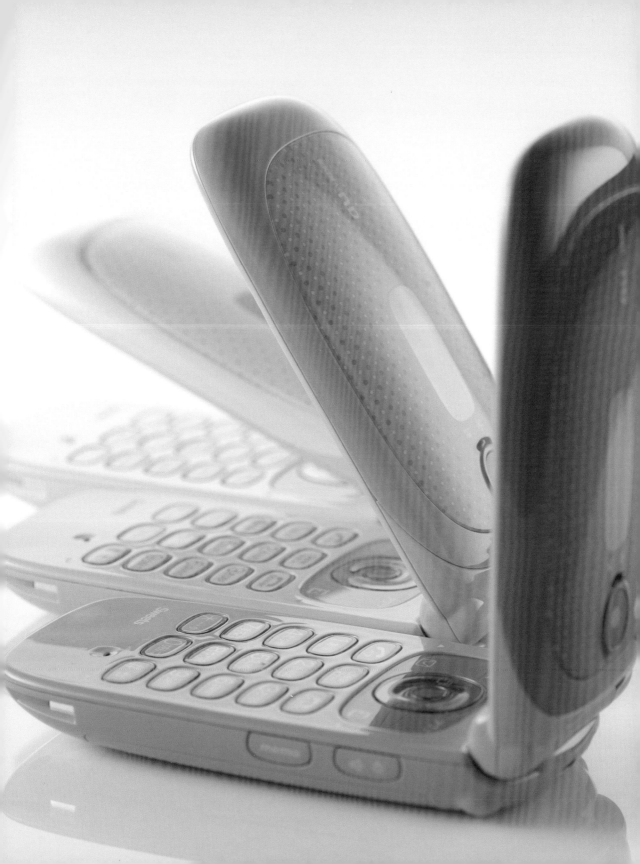

Los países asiáticos no sólo intentan liderar el mercado global en lo referente a la ciencia, la tecnología y la gestión de sus empresas: el diseño también juega un papel decisivo en sus reflexiones económicas y estratégicas. La conciencia con la que aplican sus propias tradiciones enlazándolas con el presente se refleja de forma bien clara. Desde los kimonos hasta los embalajes, desde los cofres shinto hasta el diseño de ordenadores, siempre nos estimulan con una gran opulencia de impresiones visuales. Esta convivencia parigual entre lo antiguo y lo nuevo define la cultura y el legado de Asia.

En la actualidad, se considera que el entorno del Pacífico asiático protagoniza el escenario económico mundial: en él, el diseño también ha adquirido una gran importancia económico-política. Un motivo importante es que numerosos países con un nivel de desarrollo muy diferente conviven en un reducido espacio, lo que crea múltiples lazos.

El presente libro va más allá de Asia para echar una mirada hacia Australia, un continente repleto de extremos. Nos muestra una perspectiva que también toma conciencia de la producción y el arte australianos, y que aquí se presenta de la mano de una selección de jóvenes diseñadores que reinventan los productos cotidianos con ímpetu y frescura. Las obras de los diseñadores destacan por la influencia de la rústica belleza de los elementos naturales, la sencillez de las superficies campestres libres o la resonancia progresiva y la cultura polifacética de las filosofías urbanas internacionales.

Si el príncipe heredero japonés Fuhimito en persona da un discurso sobre la importancia del diseño, esto no sólo ennoblece a la propia disciplina, sino que también es muestra de la gran relevancia que tiene la creación de productos. Las empresas asiáticas ya empezaron a considerar el diseño como una "herramienta global" en los años 80, cuando se pusieron en marcha para conquistar los mercados del mundo con sus productos. Con el fin de poder comprender mejor la mentalidad de aquellos países que para ellos representaban mercados potenciales importantes contrataron a empresas de diseño europeas y americanas.

Actualmente, a comienzos del siglo XXI, el intercambio entre Europa y el Pacífico asiático se desarrolla a una velocidad vertiginosa. Entretanto, la "comunidad del diseño asiático" ya está presente en todo el mundo y se siente como en casa en Milán y Nueva York tanto como en Shangai o Sydney; esta evolución acelera la fusión dinámica de los mercados internacionales.

El presente libro nos deleita con una panorámica sobre las tendencias más actuales del joven mundo del diseño del Pacífico asiático. Independientemente de las diferencias existentes entre las obras, las ideas y los productos, todos tienen un denominador común: el diálogo iniciado entre las culturas que sobrepasa las fronteras nacionales adquiere una importancia cada vez mayor.

Non è solo nella scienza, nella tecnica e nel management che i paesi asiatici aspirano ad un posizione di leadership nel contesto globale. Anche al design spetta un ruolo da protagonista nelle loro riflessioni economico-strategiche. Si delinea con chiarezza una tendenza: la consapevolezza con cui le proprie tradizioni vengono fatte confluire nel presente. Dal kimono all'imballaggio, dagli scrigni Shinto al computer design: all'osservatore si presenta tutta una molteplicità di impulsi visivi dai quali trarre ispirazione. Convivendo pariteticamente, vecchio e nuovo concorrono a definire la cultura ed il patrimonio della civiltà asiatica.

La regione asiatico-pacifica oggi viene considerata comunemente come il futuro protagonista della scena economica internazionale sulla quale anche il design va acquisendo un grande peso politico-economico. Una delle ragioni fondamentali di questo fenomeno è rappresentata dalla concentrazione in un'area ristretta di paesi caratterizzati da un diverso livello di sviluppo fra i quali sussiste un complesso intreccio di relazioni.

Oltre ad offrire una panoramica sulla realtà asiatica, questo libro spazia fino al continente australiano, denso di estreme contraddizioni. Una prospettiva, questa, che è consapevolmente radicata nella concezione artistica e produttiva australiana e qui presentata sulla base di una selezione di giovani designer che ripropongono gli oggetti della quotidianità con slancio ed entusiasmo innovativo. Le loro creazioni si contraddistinguono per l'influenza esercitata dalla bellezza un po' ruvida degli elementi naturali, dalla semplicità degli spazi aperti rurali o dalla progressiva risonanza e dal multiculturalismo delle visioni urbane.

Il fatto che lo stesso principe ereditario Fumihito abbia ritenuto opportuno dedicare una sua allocuzione al ruolo del design, non insigne solo questa disciplina di un riconoscimento prestigioso, ma dimostra anche la grande importanza rivestita da questo settore. Le aziende asiatiche hanno cominciato a concepire il design come "Global Tool" già negli anni Ottanta del secolo scorso, quando si accingevano a conquistare con i loro prodotti i mercati internazionali. Per comprendere meglio la mentalità di tutti quei paesi che per loro rappresentavano importanti mercati di sbocco, ricorsero al supporto di studi di design europei e americani.

Oggi, agli inizi del ventunesimo secolo, l'interscambio fra Europa e area asiatico-pacifica si sta moltiplicando ad una velocità mozzafiato. La cosiddetta Asian Design Community opera ormai globalmente ed è perfettamente integrata tanto a Milano e New York quanto a Shangai o Sydney...una tendenza che va accelerando il dinamismo con cui i mercati internazionali si stanno già fondendo.

Questo libro offre una panoramica sui trend più attuali che caratterizzano il giovane contesto del design di matrice asiatico-pacifica di maggior tendenza. Nonostante la diversità delle creazioni, delle idee e dei prodotti qui presentati, si palesa soprattutto un fenomeno: la crescente importanza che il dialogo emergente fra civiltà ed oltre i confini nazionali va progressivamente assumendo.

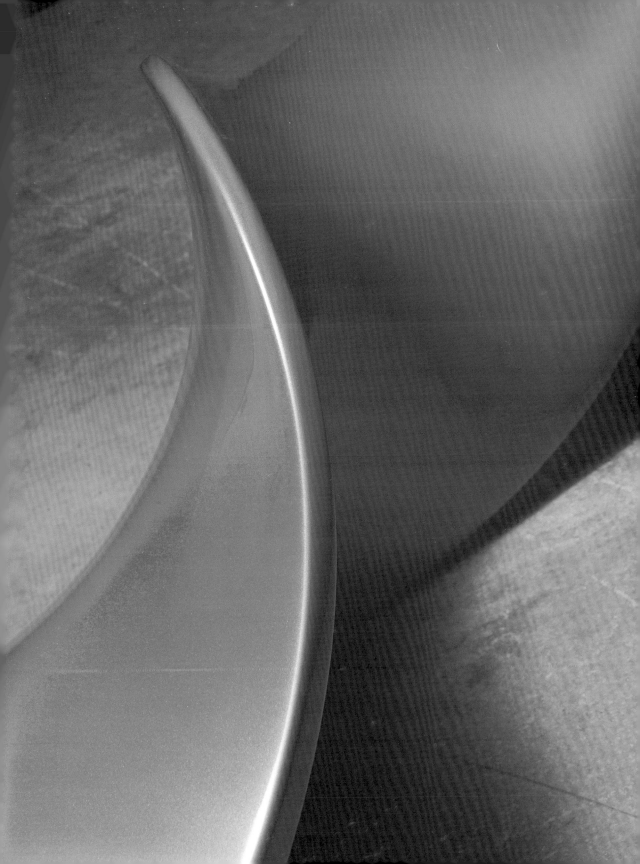

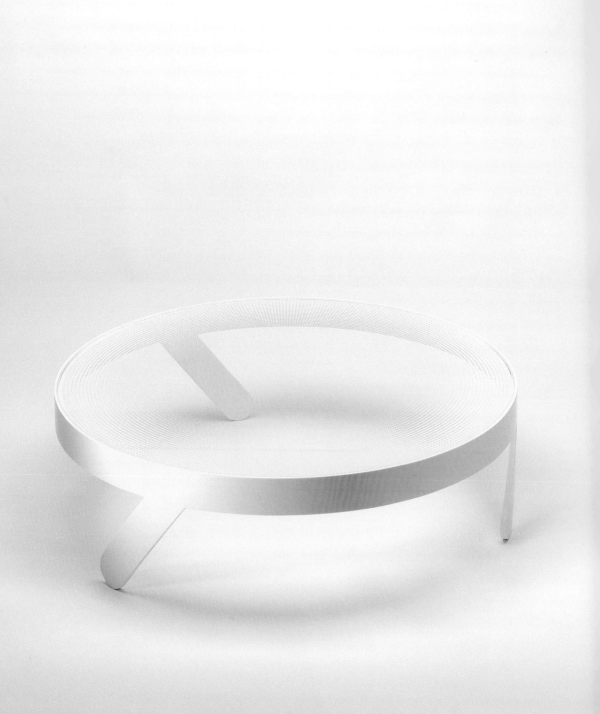

A+A COOREN | PARIS, FRANCE
Aki and Arnault Cooren

A+A cooren is a French-Japanese design agency. This connection is reflected in their products; they are partial to international projects and clients.

www.aplusacooren.com

1 Table Twisty
2 Dragonfly, *coathanger*
3 Lupo

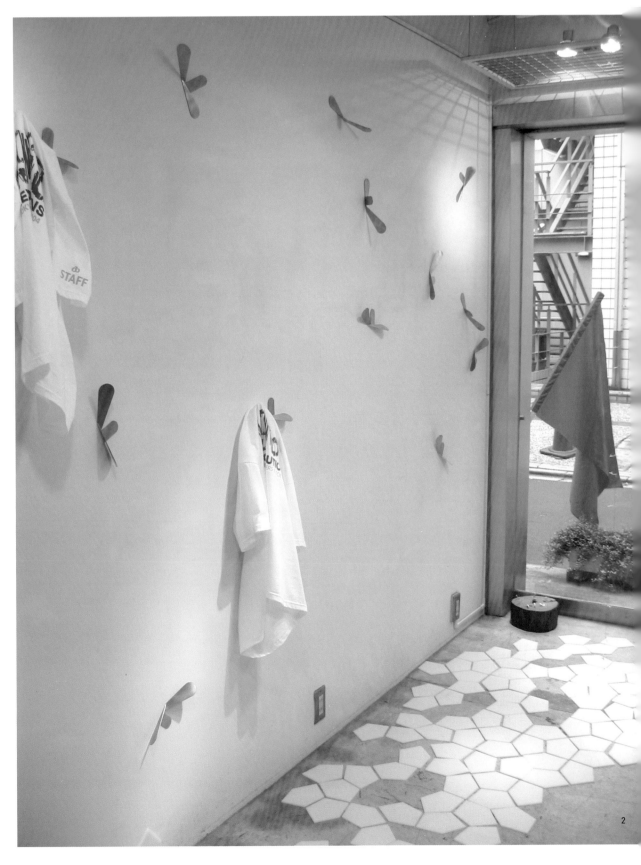

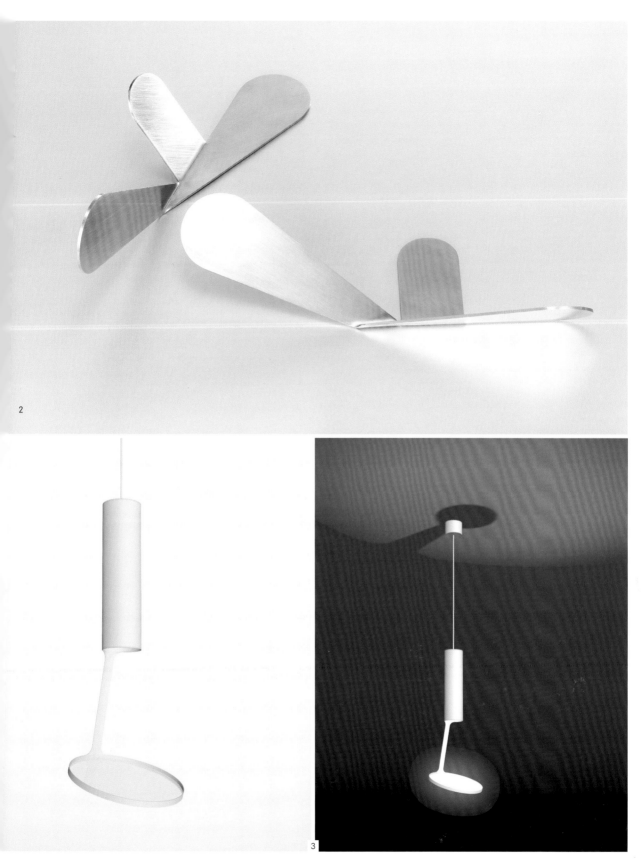

2

3

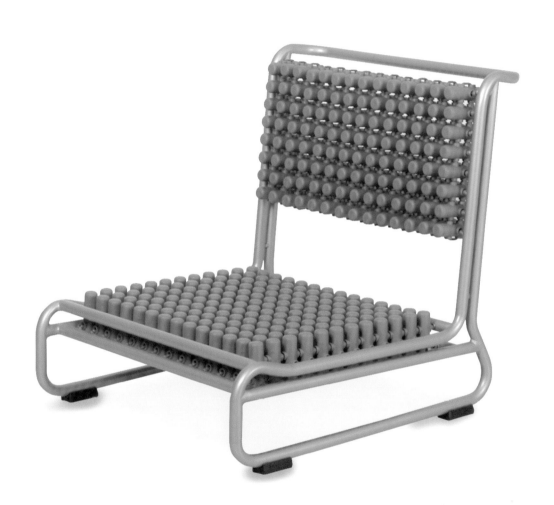

ACCUPUNTO INTERNATIONAL | JAKARTA, INDONESIA
Leonard Theosabrata

Accupunto is a furniture series that provides a high level of comfort using the benefits of acupressure. It brings together the synergy of past and present design by combining the ancient method of acupuncture with western functionality.

www.accupunto.com

1 Pin System, *tatami*
2 Pin System, *lounge set*
3 Pin System, *day bed*
4 Pin System, *table set*
5 Pin System, *bench*

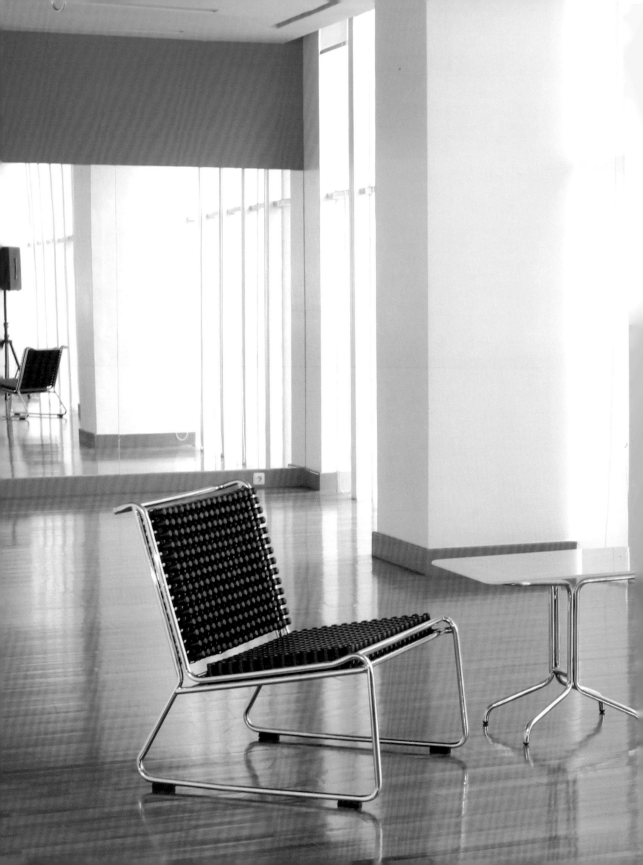

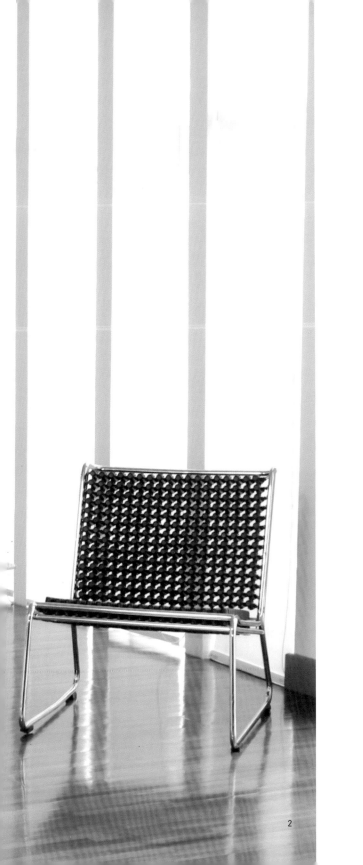

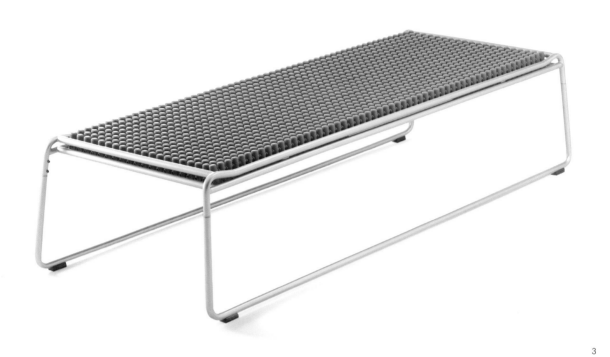

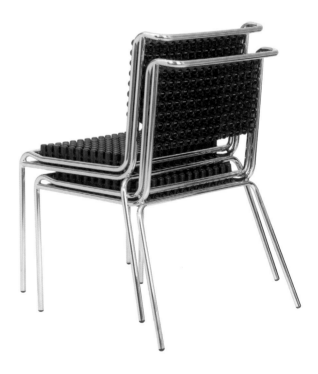

3

4

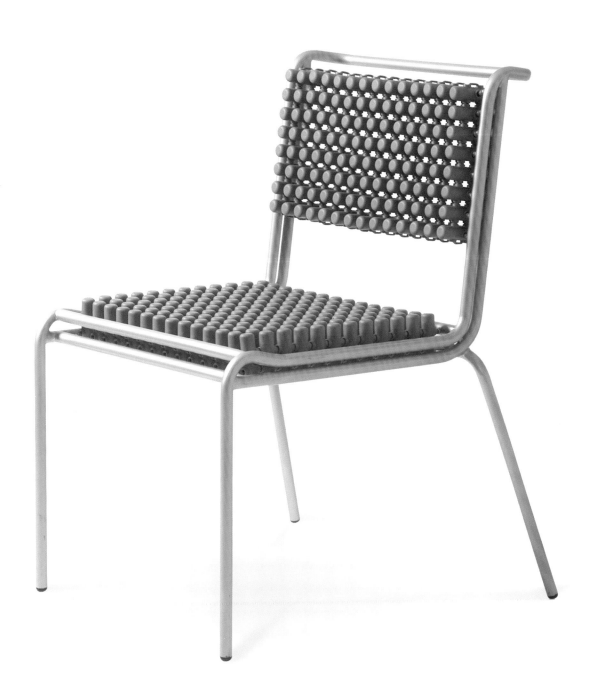

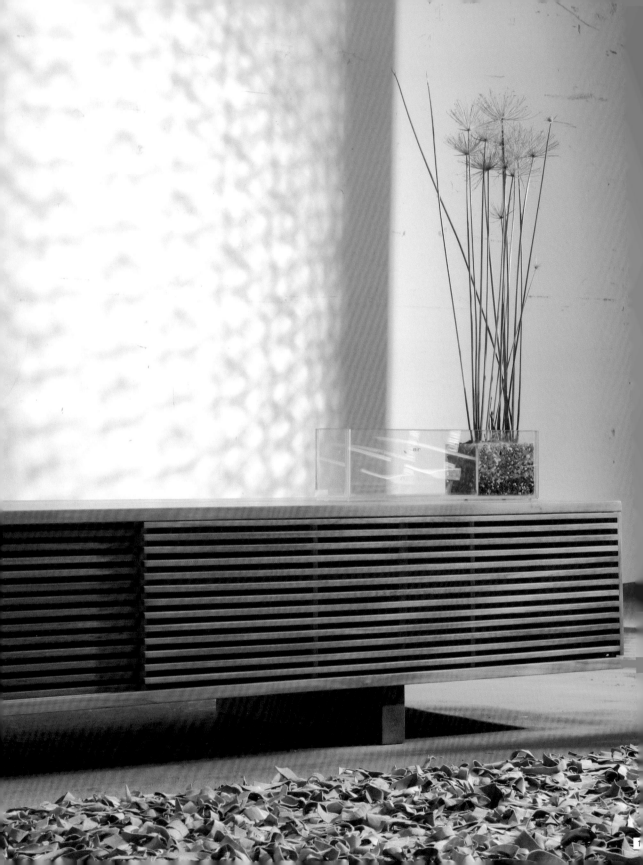

AIR DIVISION PRIVATE LIMITED | **SINGAPORE, SINGAPORE**
Nathan Yong Kok Seng, Vincent Chia Hwee Khoon

Air Division conceptualize an object from drawing board to production to selling to the end user's home. Their design considerations are not based on aesthetic decisions alone, nor are they purely functional. They balance these two extremes in consideration of the appropriateness of materials and their combination.

www.airdivision.net

 1 Telefunken
 2 Trunk
 3 Relax
 4 Roshidah
 5 Bently
 6 Count
 7 Cable
 8 Thin
 9 Loop
10 Satellite
11 Playground
12 Plane

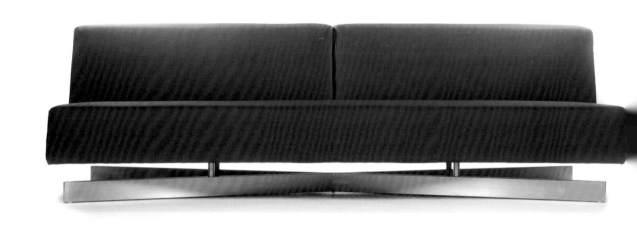
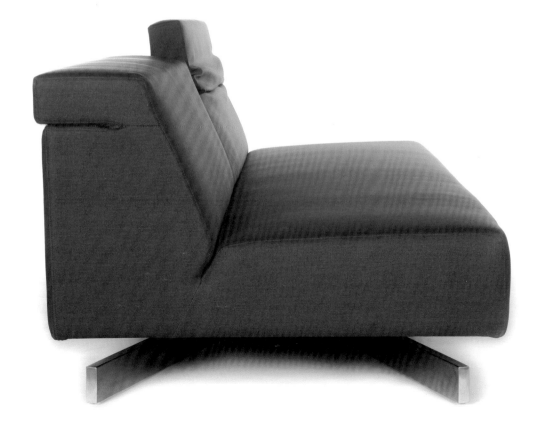

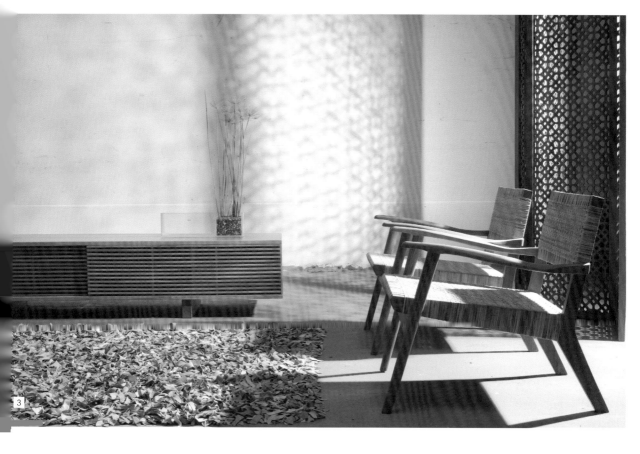

3

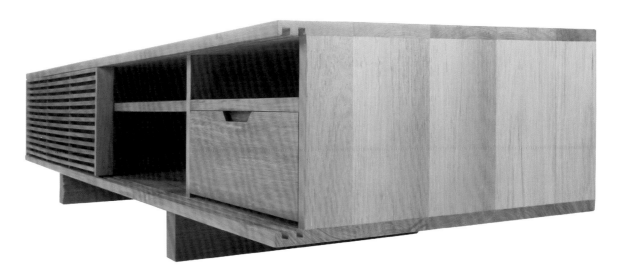

4

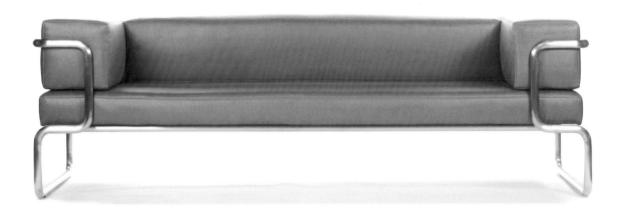

5

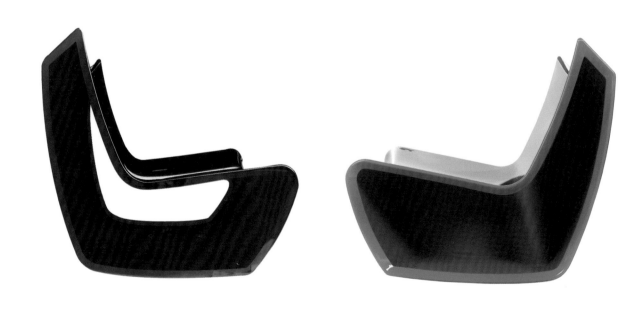

6

7

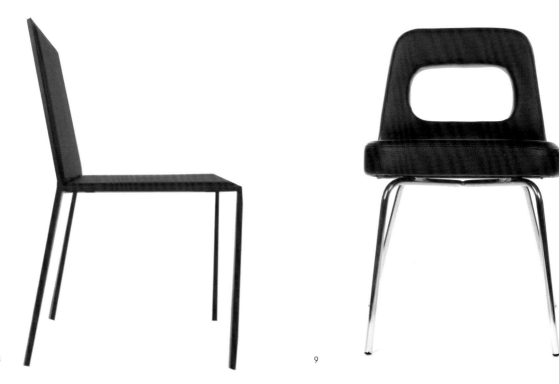

8 9

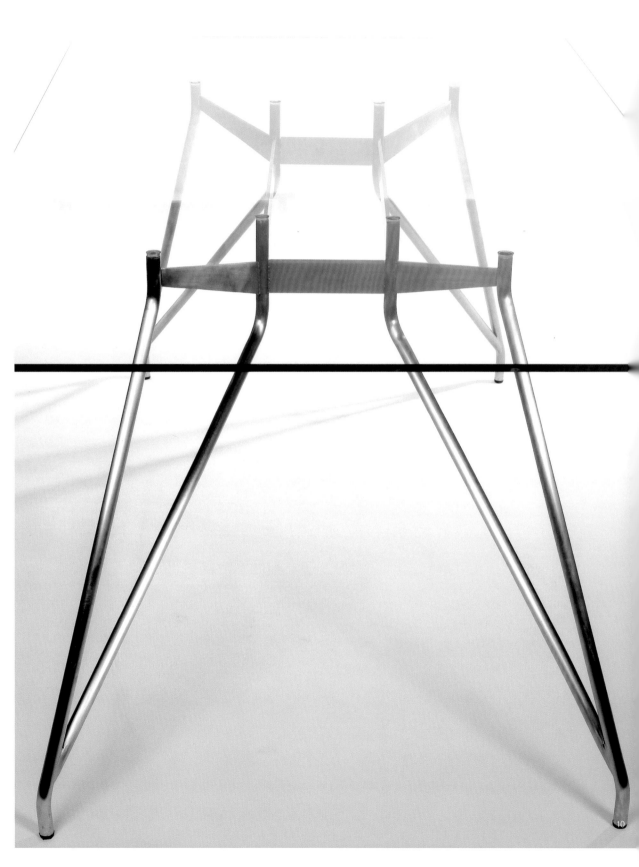

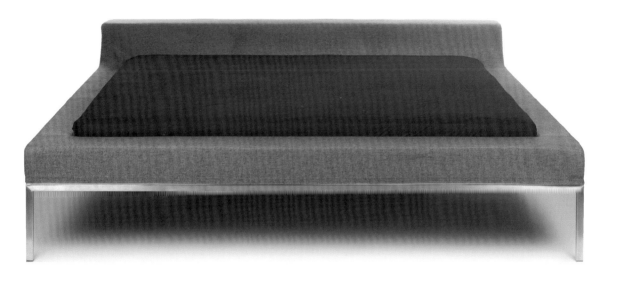

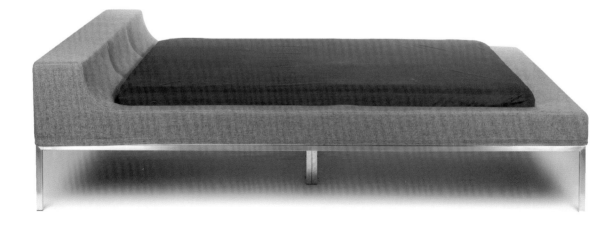

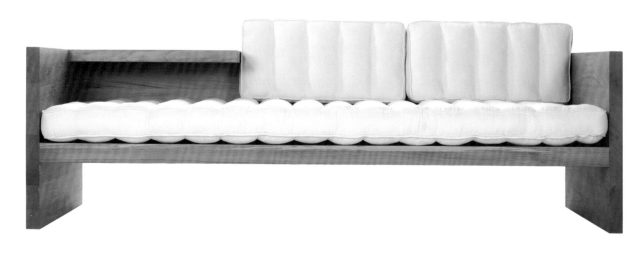

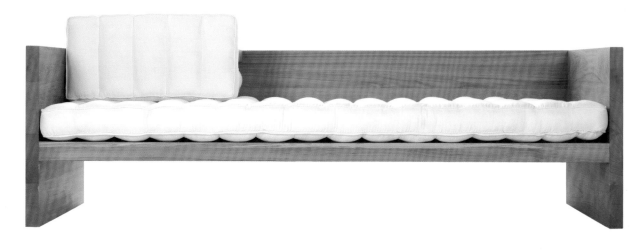

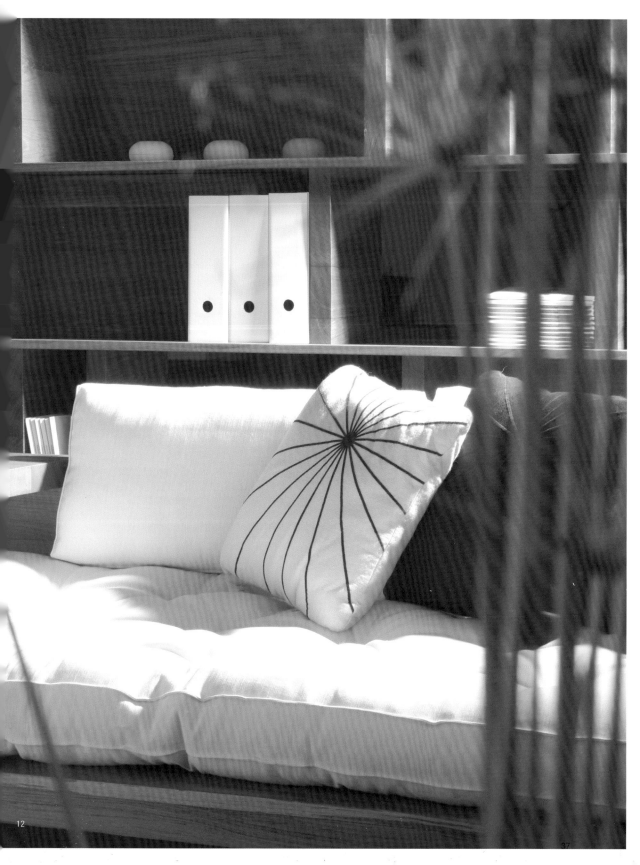

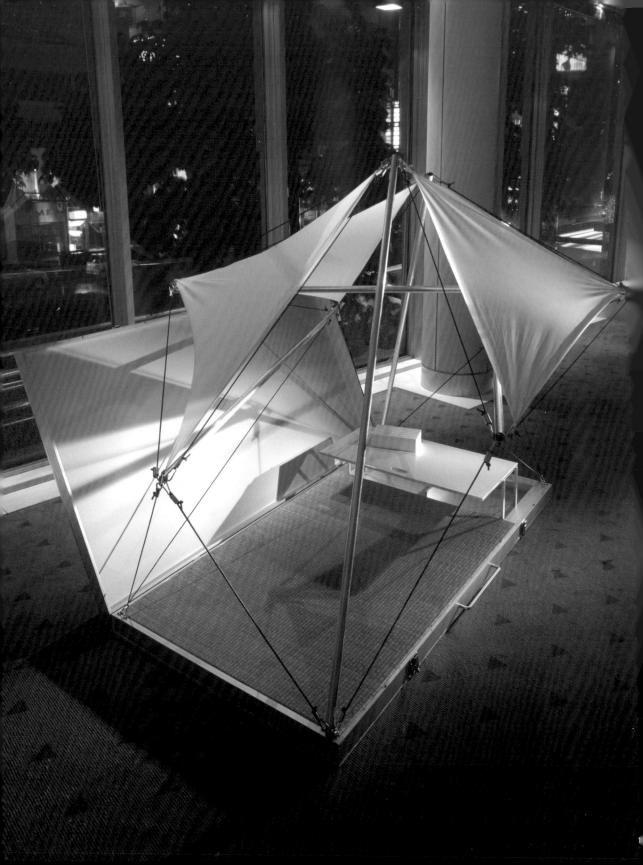

ATELIER OPA | TOKYO, JAPAN
Toshihiko Suzuki

Mobility of space and being sustainable is the theme of inclination for 'space-like furniture and products like space'. Defining the object in between furniture and space as [Mobile Architecture], the series of design have been exhibited in the international design fairs and museums.

www.product.tuad.ac.jp/suzuki_lab

1 mobile Ichjo
2 So-an, *mobile tea room*
3 Byobu, *screen lighting*
4 Ahf
5 mobile Hanjo
6 Liga, *led lighting*
7 In-fill-flexible, *vase*

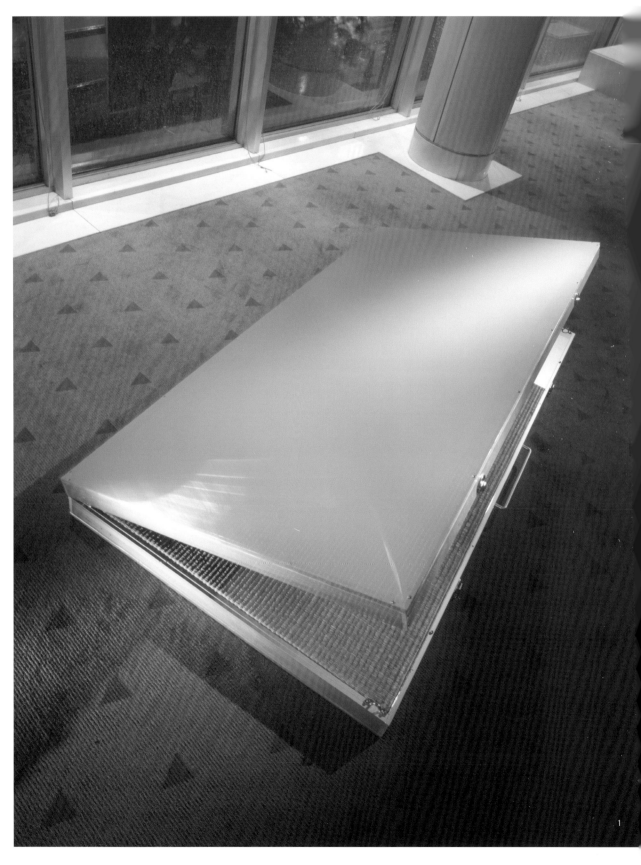

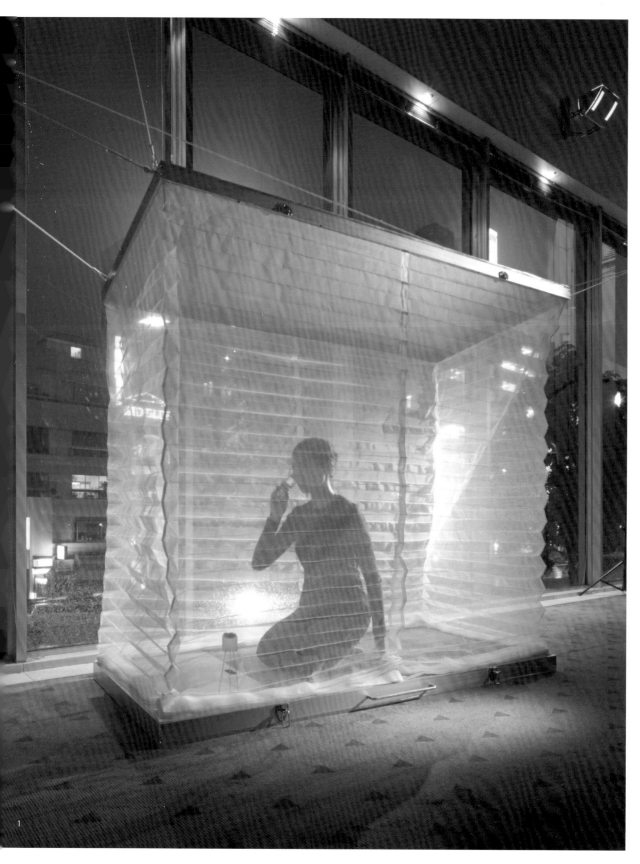

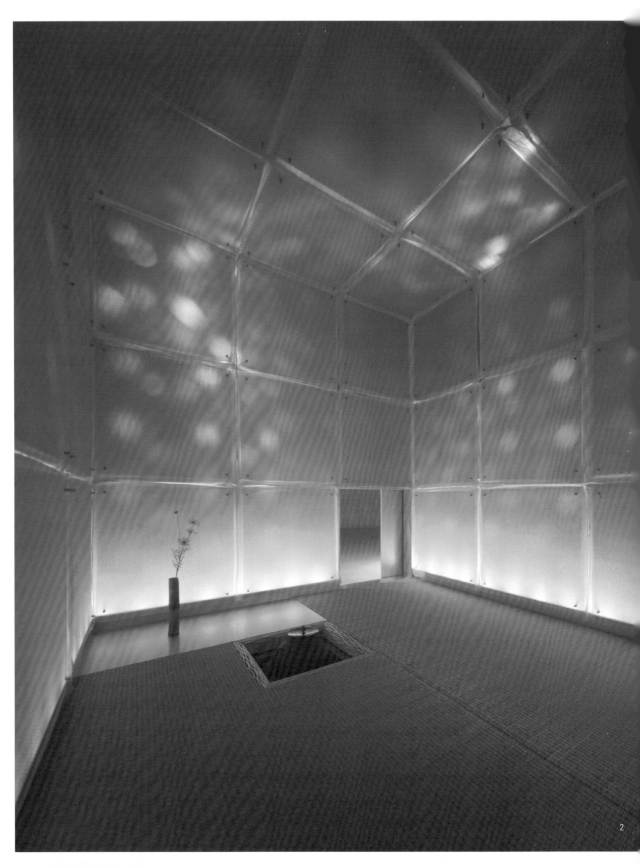

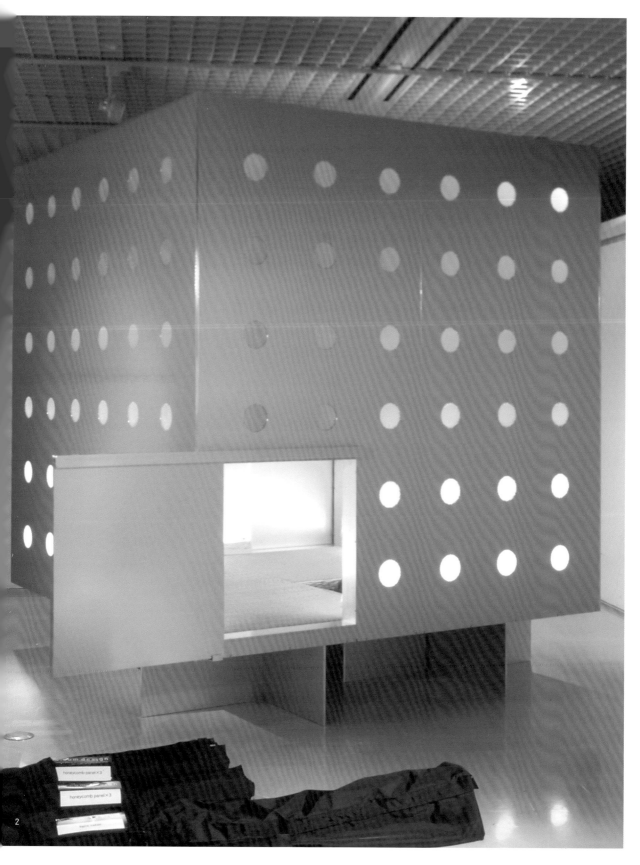

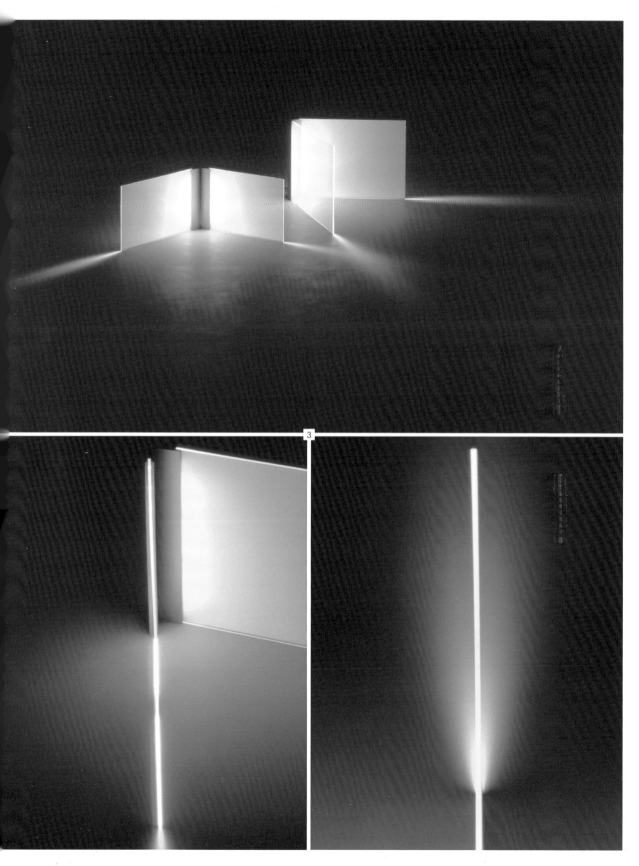

3

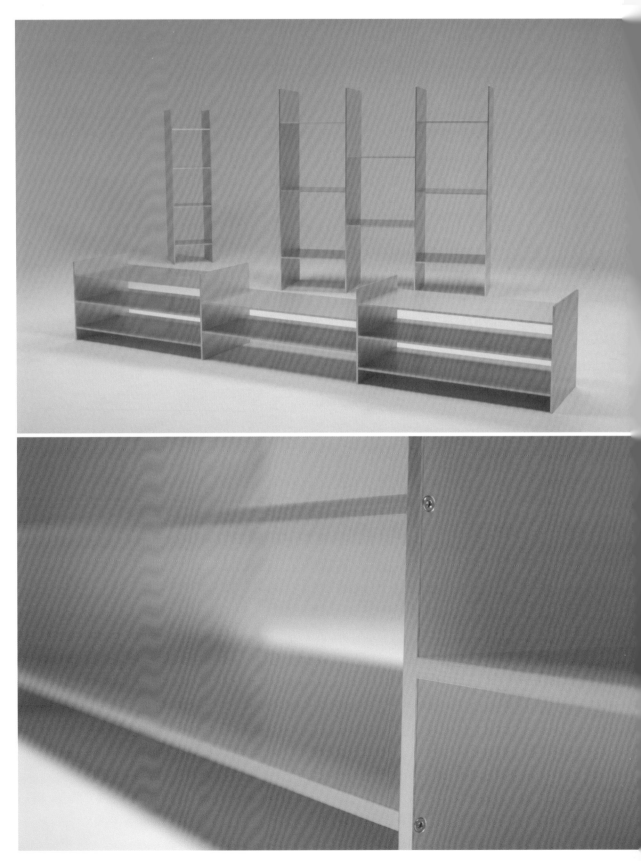

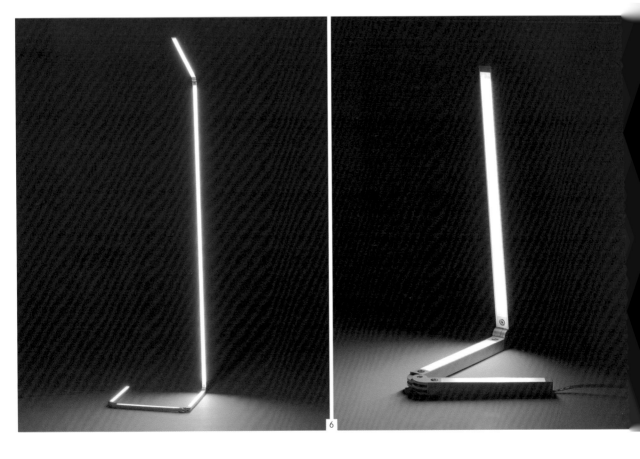

6

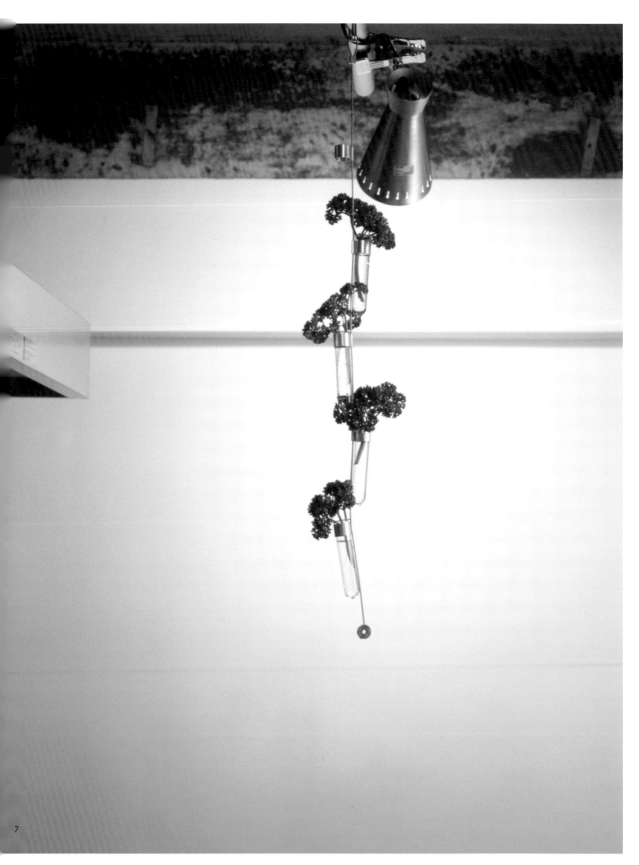

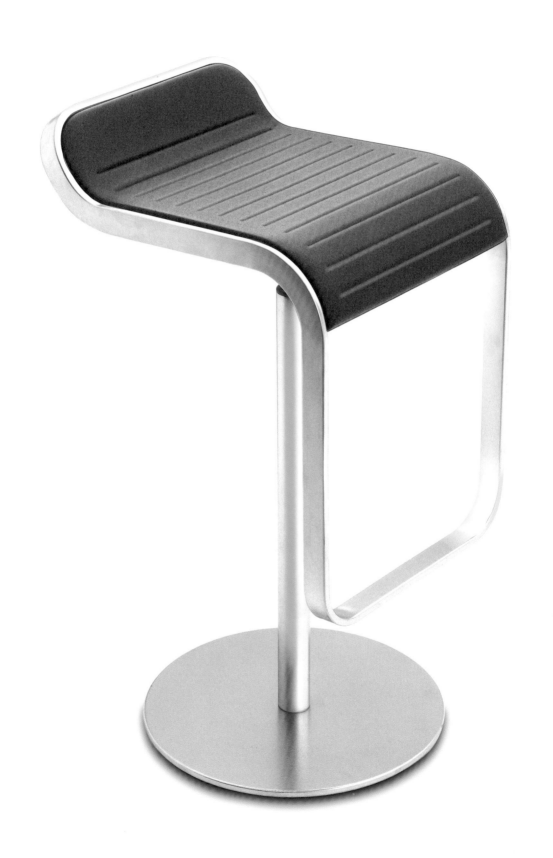

SHIN & TOMOKO AZUMI | LONDON, UK
Shin Azumi, Tomoko Azumi

Shin and Tomoko Azumi design furniture, products and stage sets in an elegantly playful style. Born in Japan, they have lived and worked in London since in the early 1990s. Shin Azumi and Tomoko Azumi have now opened individual design studios.

www.azumi.co.uk

1 Lem
2 Orologi, *coat hanger & clock*
3 Volta
4 Leo
5 Za1 & Za2, *stacking stool*
6 Za Angle
7 Log

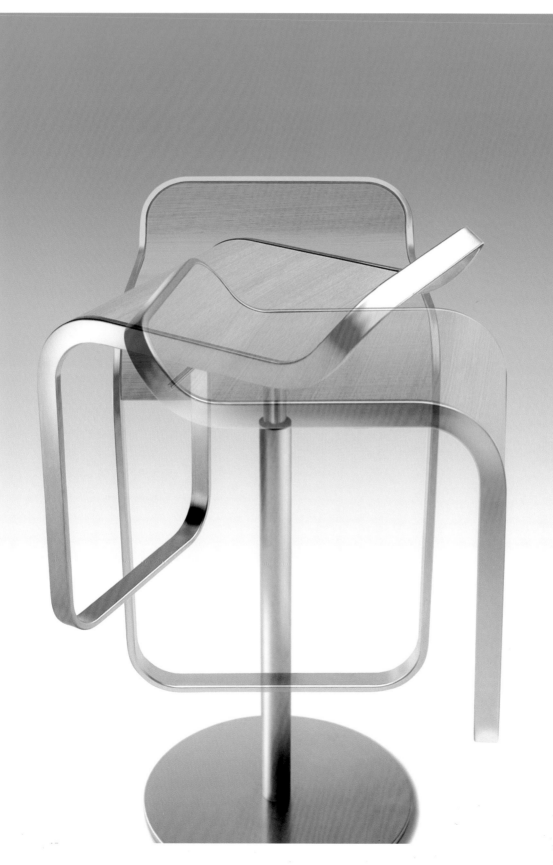

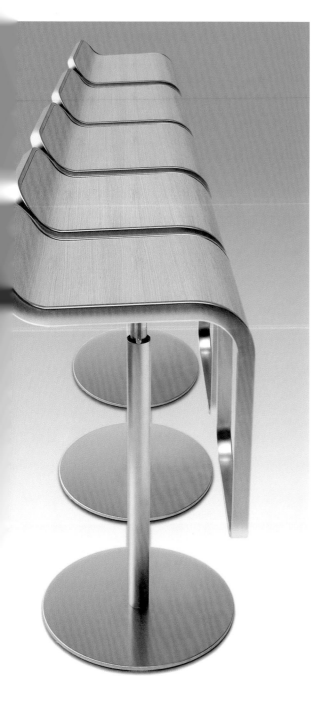

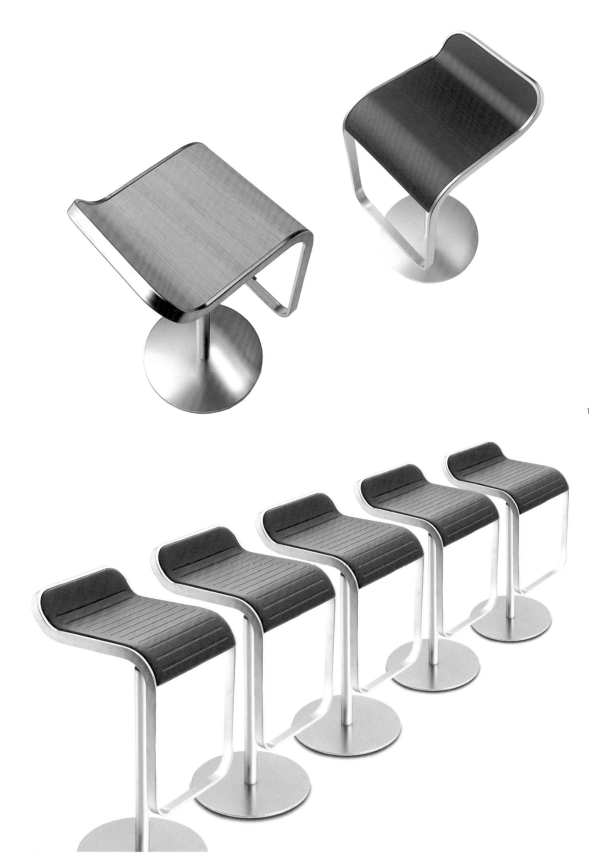

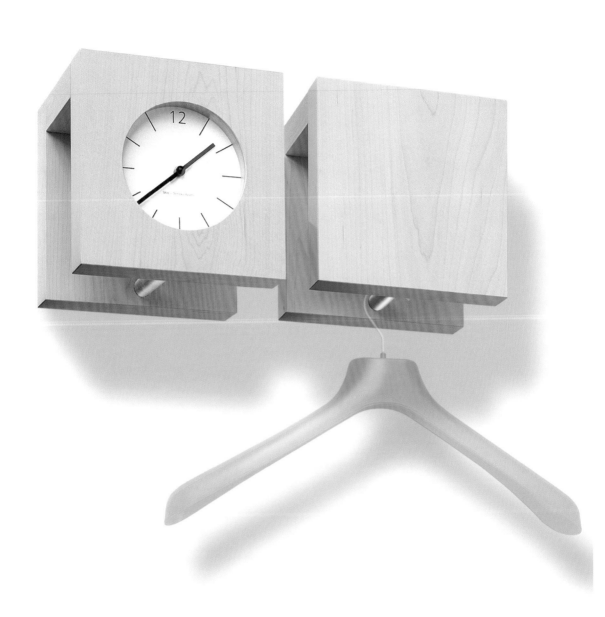

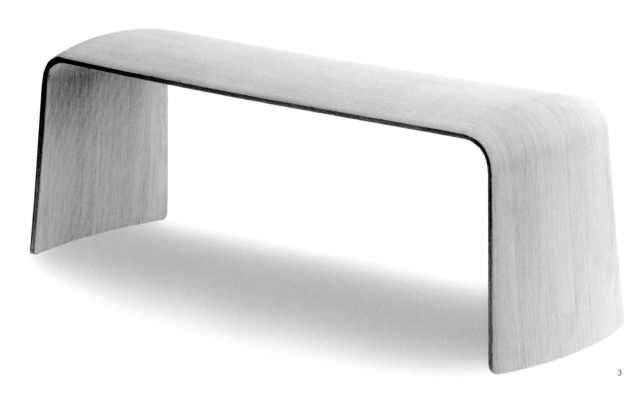

3

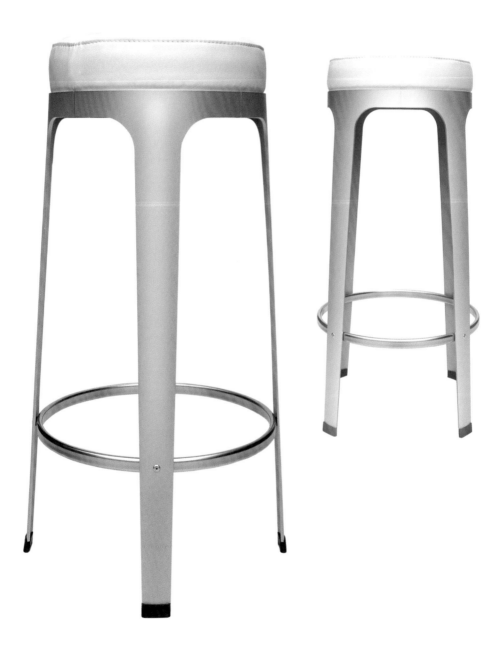

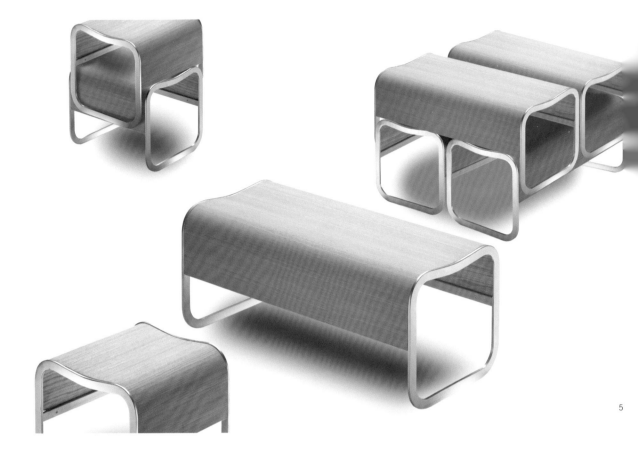

5

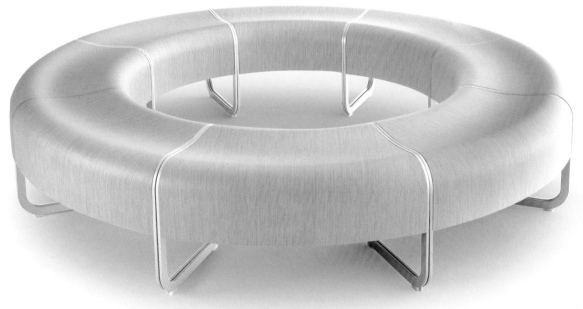

6

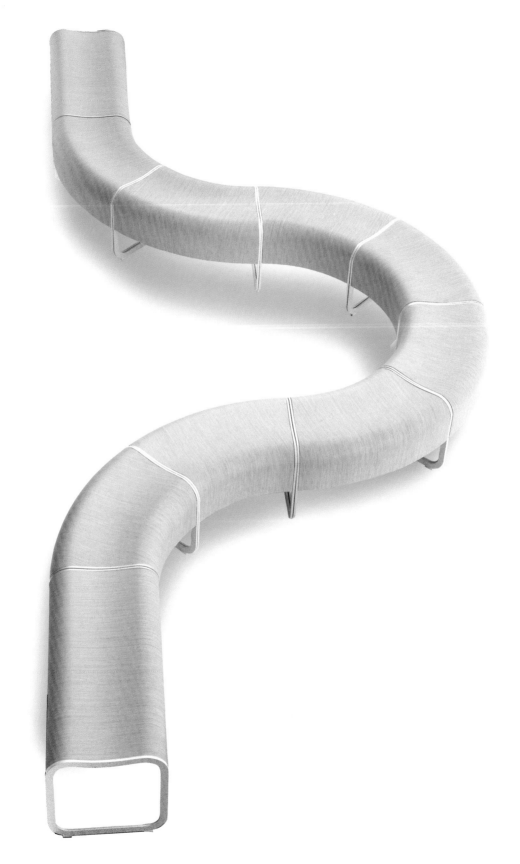

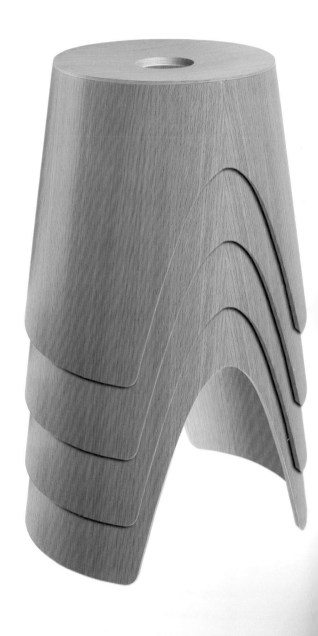

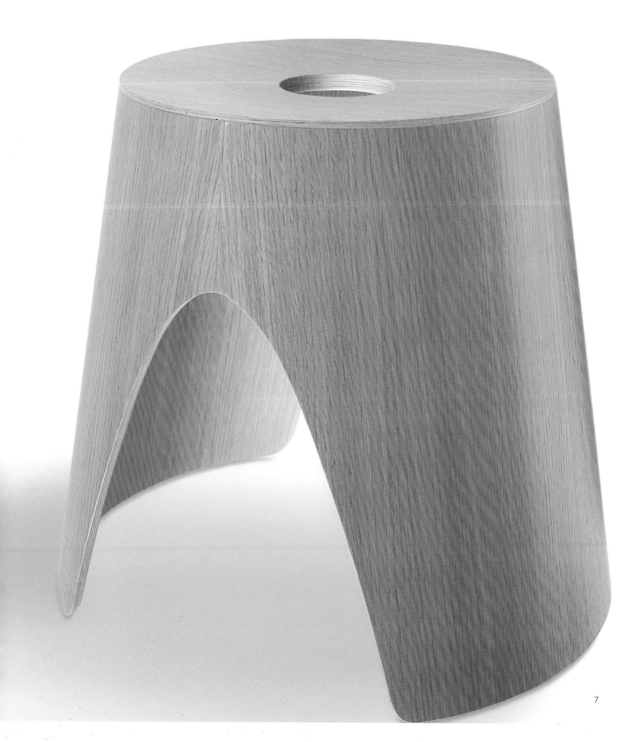

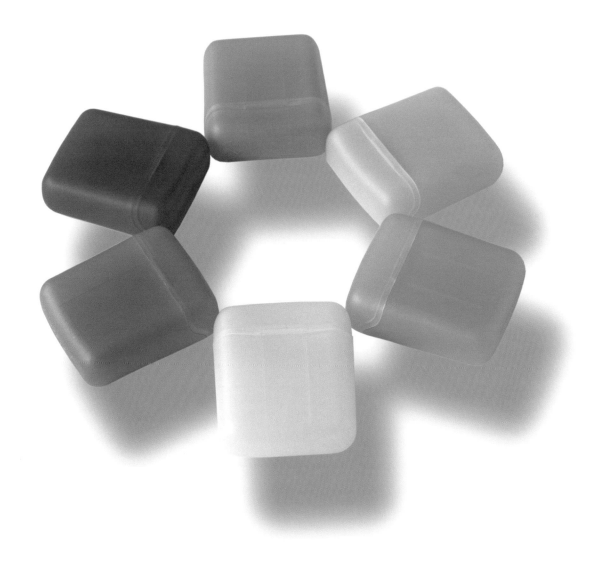

BLAESS | SYDNEY, AUSTRALIA
Steven Blaess

Blaess creates and produces projects, furniture and interior products characterized by simple and obvious shapes. Projects currently being reviewed by Italian companies include lighting for Artemide and iGuzzini, furniture for Kartell and B&B Italia and products for Alessi.

www.blaess.com

1 Pincusblaess, *tampon purse pack*
2 Credenza, *bench*
3 Nursing pad, *travel case*
4 Marbloglazia, *hand basin*
5 Meditation Pod
6 Marli, *opener*

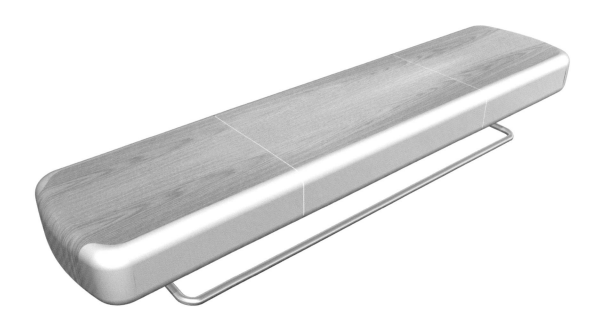

2

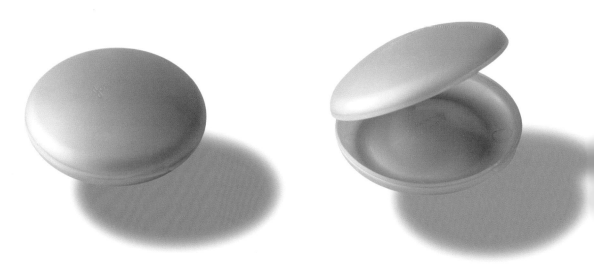

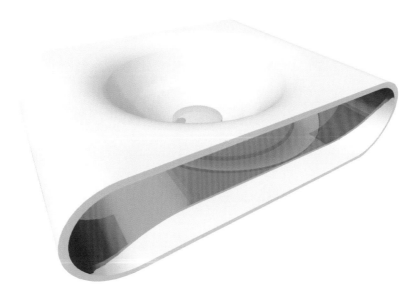

4

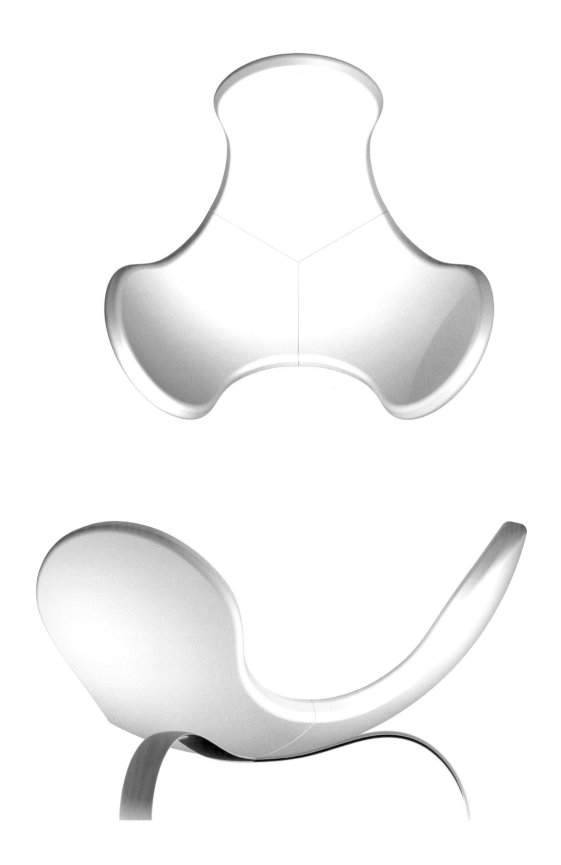

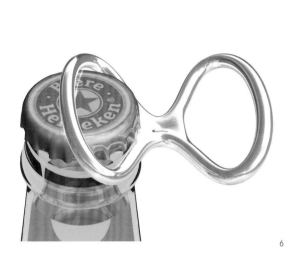

6

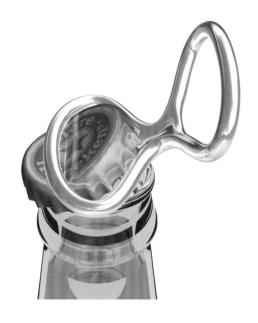

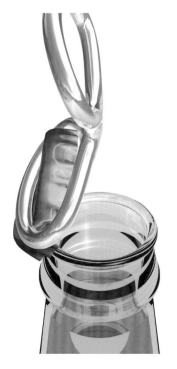

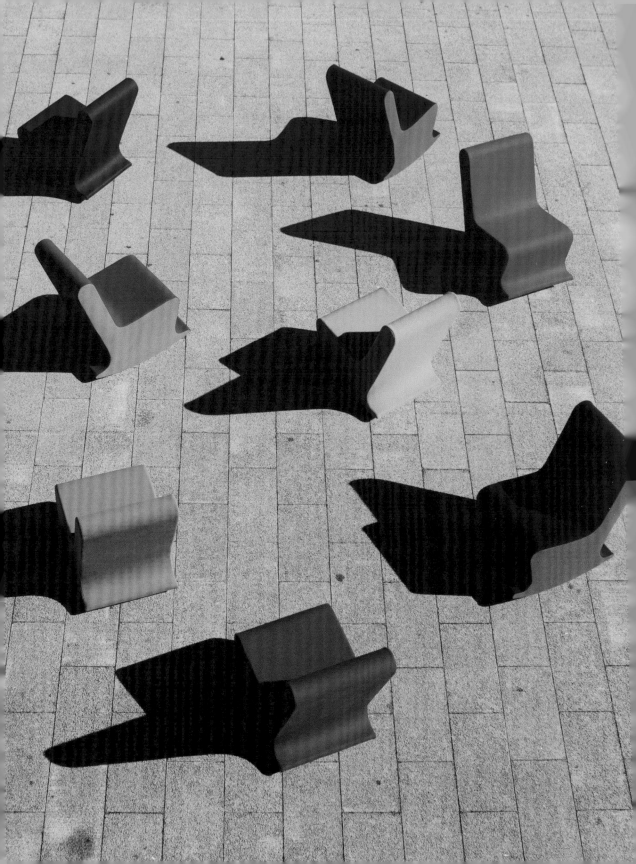

CLAUDIO COLUCCI DESIGN | **TOKYO, JAPAN**
Claudio Colucci

Colucci likes his designs to include aspects that are humorous, sensuous or mysterious. These aspects may disturb the user because their appearance may be a long way from their function.

www.colucci-design.com

1 Dada
2 on
3 to be or not to be
4 Fisholino
5 Heart
6 Bottle
7 Dolce Vita

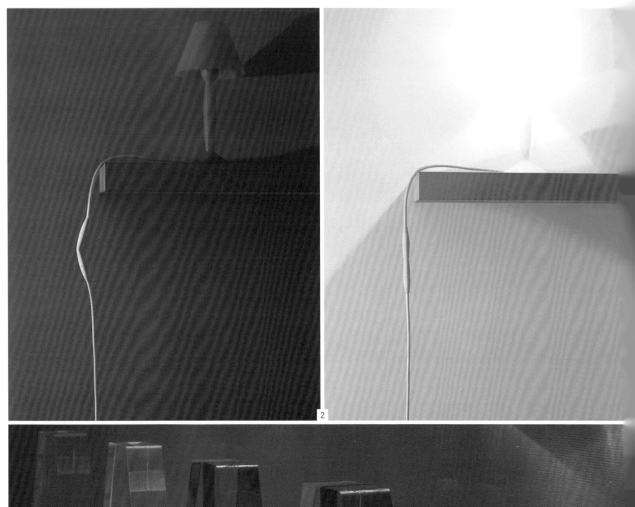

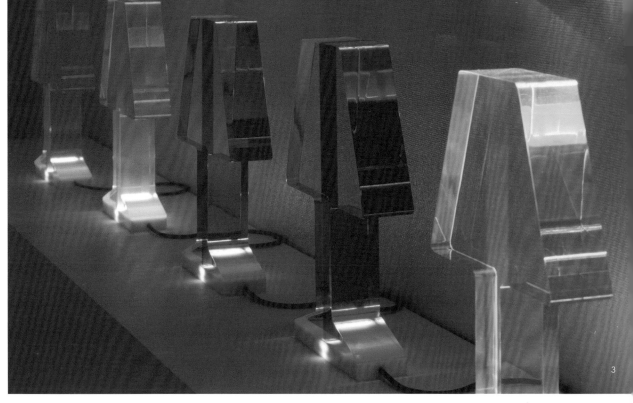

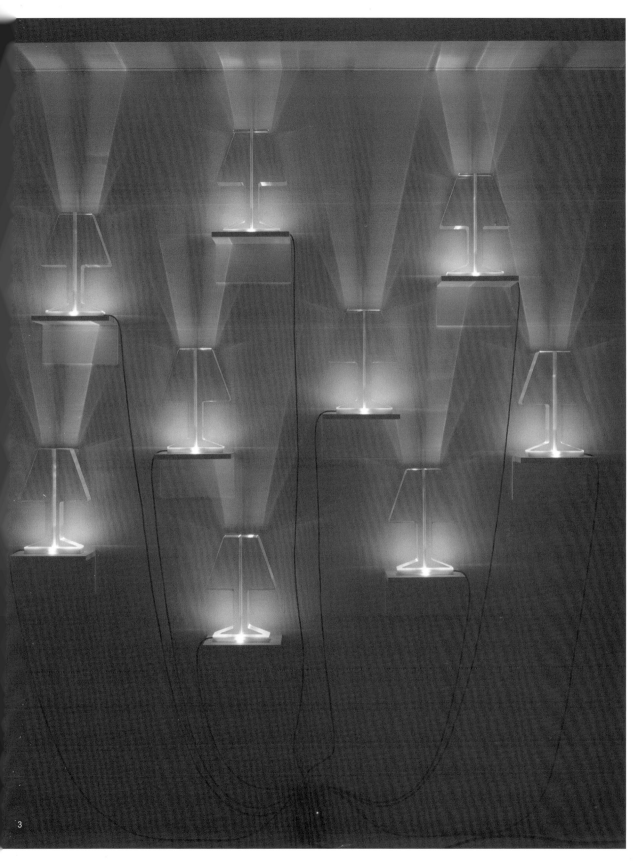

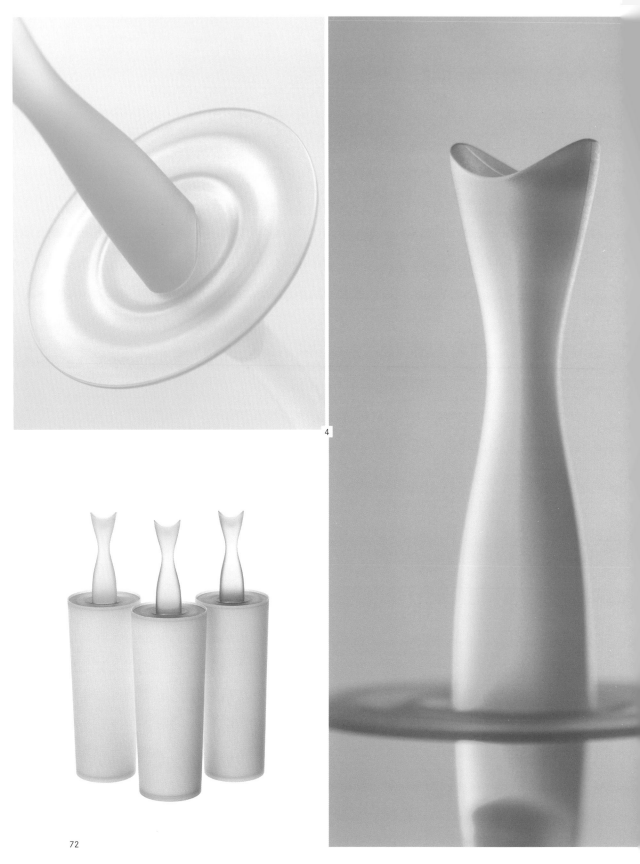

4

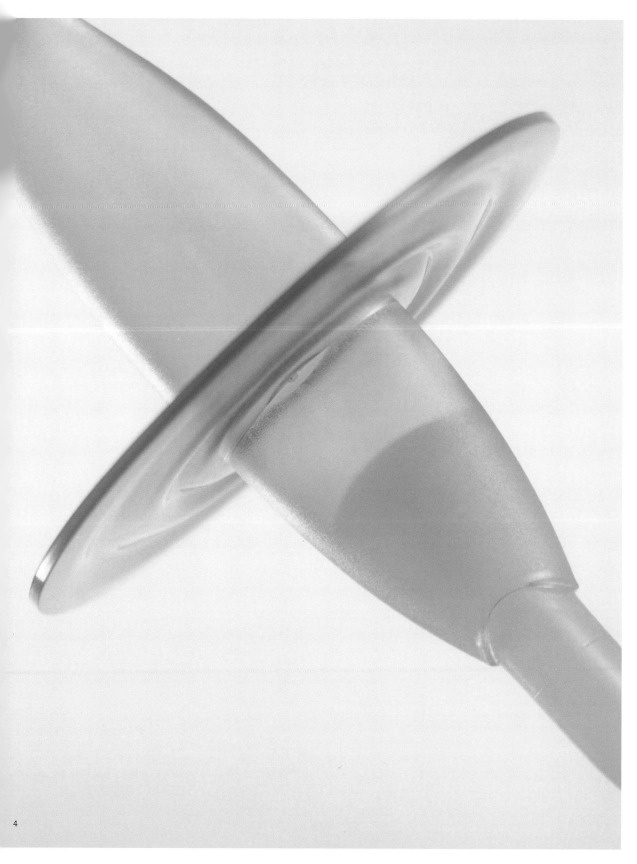

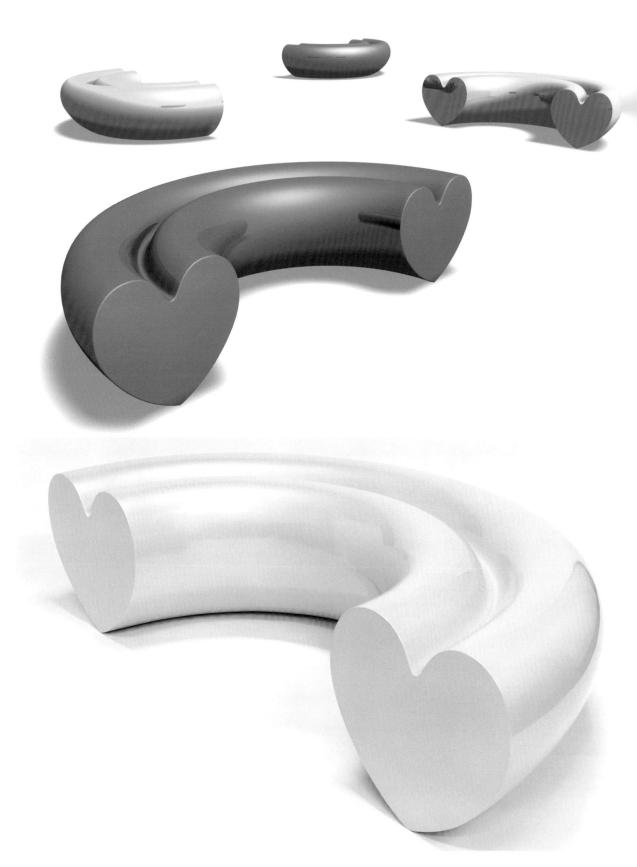

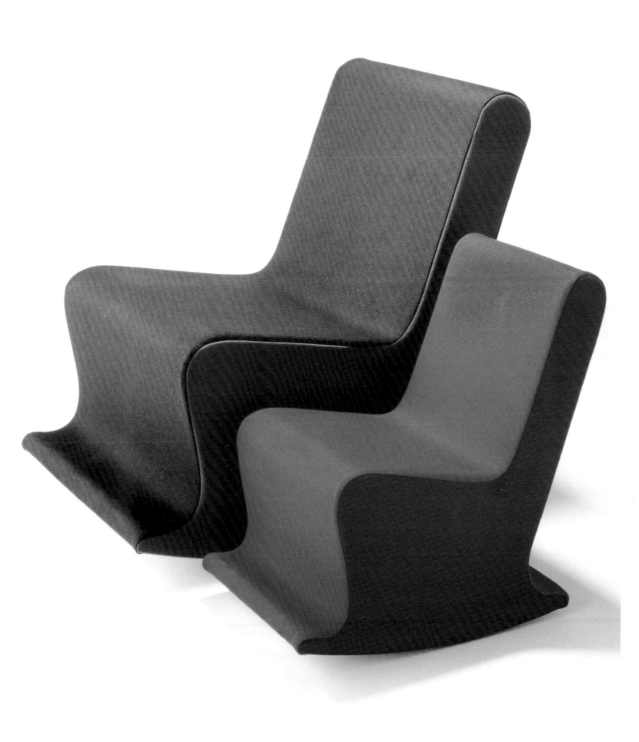

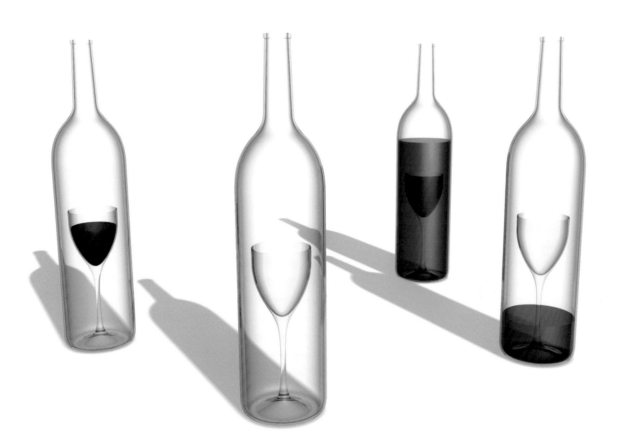

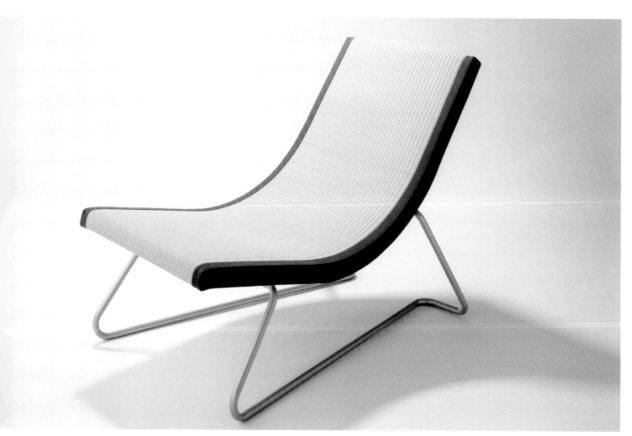

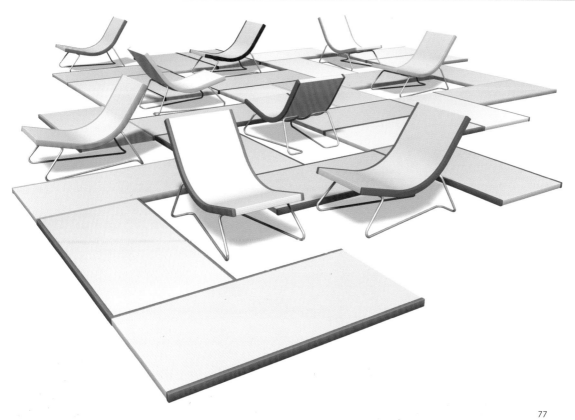

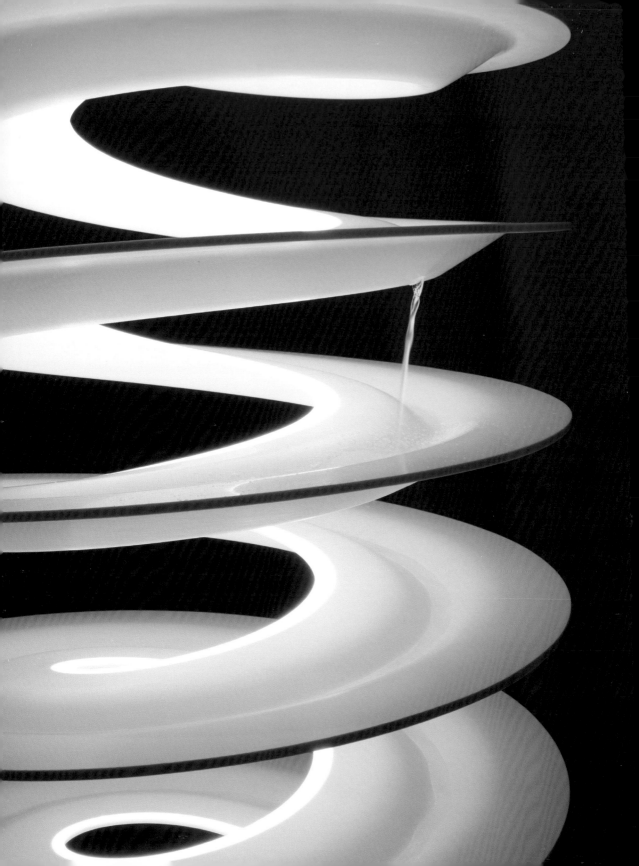

CURIOSITY | TOKYO, JAPAN
Gwenael Nicolas

Gwenael Nicolas came to Japan after graduating at the RCA in London. Then, he worked with renowned creators such as Issey Miyake and Naoki Sakai of Water Studio. In 1988 he established his own design office Curiosity in the heart of Tokyo.

www.curiosity.co.jp

1 Spiral
2 Boomerang Christa
3 Boomerang Plus
4 Boomerang Bench

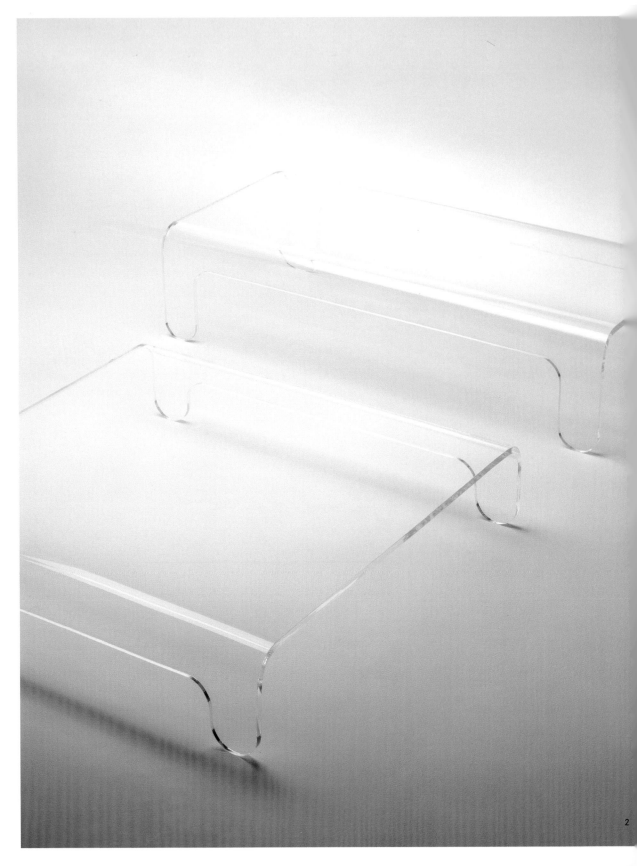

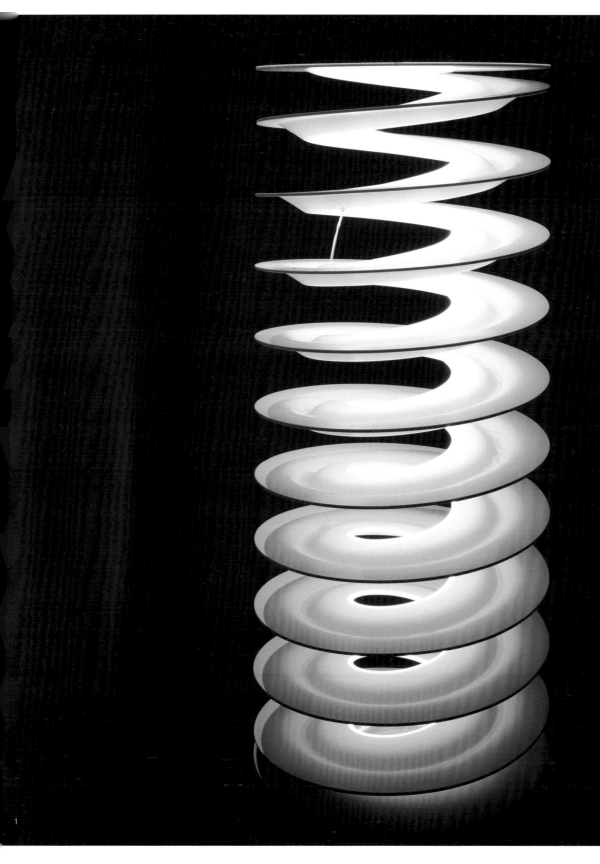

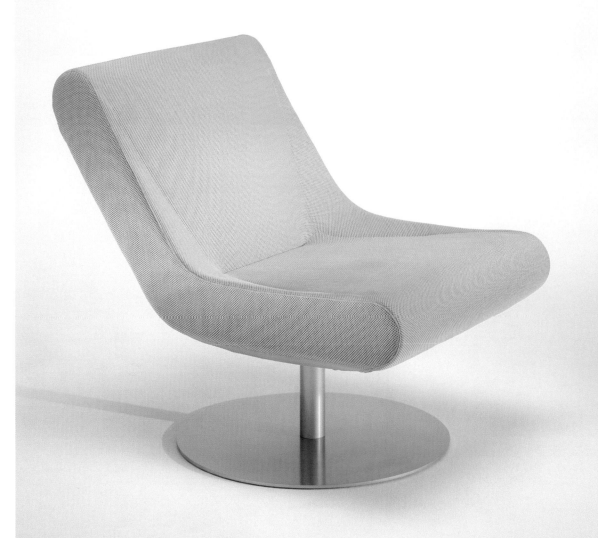

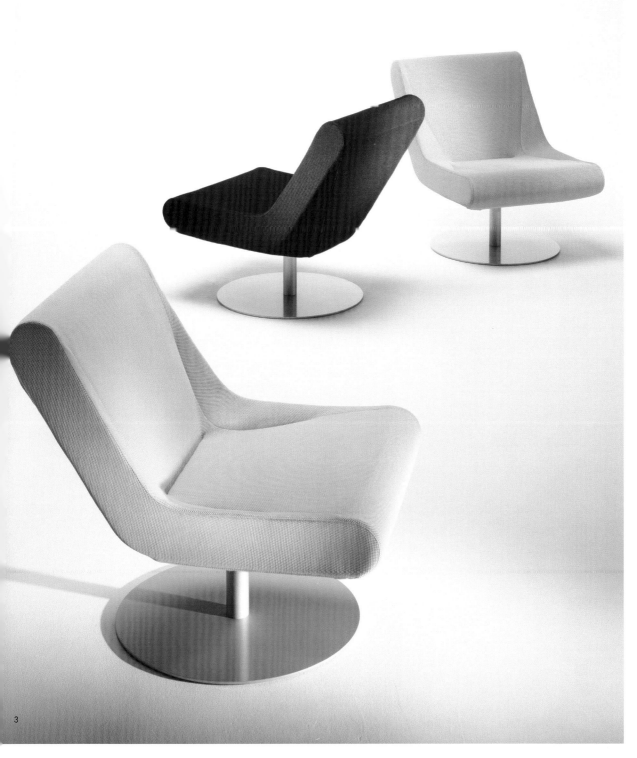

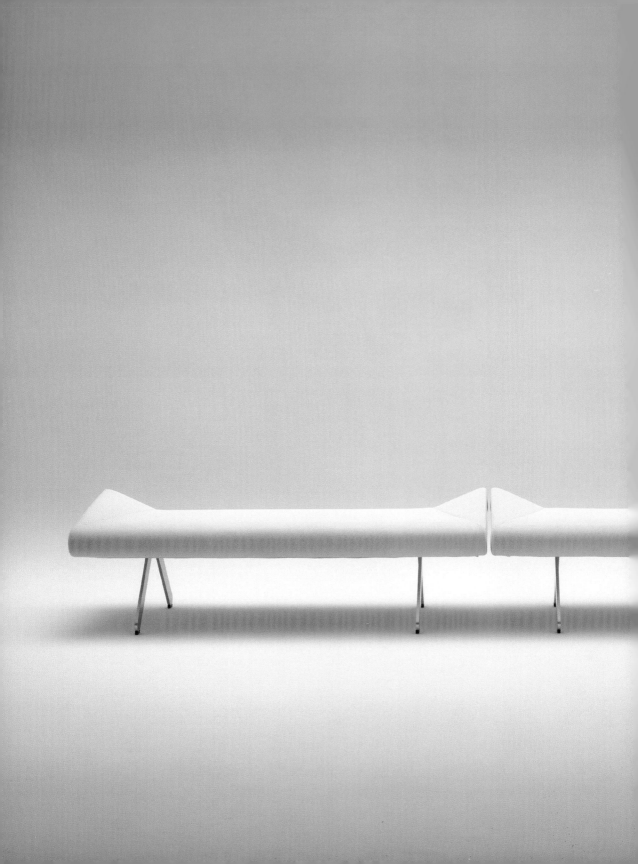

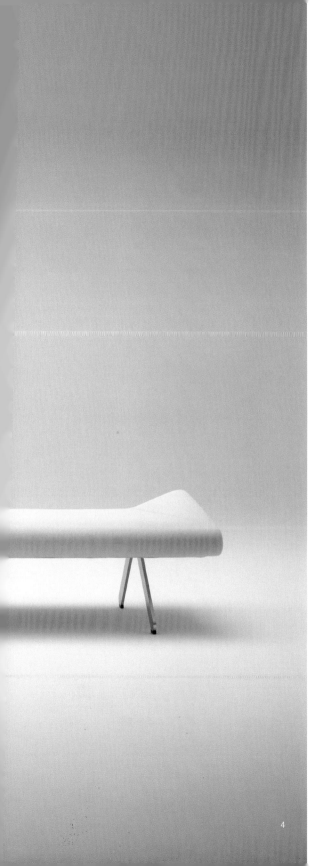

4

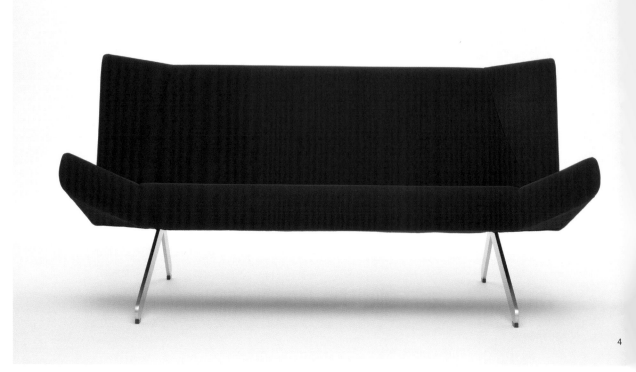

4

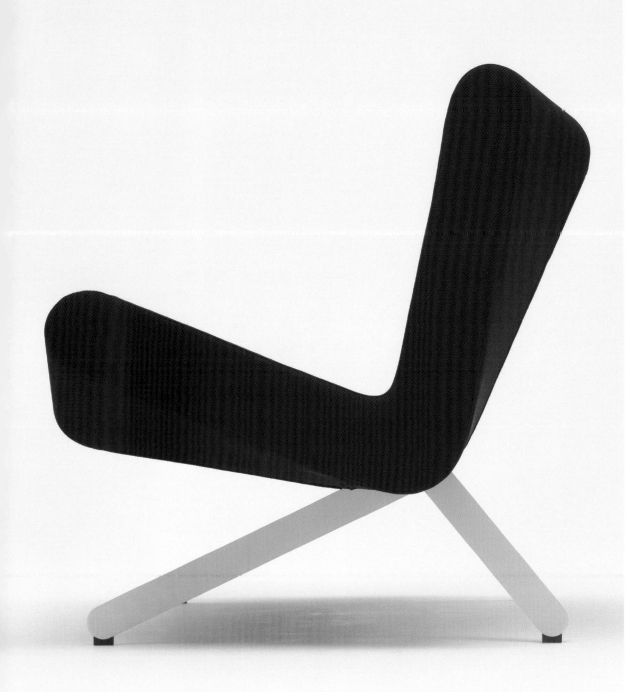

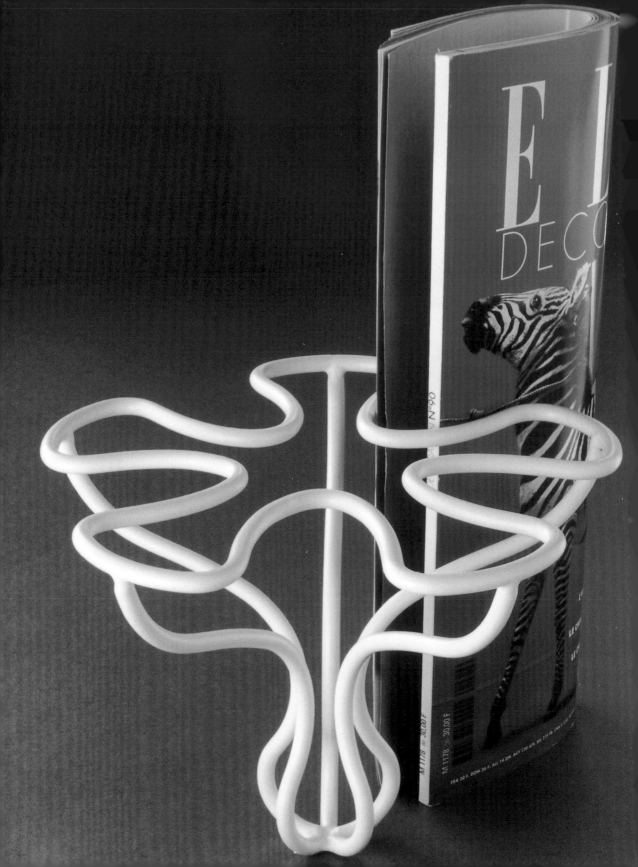

DESIGN STUDIO S | TOKYO, JAPAN
Fumie Shibata

After working for Design Center Toshiba Co., Fumie Shibata established a Tokyo-based design office, Design Studio S. Here she developed a base of specialty clients who have retained her firm for design projects ranging from communications to furniture, infant products and home appliances.

www.design-ss.com

1 Flower magazine, *magazine rack*
2 Sweets, *mobile phone*
3 Baby Label, *bath thermometer*
4 Due, *watering pot*
5 Ken on-Kun
6 Tumbler, *weight scale*
7 Baby Label, *cup*
8 Baby Label, *toilet trainer*
9 Baby Label, *bath tub*

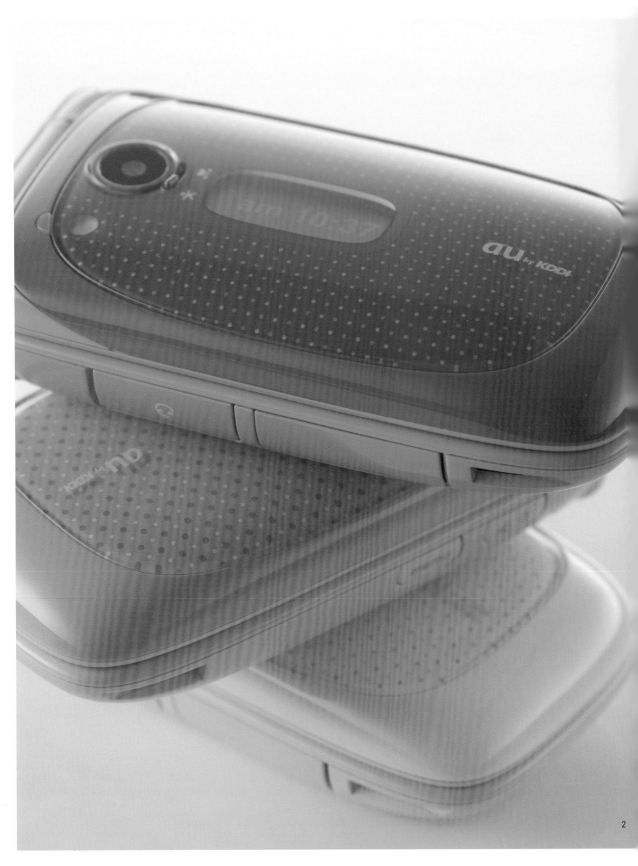

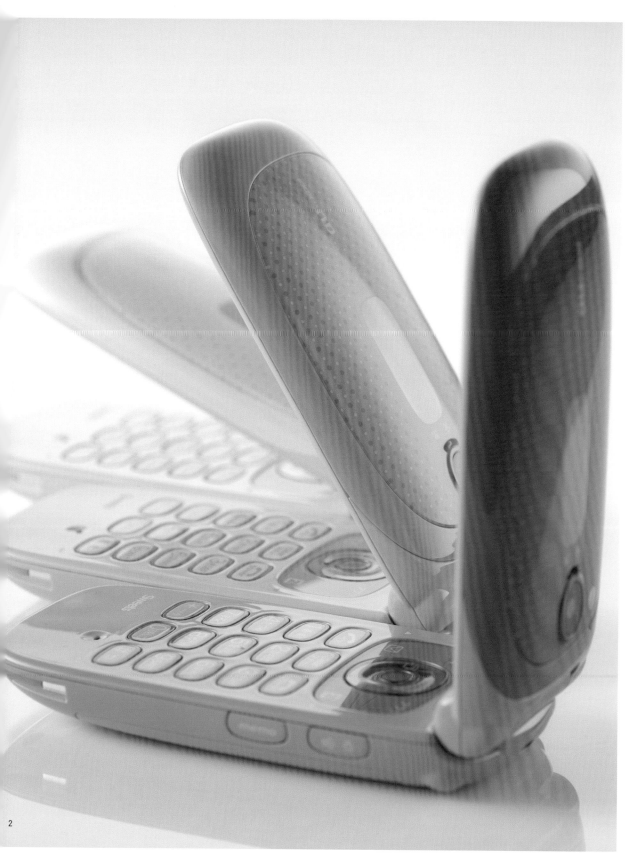

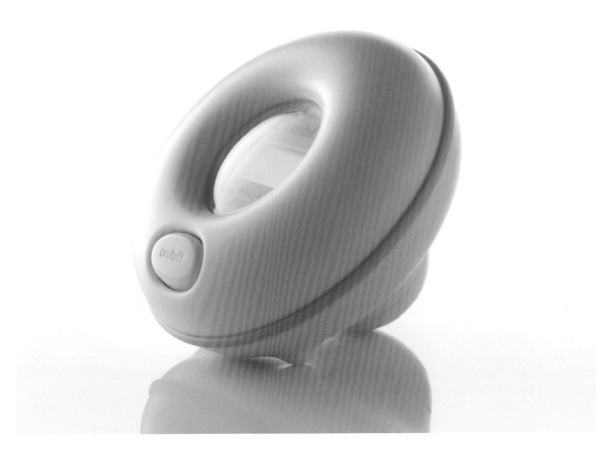

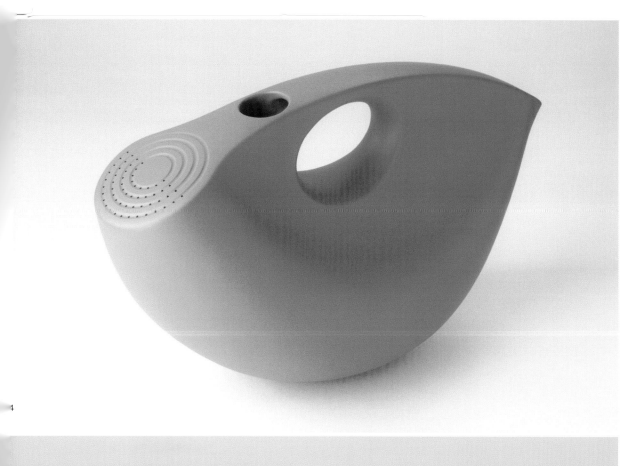

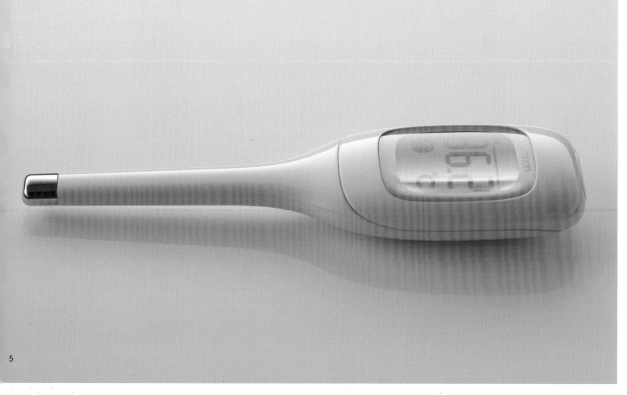

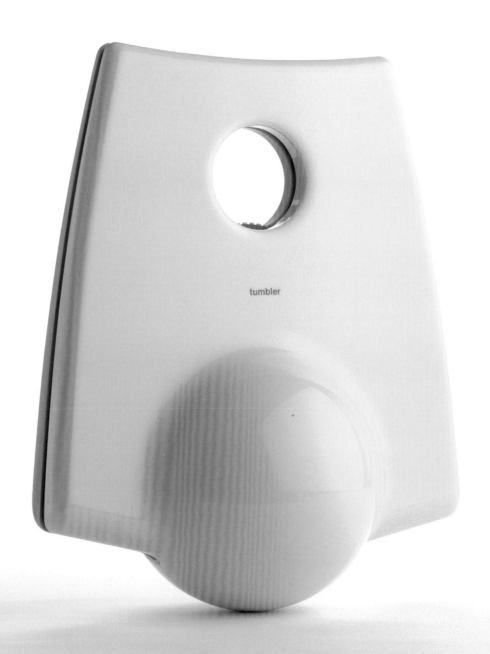

tumbler

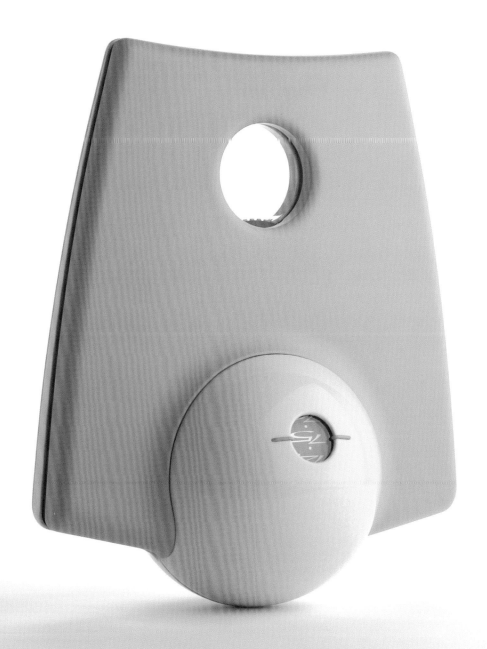

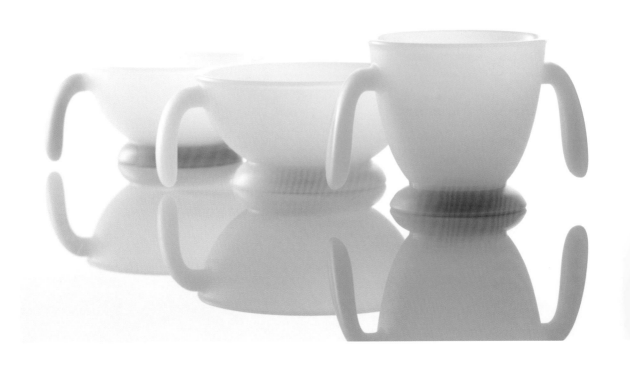

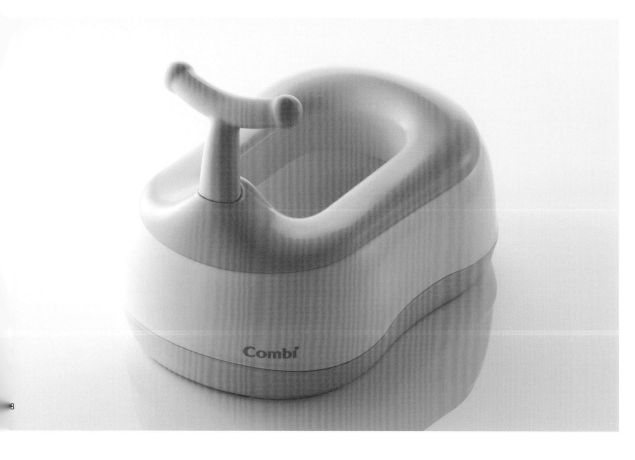

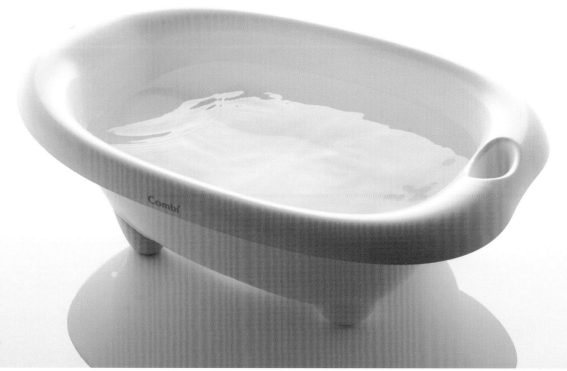

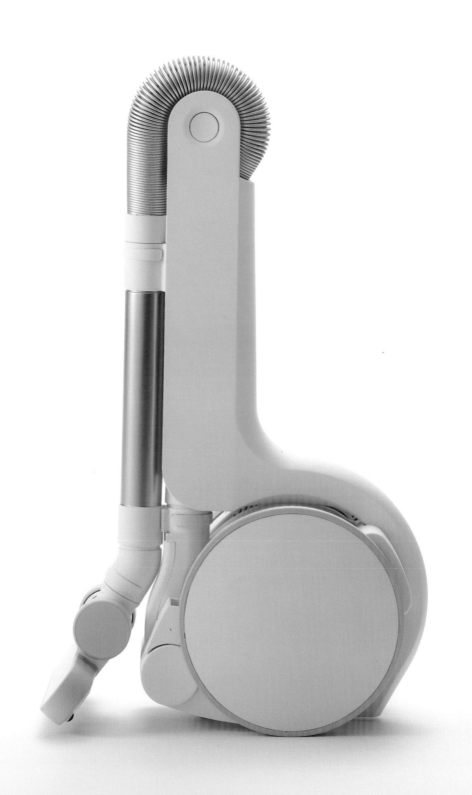

HERS EXPERIMENTAL DESIGN LABORATORY | **OSAKA, JAPAN**
Chiaki Murata

Chiaki Murata has managed to use his technical knowledge to build a solid reputation as a designer. He has even started his own line of products: Metaphys. The Osaka-based designer present his new collection at the Milan Salone.

www.hers.co.jp

1 Uzu
2 Picture
3 factory
4 Uno
5 Falce
6 Hono
7 Kion

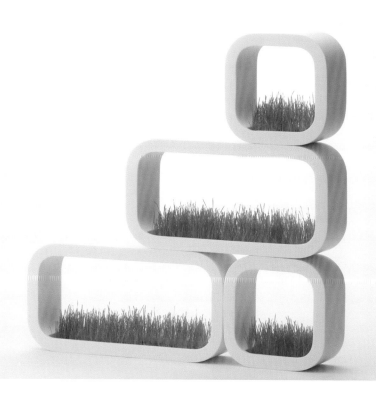
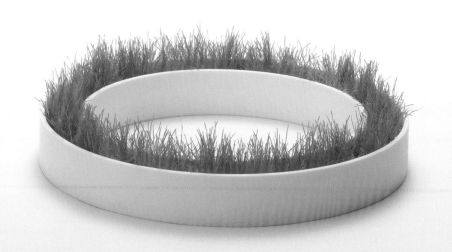

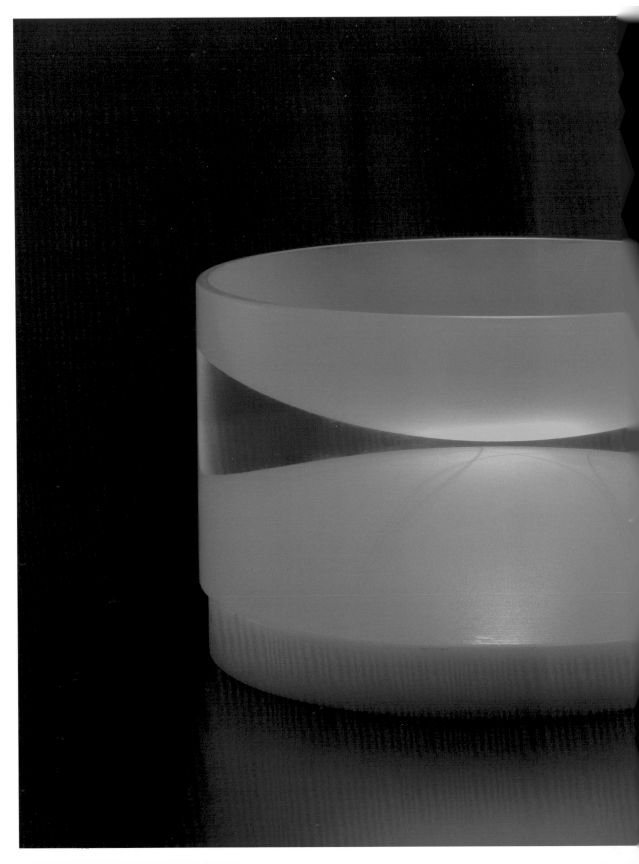

4

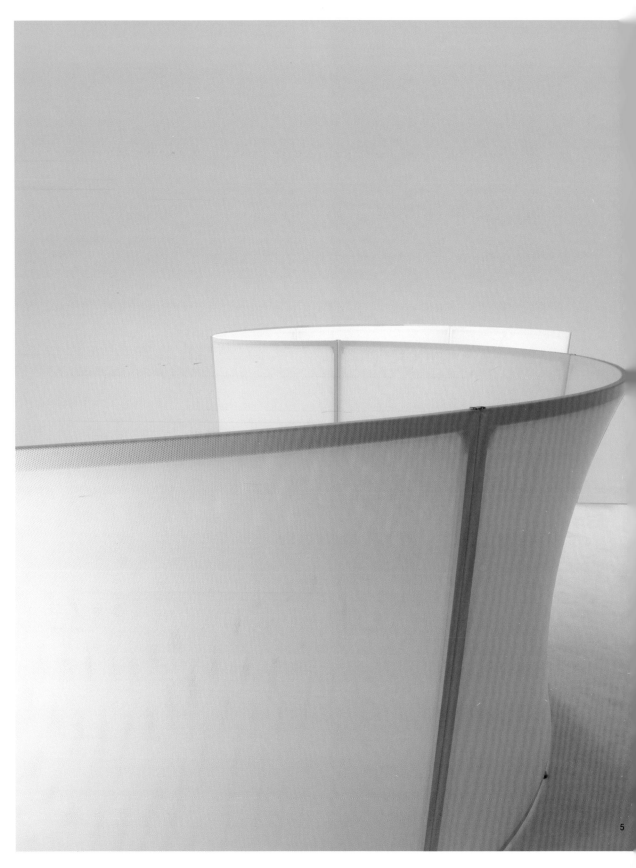

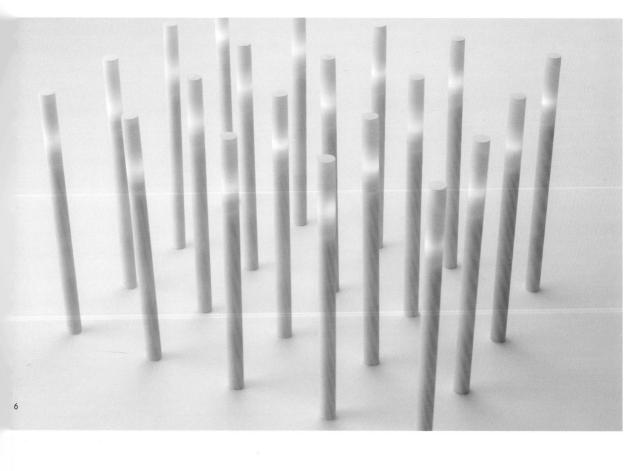

6

7

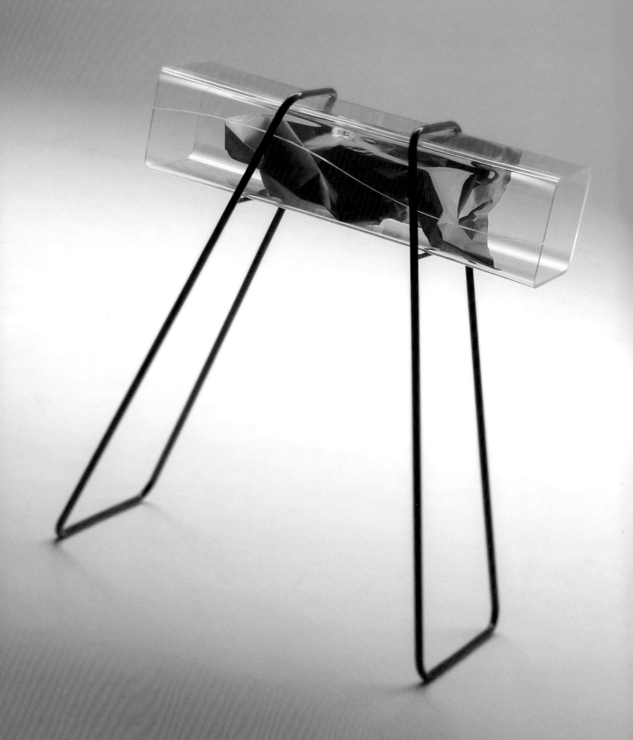

HIHARA INDUSTRIAL DESIGN OFFICE | SHIZUOKA, JAPAN
Sachio Hihara

The all-dominant theme of Sachio Hihara work is a seat, which is a cross between the Japanese cushion and the Western chair. The creative visions of his work are love and peace.

www.sachio.jp

1 Sachi.rack
2 Soramane
3 Obi, *bench*
4 Ami
5 Monaka

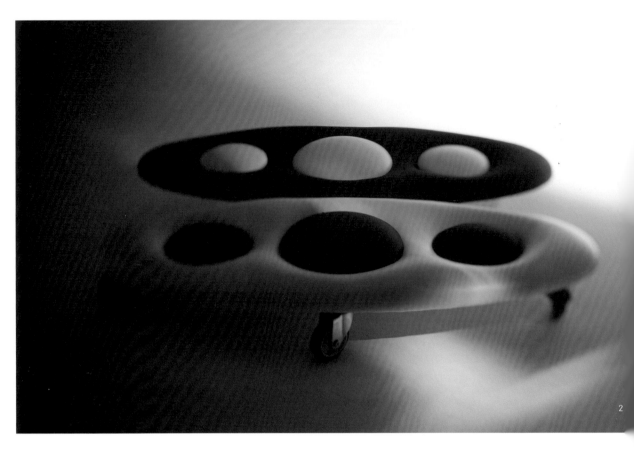

2

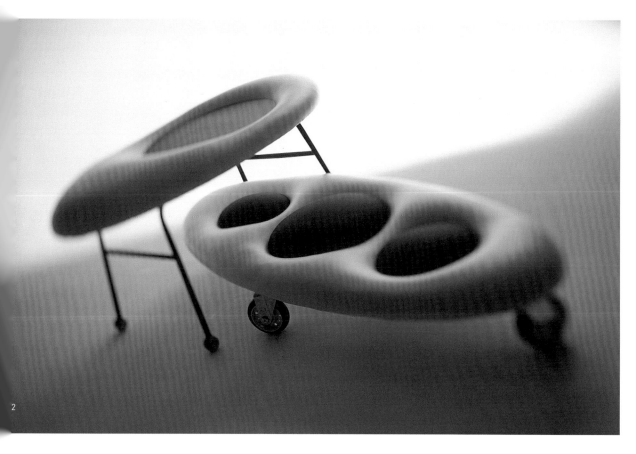

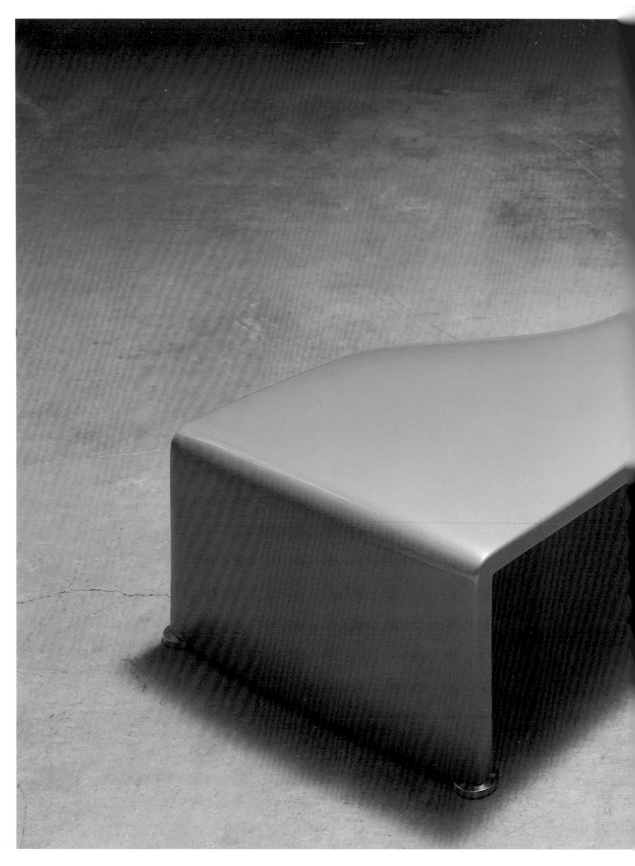

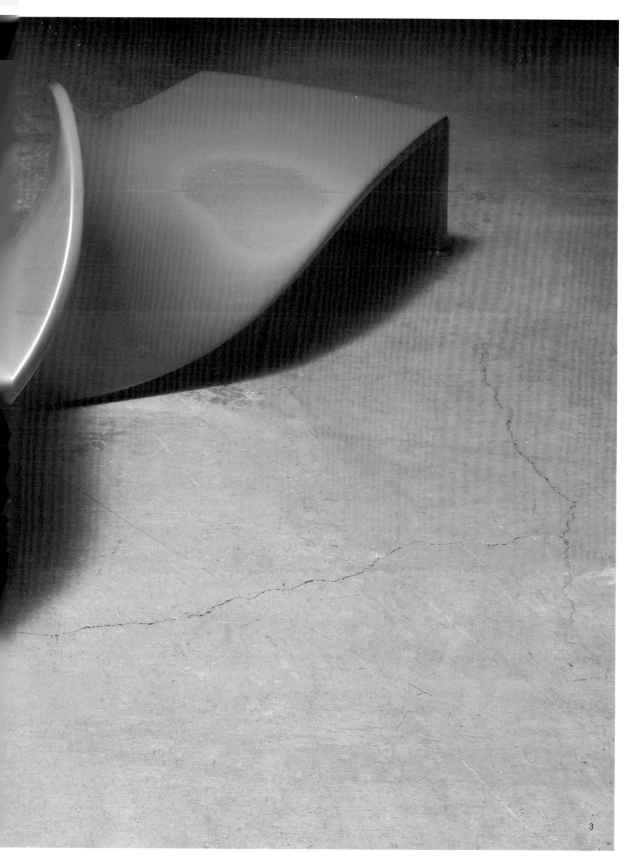

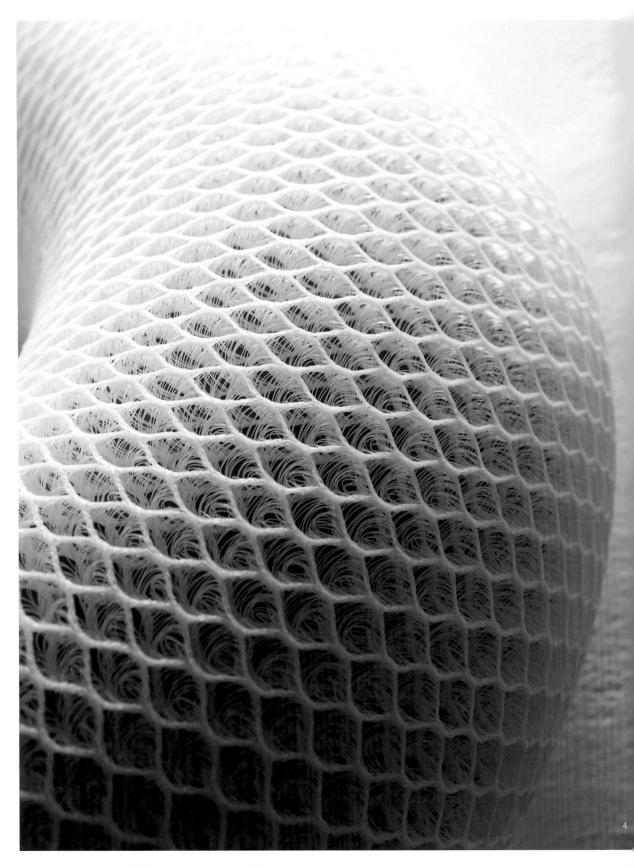

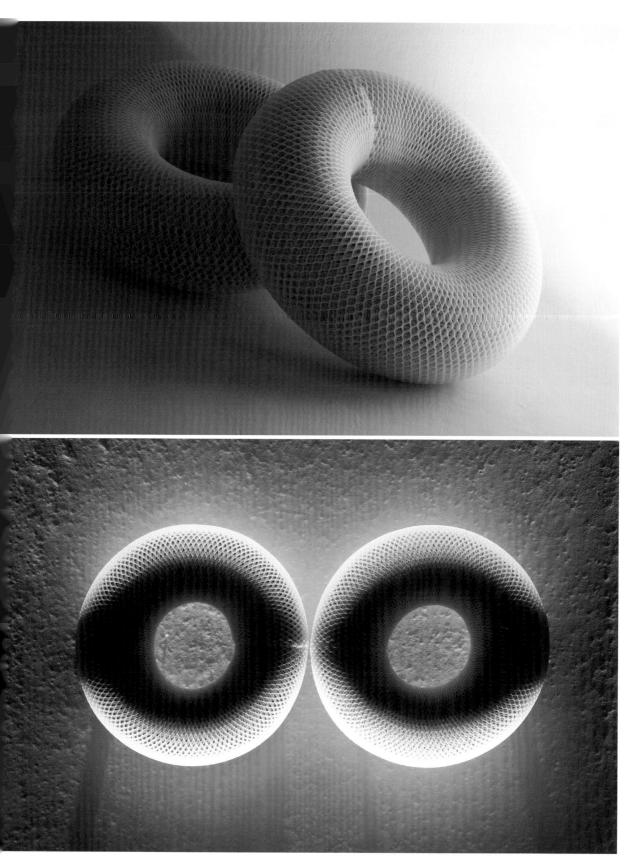

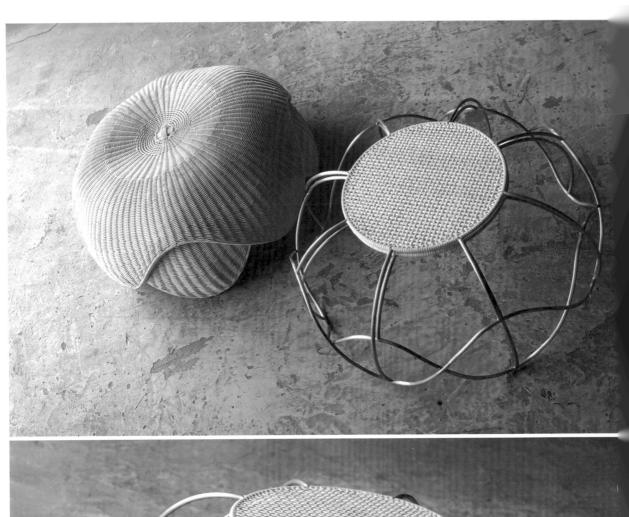
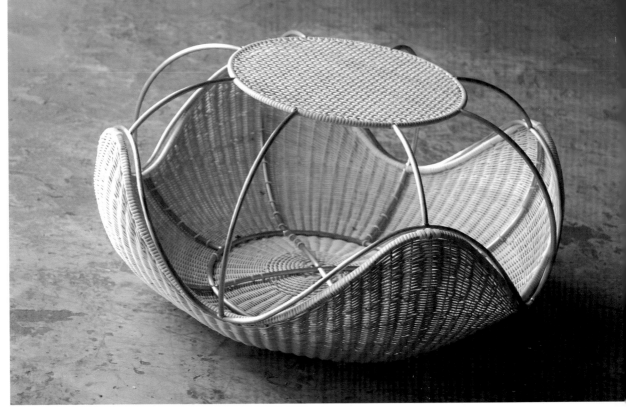

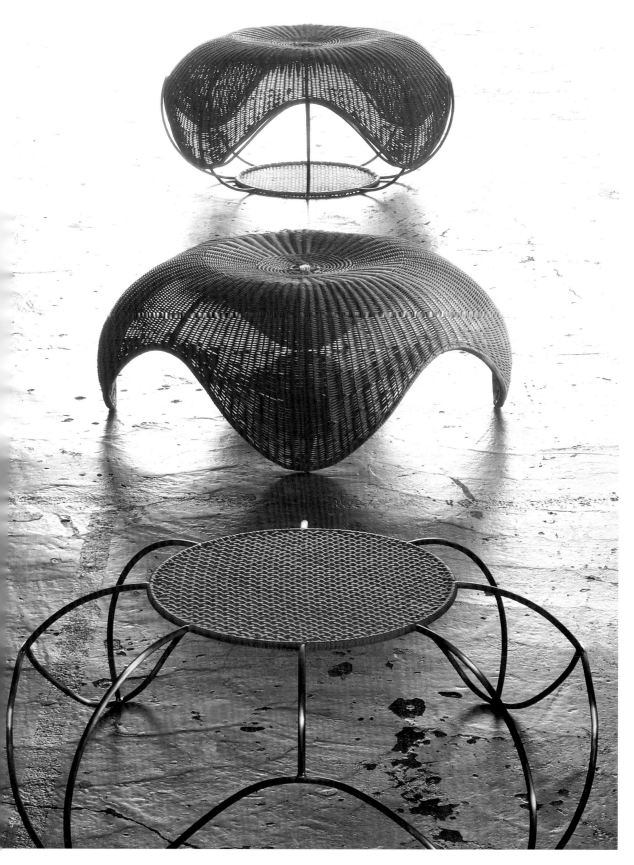

HSU-LI TEO, STEFAN KAISER | VICTORIA, AUSTRALIA

For the designers team, artwork, selected and displayed with care, will resonate as more than just a physical presence. They will affect the emotive quality of the space.

www.globalhouse.com.au

Sticks, *paravent*

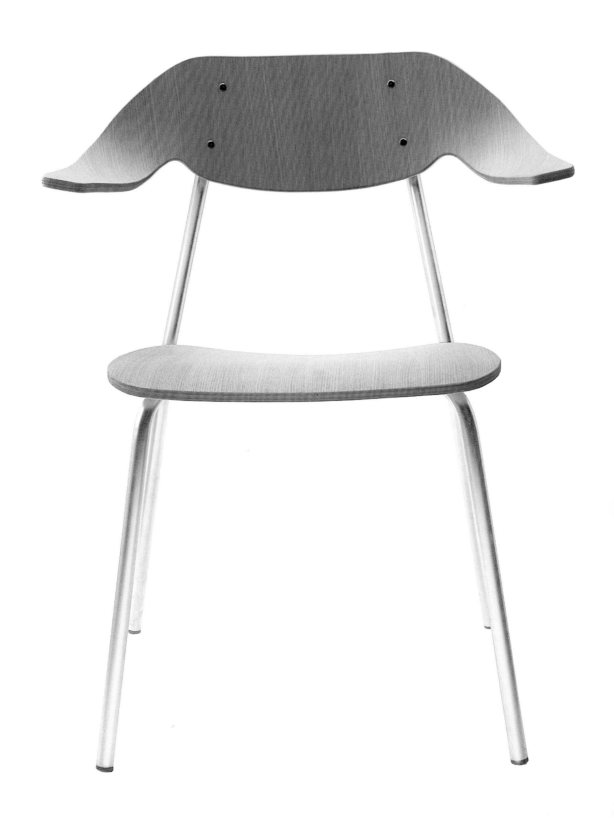

INODA + SVEJE | MILANO, ITALY
Kyoko Inoda, Nils Sveje

The studio was founded in 2000. Based on the joint values of the founding partners, it emphasizes the simplicity of Japanese and Danish design history.

www.inoda.com

1 Vanilla
2 Mirrorlamp, *illuminating hand mirror*
3 Suspense
4 Wireless Speaker
5 24Kegler, *game*
6 Bench B4

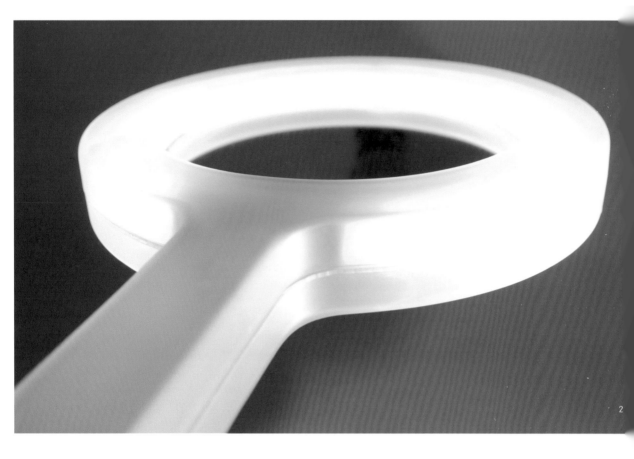

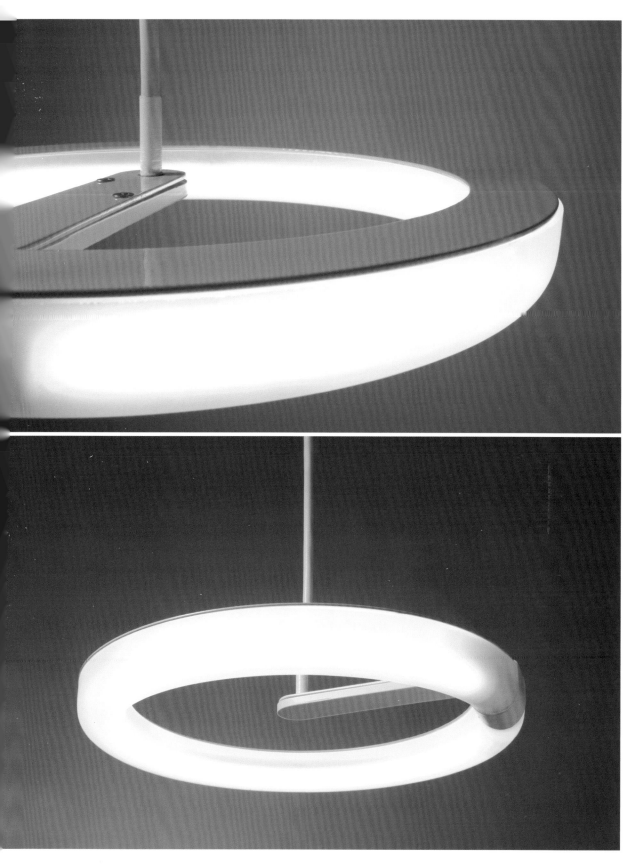

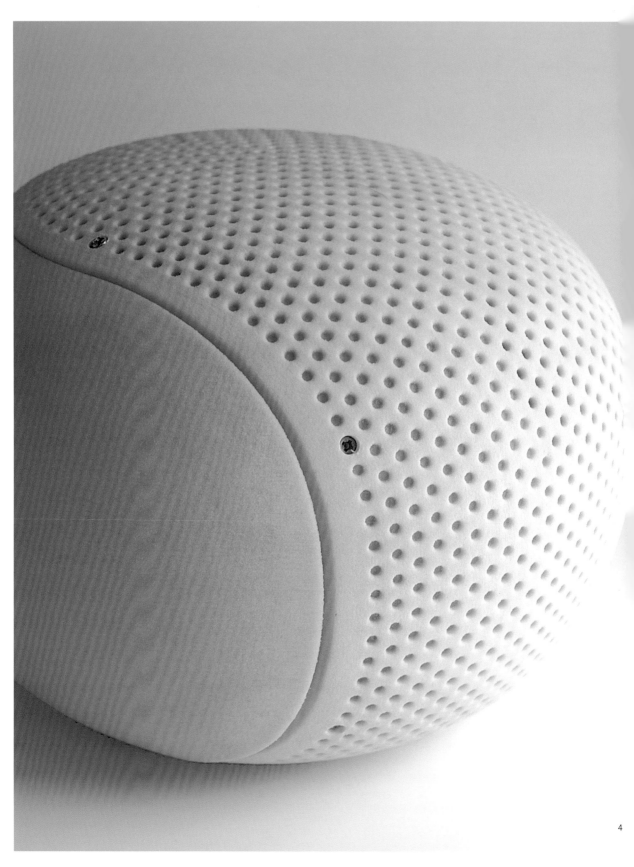

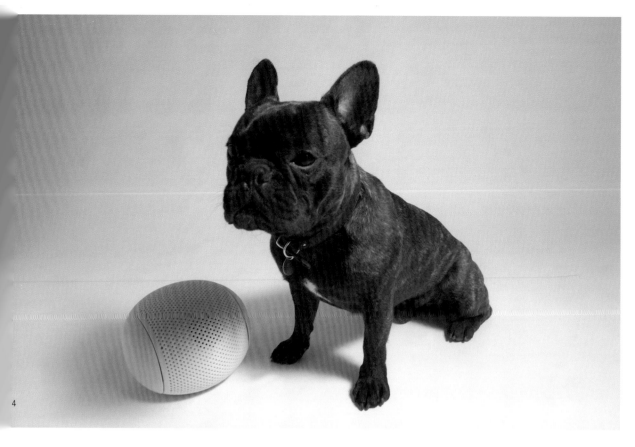

4

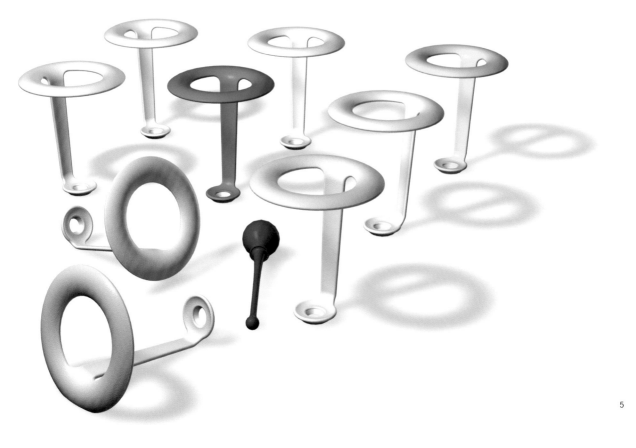

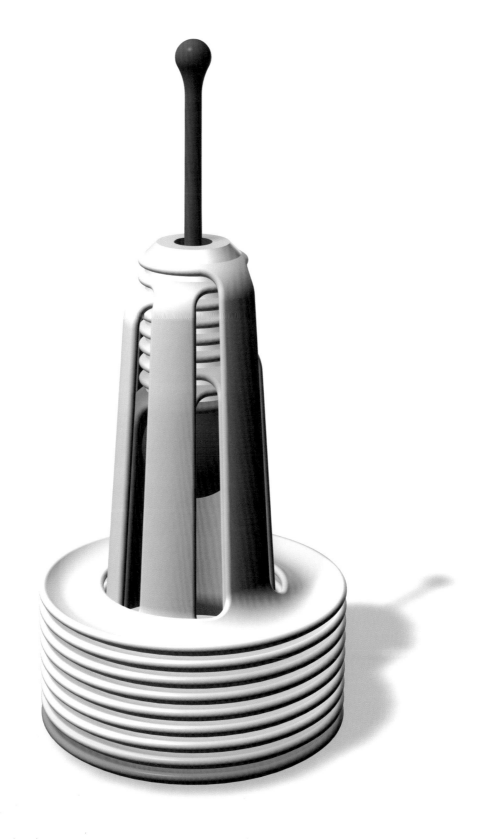

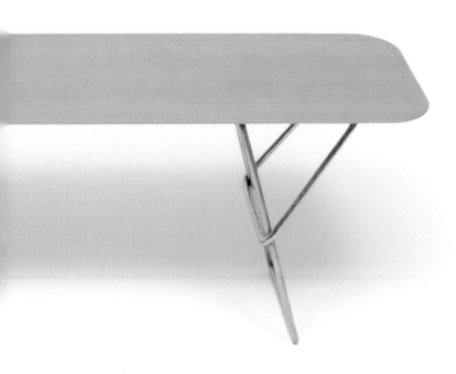

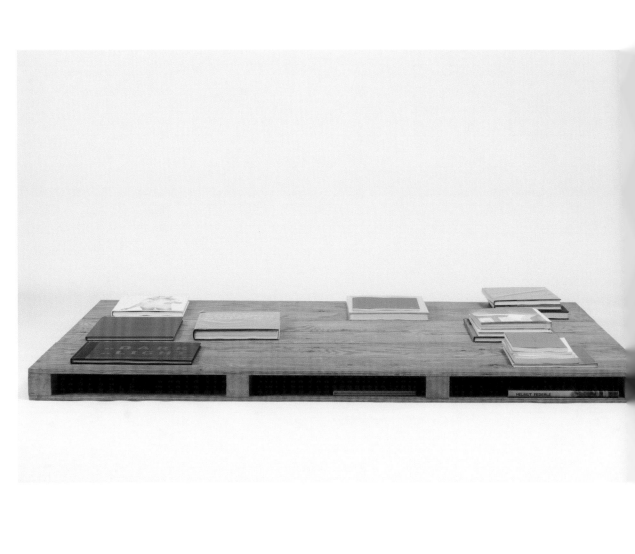

ISOLATION UNIT / SPACE AND PRODUCT DESIGN | OSAKA, JAPAN
Teruhiro Yanagihara

The Isolation Unit is defined as a principle of personal relativity, but not as a concept of it. The work is not just the object being created as a product itself; it is developed with the simple view that the circumstances surrounding the work are the important elements of the design.

www.isolationunit.info

Ple02

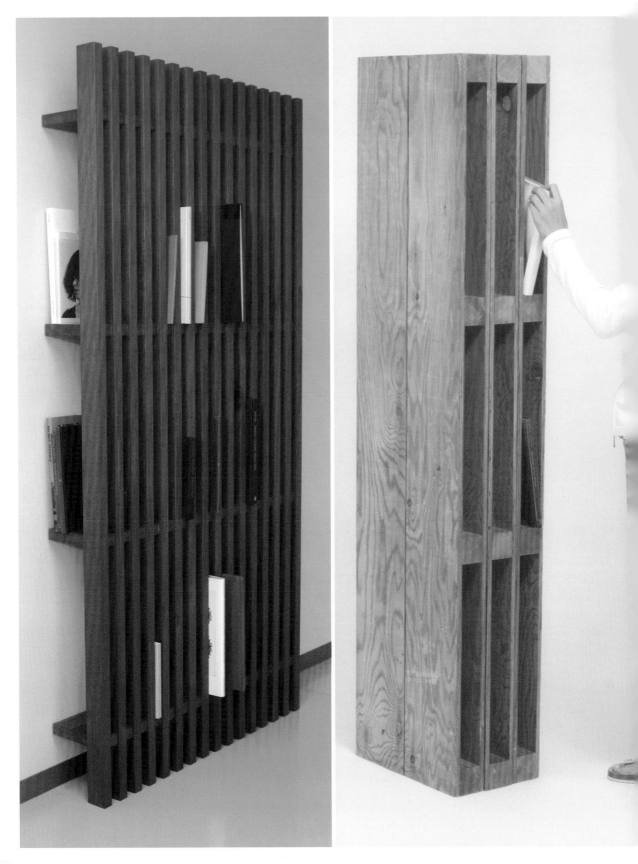

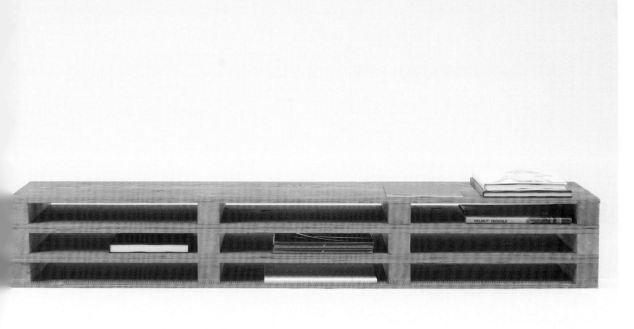

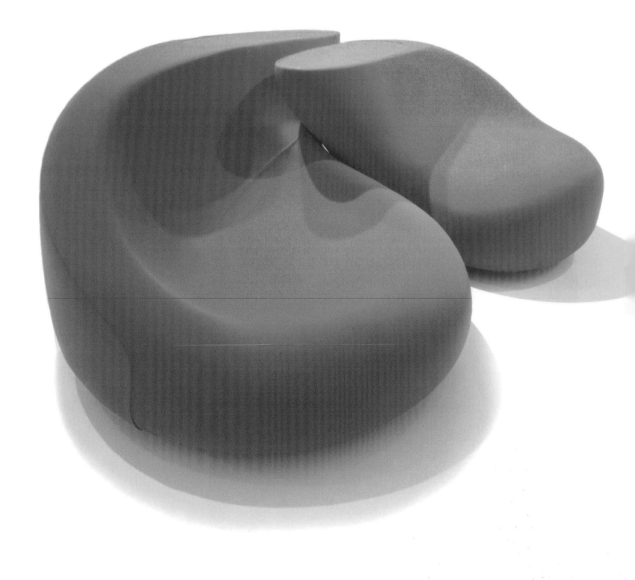

SETSU E SHINOBU ITO | MILAN, ITALY
Setsu Ito, Shinobu Ito

Their work has been published and exhibited throughout Europe and Japan and has received several awards. Some pieces today are part of the permanent collection at the Museum of Contemporary Art in Munich. Setsu is also a Visiting Lecturer in Milan at the Domus Academy and at the Istituto Europeo di Design, and in Tokyo at the Tama Art University.

www.studioito.com

1 AU.
2 Nu
3 Yu
4 Isola-S
5 Saturnia
6 Tre-Re, *sculptured sofa*

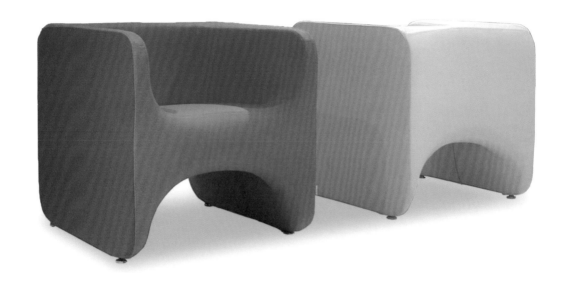

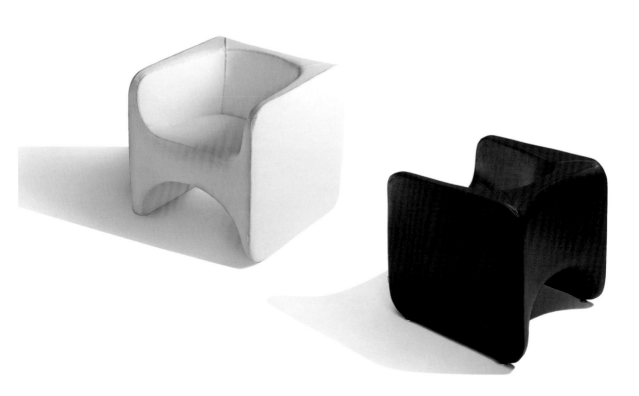

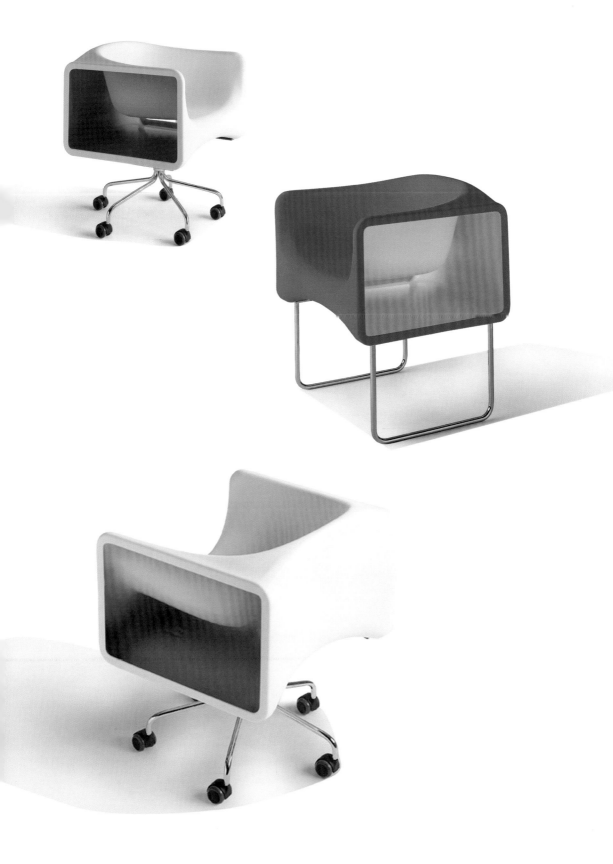

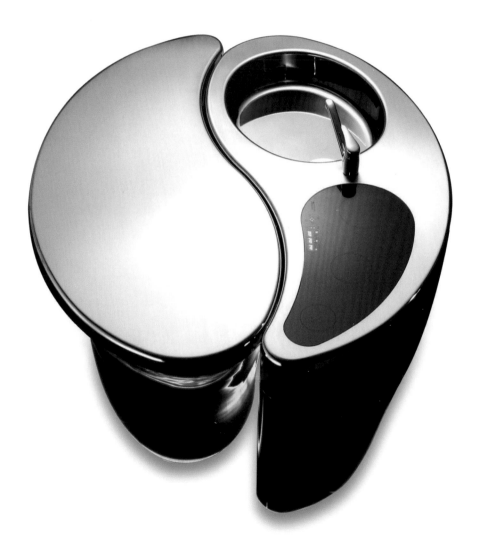

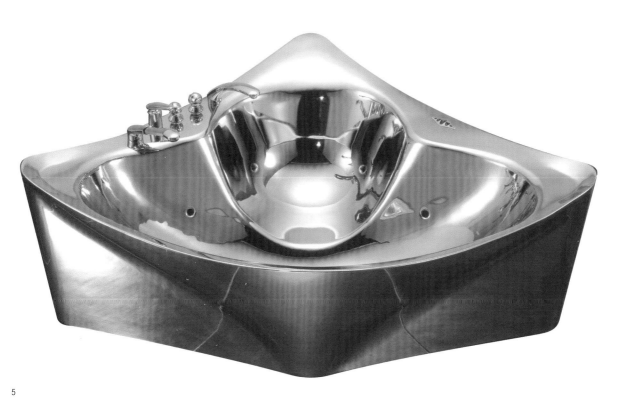

5

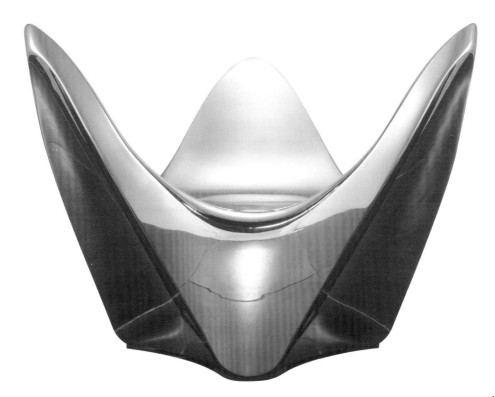

6

JOHNNY CHAMAKI DESIGN STUDIO | SYDNEY, AUSTRALIA
Johnny Chamaki

The Johnny Chamaki Design Studio was founded in 2002 with a focus on furniture, objects, interiors and architecture. His Design Studio's mission is to provide designs which embody art, design, technology and ultimately mother nature.

www.johnnychamaki.com

1 Leaf chaise
2 MyRug
3 AirBorne
4 DragonFly
5 AquaPuss
6 FlyFly
7 Mosquito
8 OutLaw

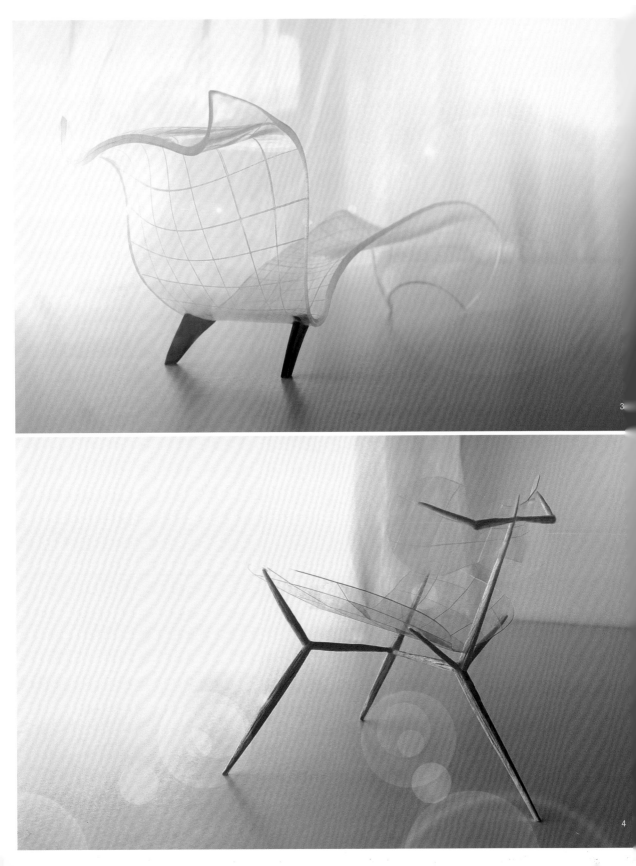

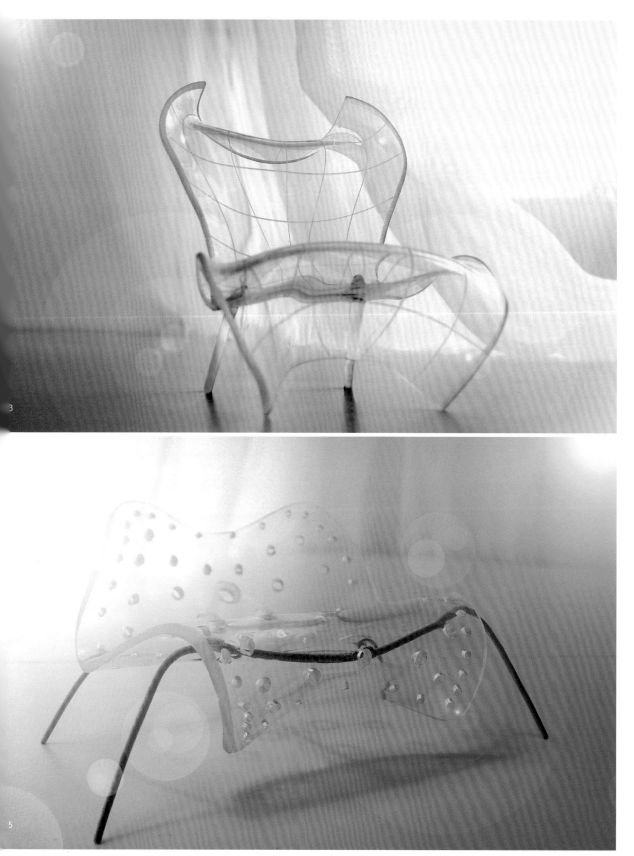

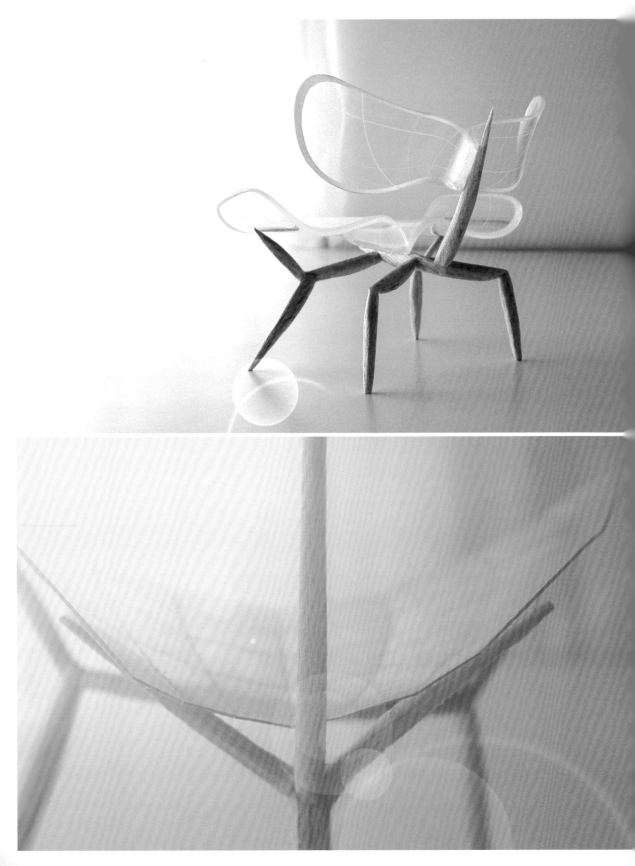

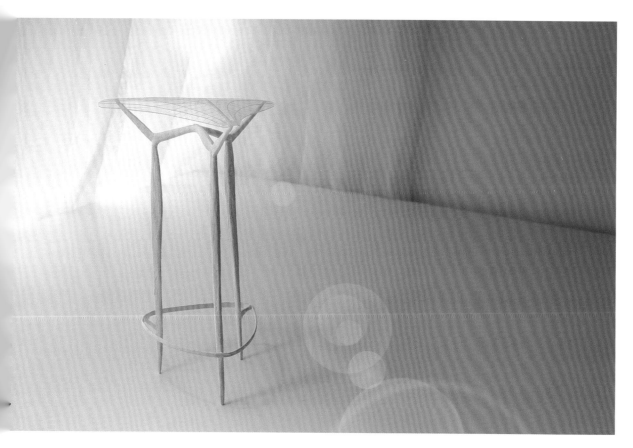

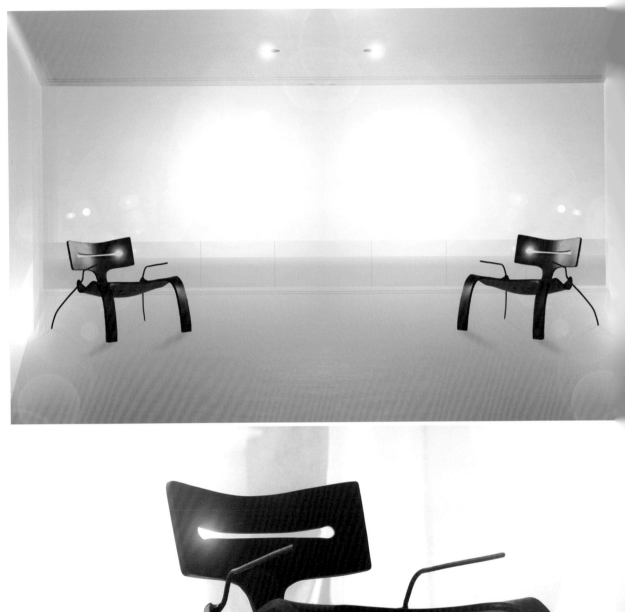
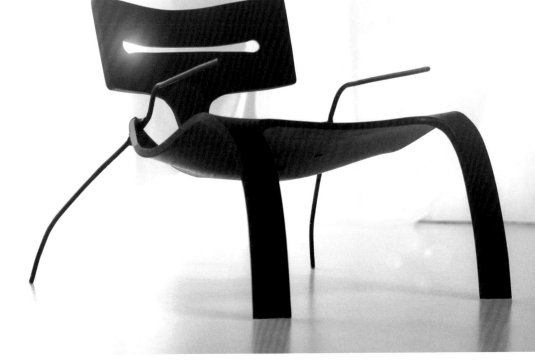

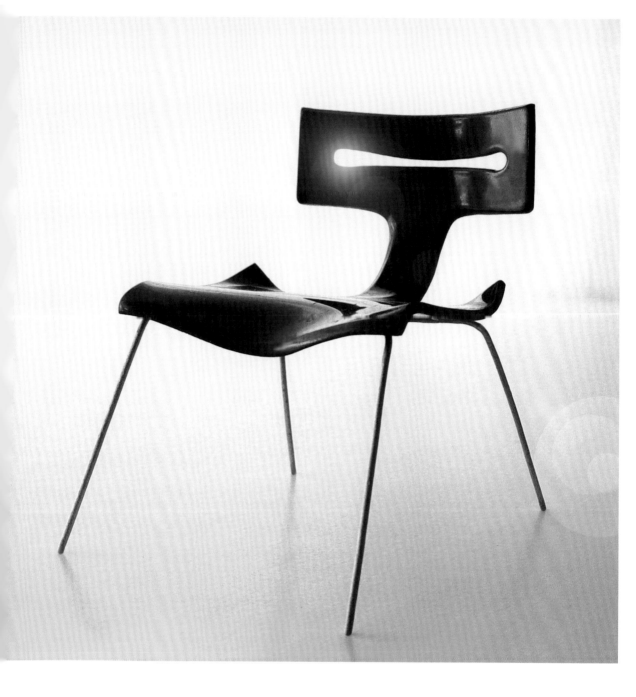

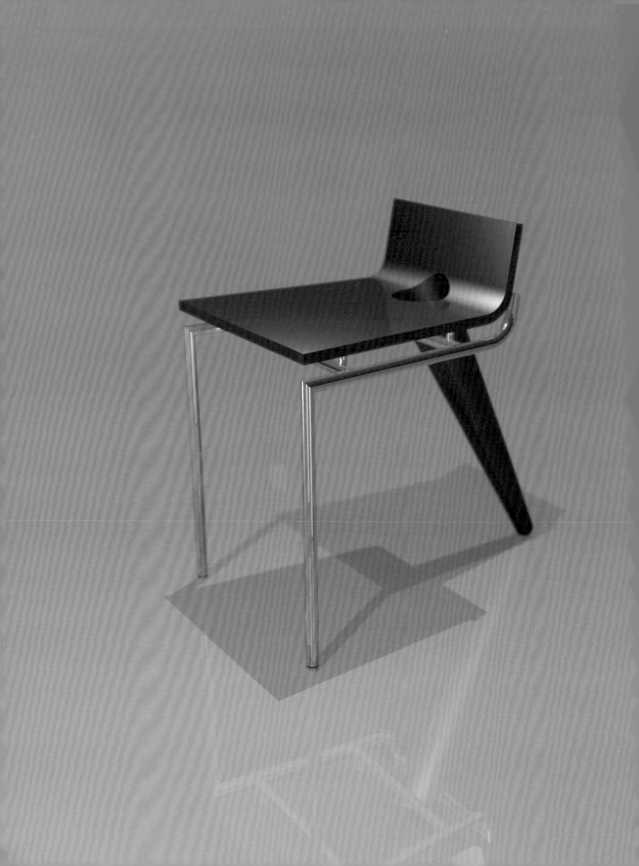

YOTA KAKUDA | LONDON, UNITED KINGDOM

Yota Kakuda was born 1979 in Japan. Since he made London his main place to work in 2003, he has gained experience at various design offices including Shin and Tomoko Azumi and Ross Lovegrove.

yotakakuda@hotmail.com

1 Unisex chair
2 Yakan stool
3 What kind of flower do you like?
4 Shoji curtain
5 Okino
6 Behind the table
7 Lotus leaf

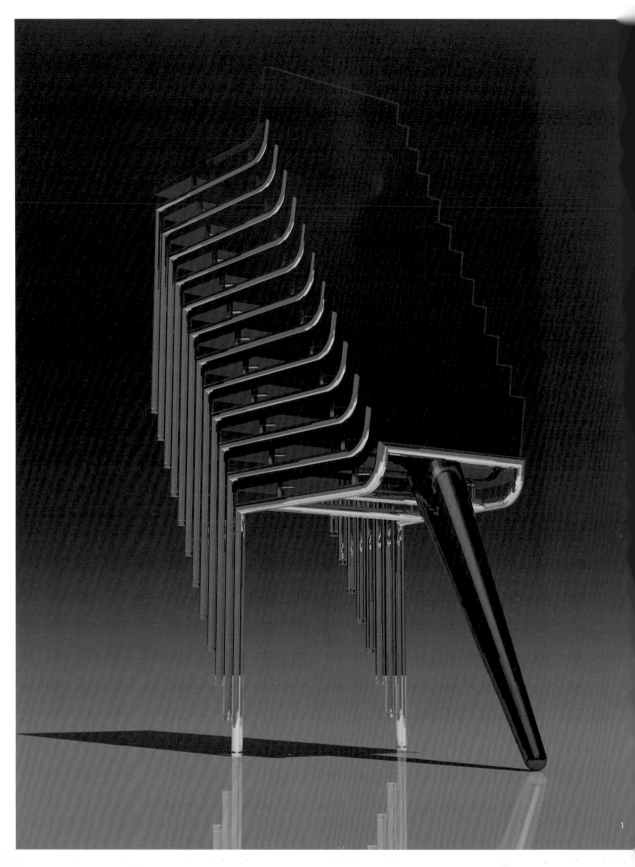

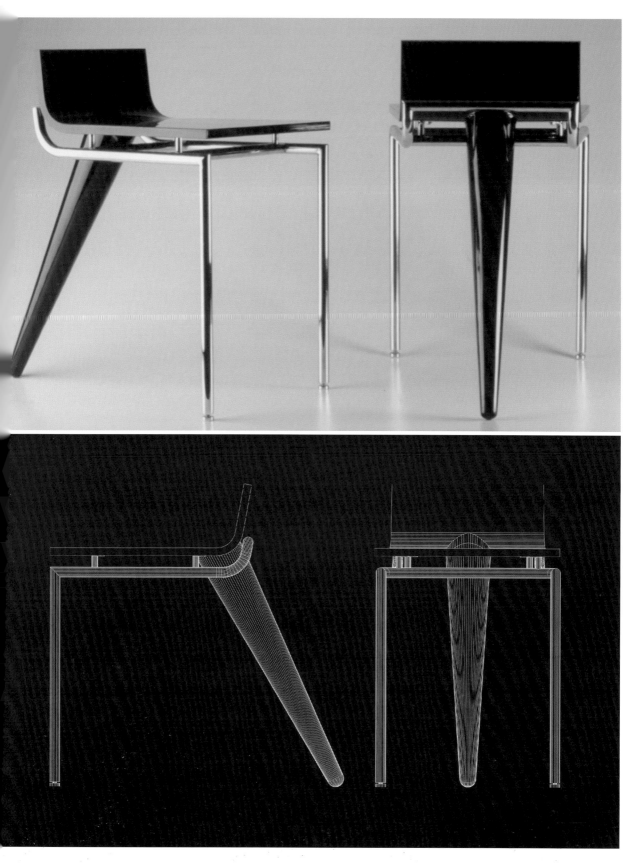

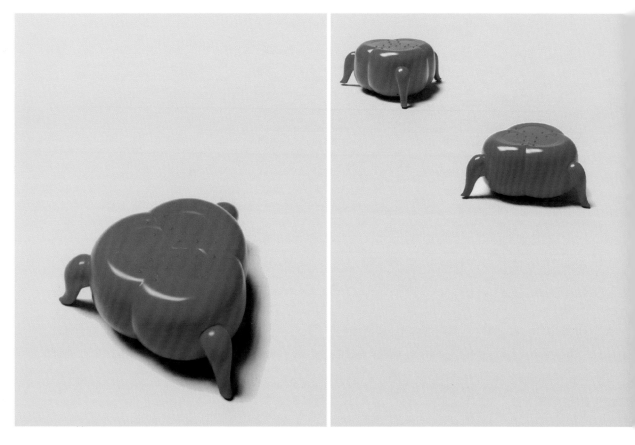

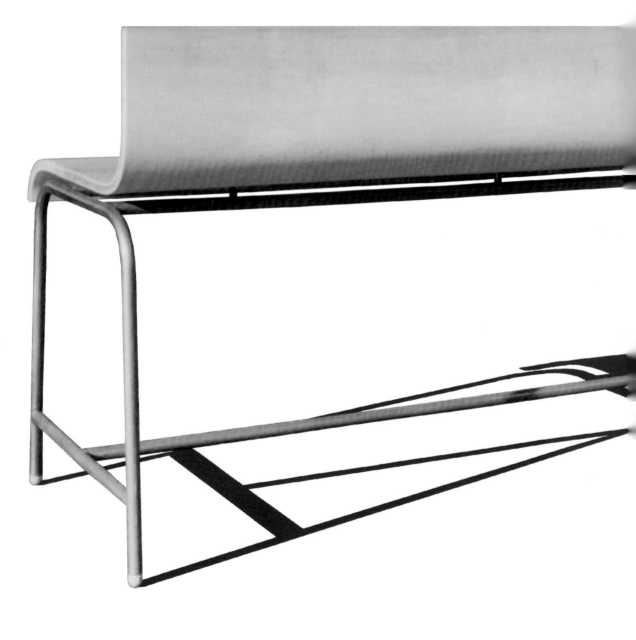

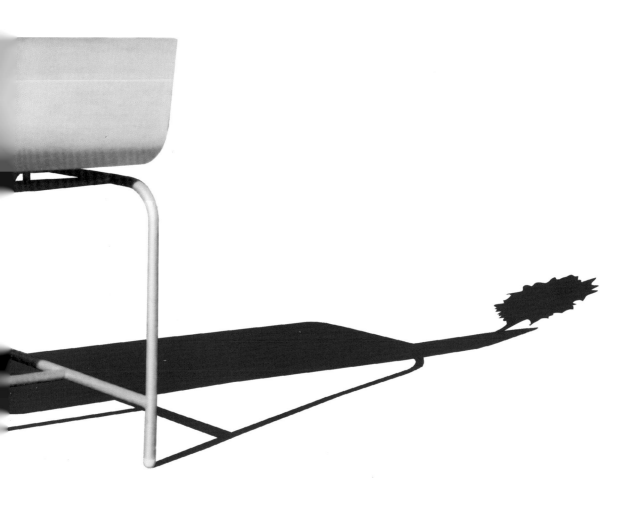

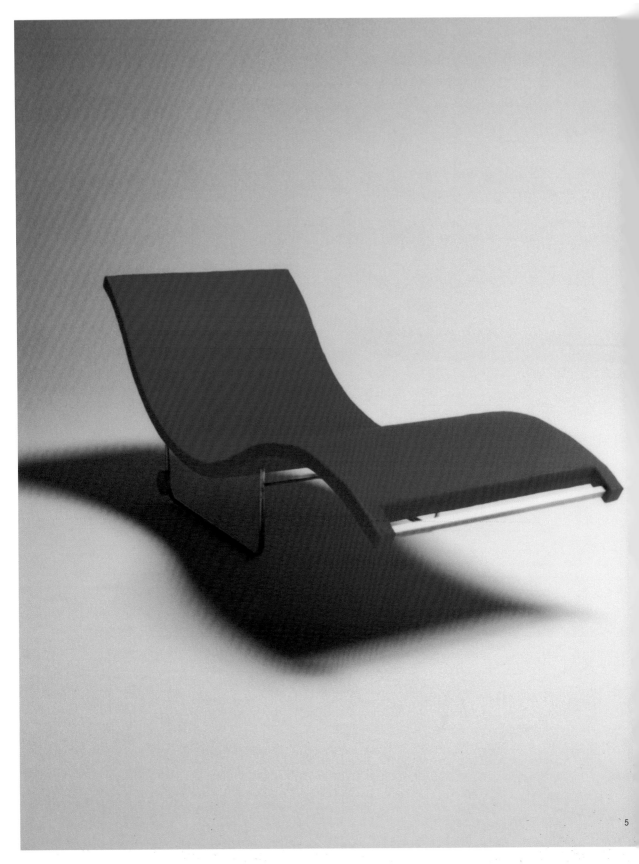

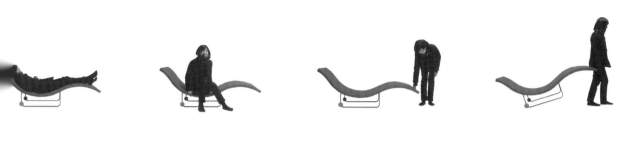
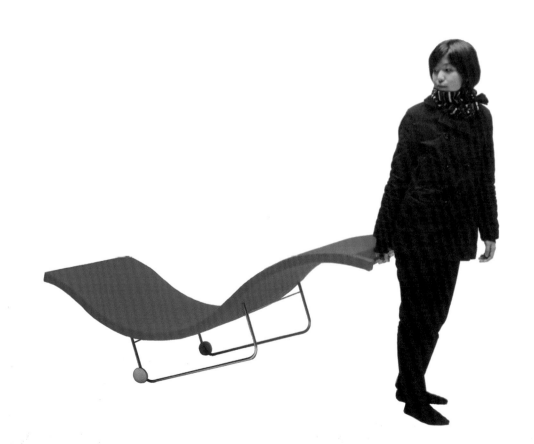

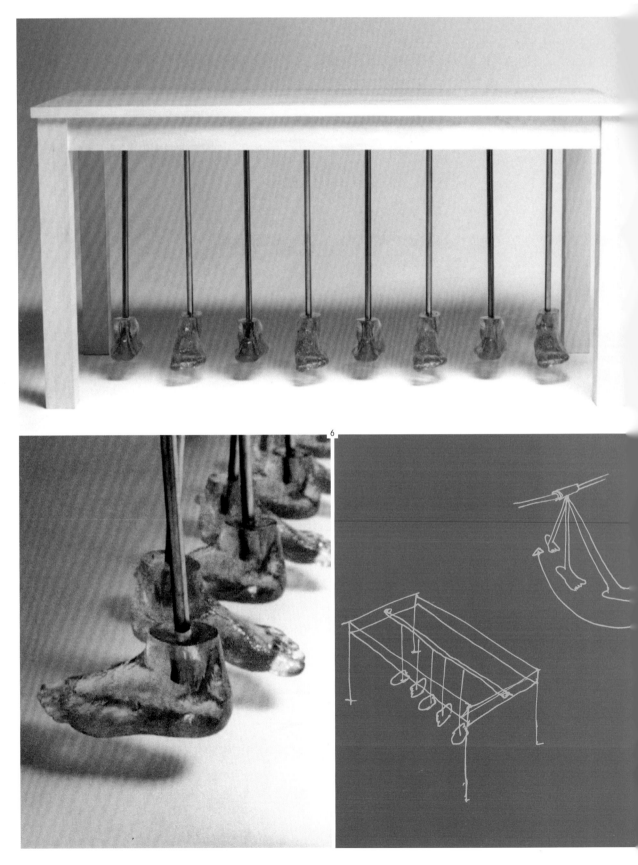

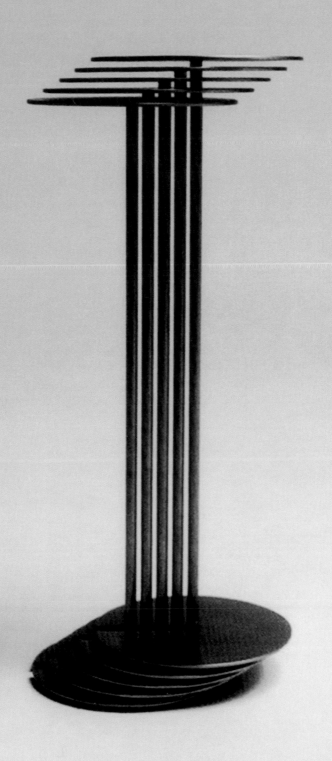

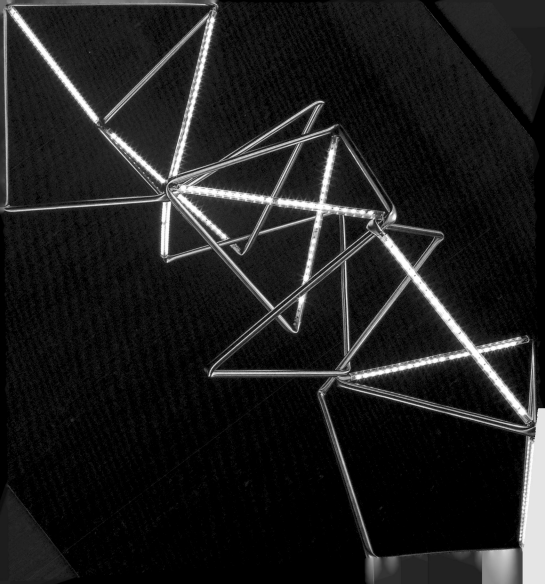

KORBAN/FLAUBERT | ST. PETERS, AUSTRALIA
Stefanie Flaubert, Janos Korban

Korban/Flaubert is a design and production office founded in 1993. Their work has been exhibited in Australia, Europe, the U.S., the U.K. and Japan. Korban/Flaubert operate as a laboratory for form, with modelmaking and materials experimentation central to the evolution of forms.

www.korbanflaubert.com.au

1 Weblight
2 Bubble stool
3 Array screen
4 Cellscreen

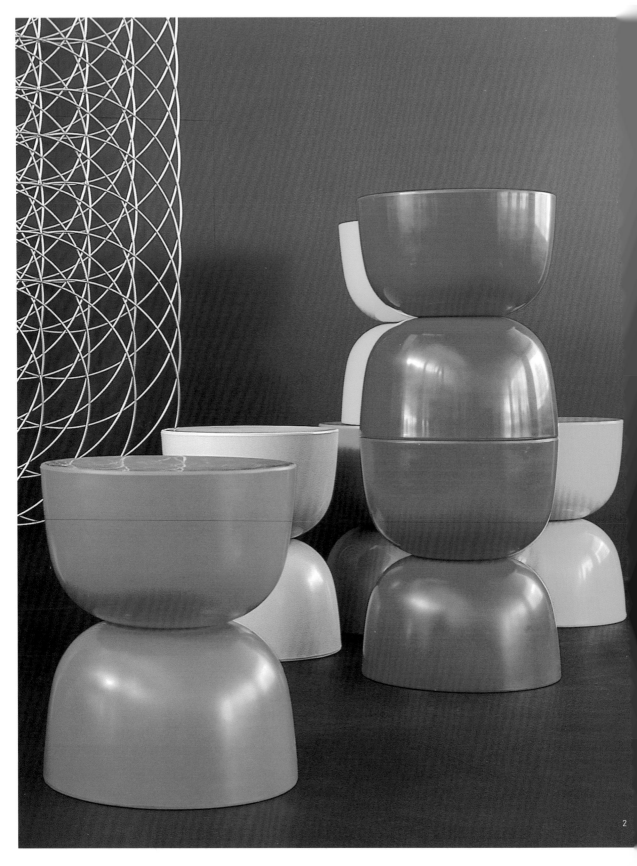

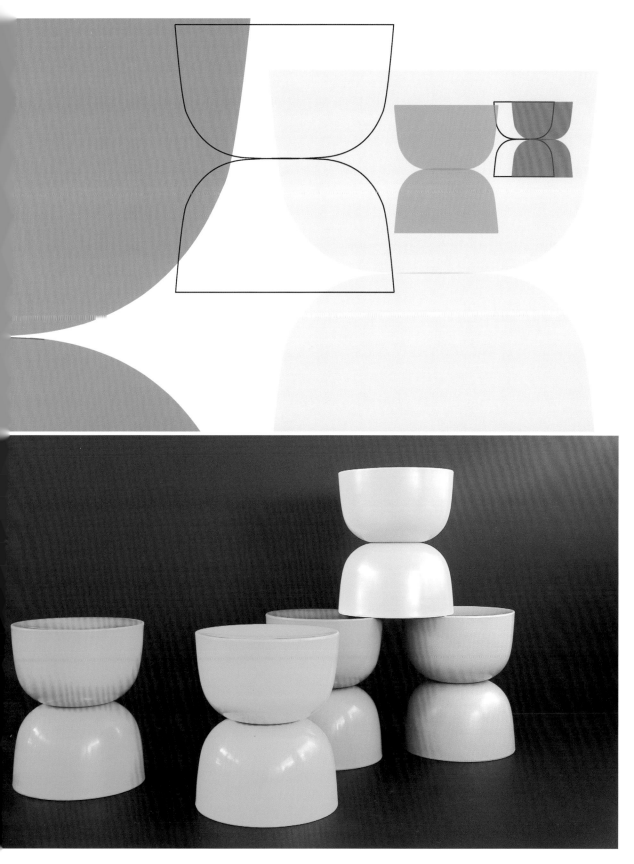

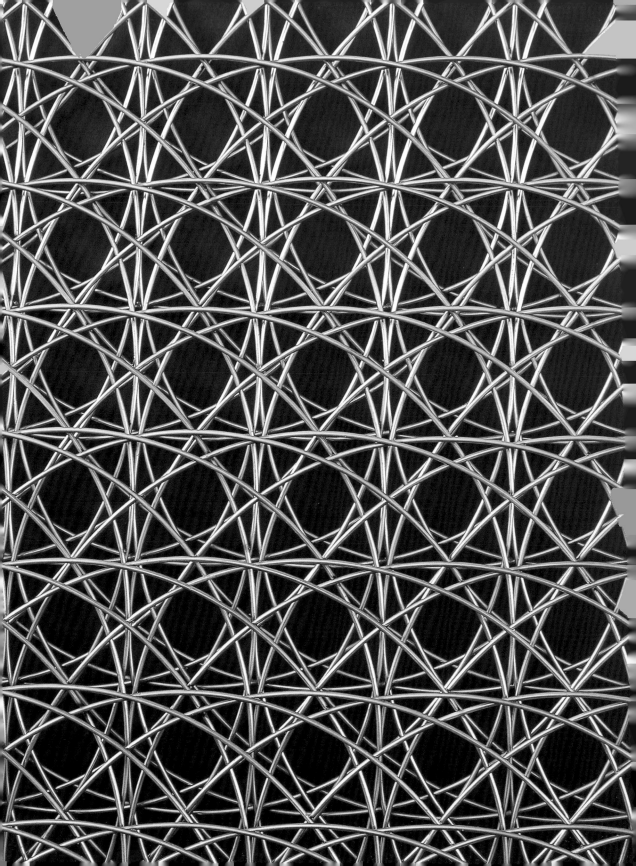

3

4

KOUSH FURNITURE | ADELAIDE, AUSTRALIA
Julie Peda

Koush furniture deals with finding new connections in form, material and individual designs, specialising in upholstered furniture for commercial premises or homes.

www.koushdesign.com

1 Arc, *bathroom fittings*
2 Trapeze
3 River road
4 Nestlamp
5 Spring benches
6 Plateau
7 Lollmotion

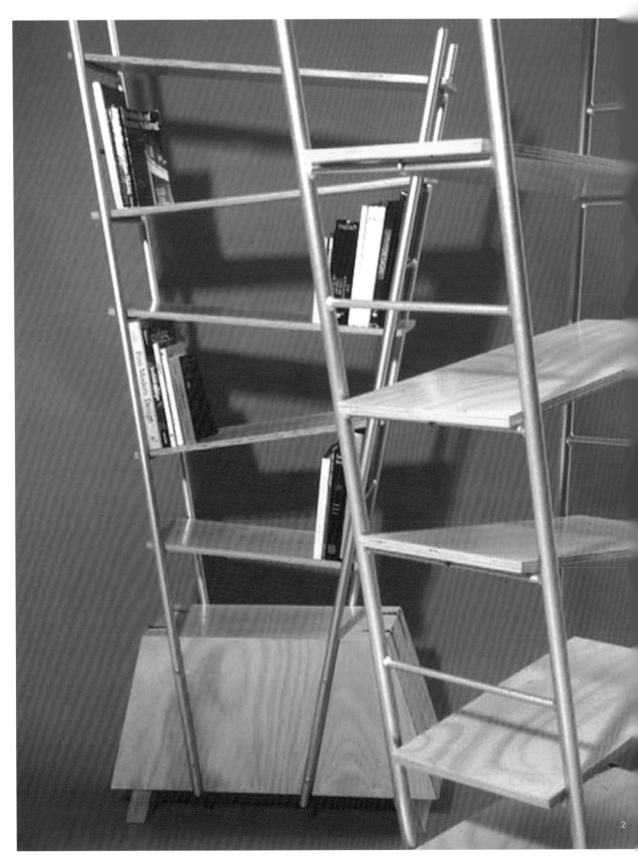

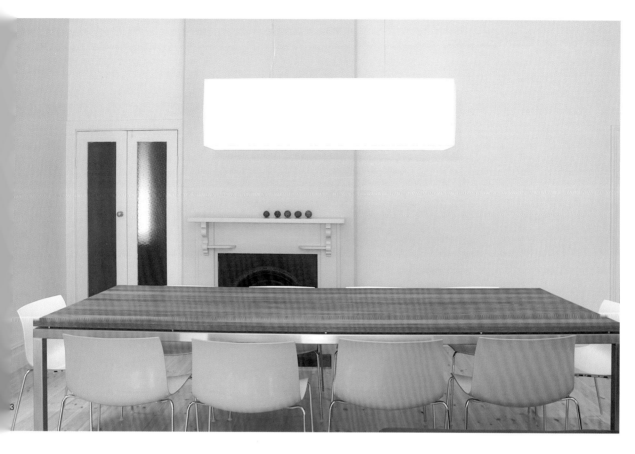

3

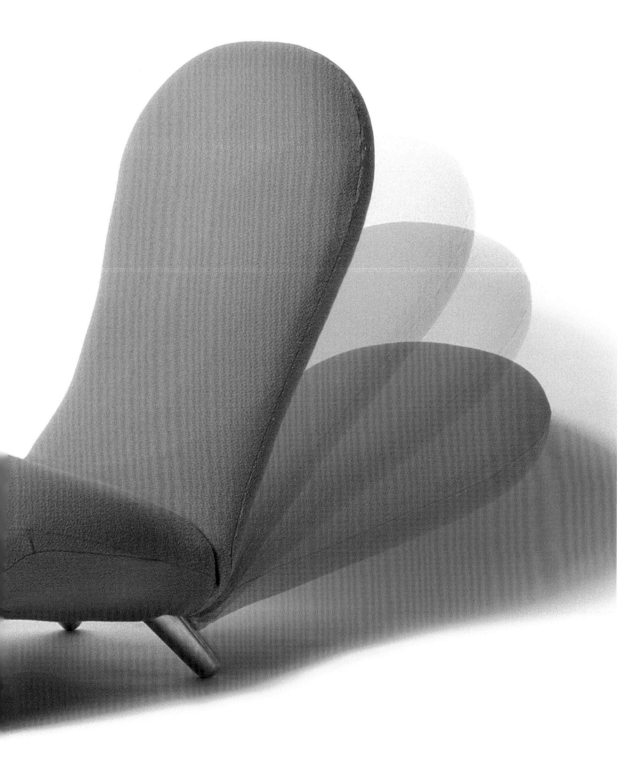

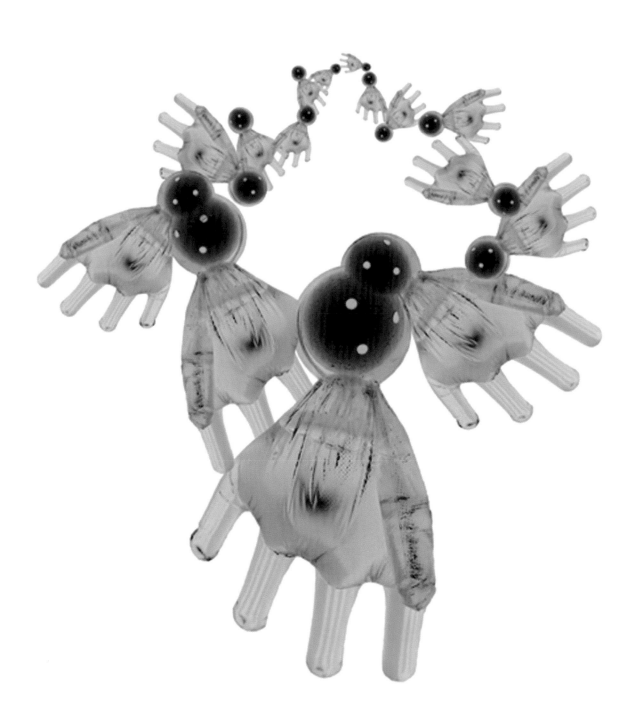

JOOHEE LEE | LONDON, UNITED KINGDOM

Joohee Lee was born in Seoul, Korea. His work includes lighting, furniture and consumer electronics. Currently he is working for Samsung Design Europe in London as a product designer and his recent personal projects have included lighting for Droog Design.

www.jooheelee.co.uk

1 Dori
2 Mutant light
3 Wire light
4 At 125 light

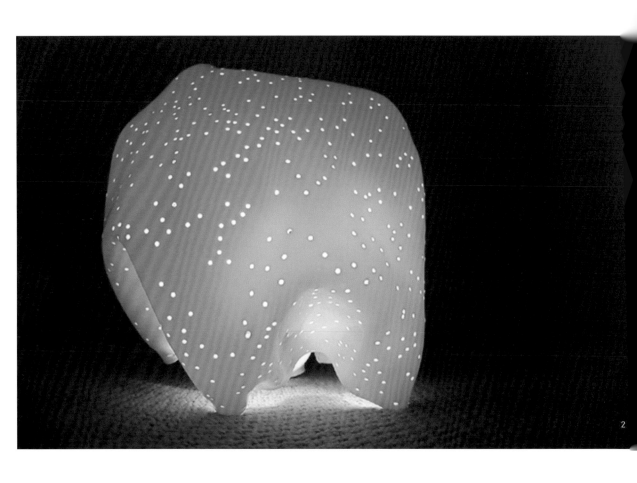

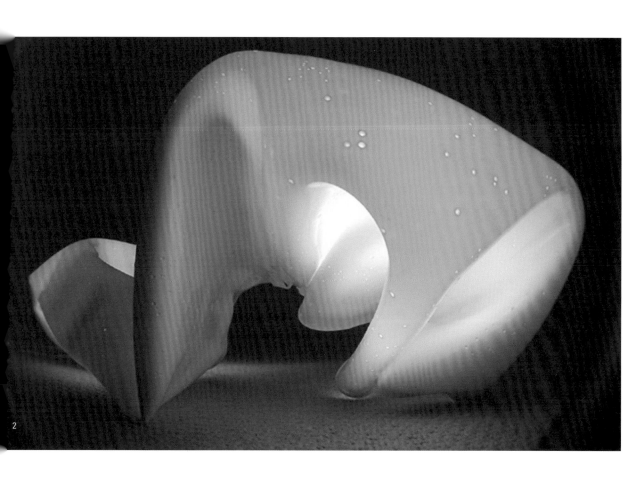

2

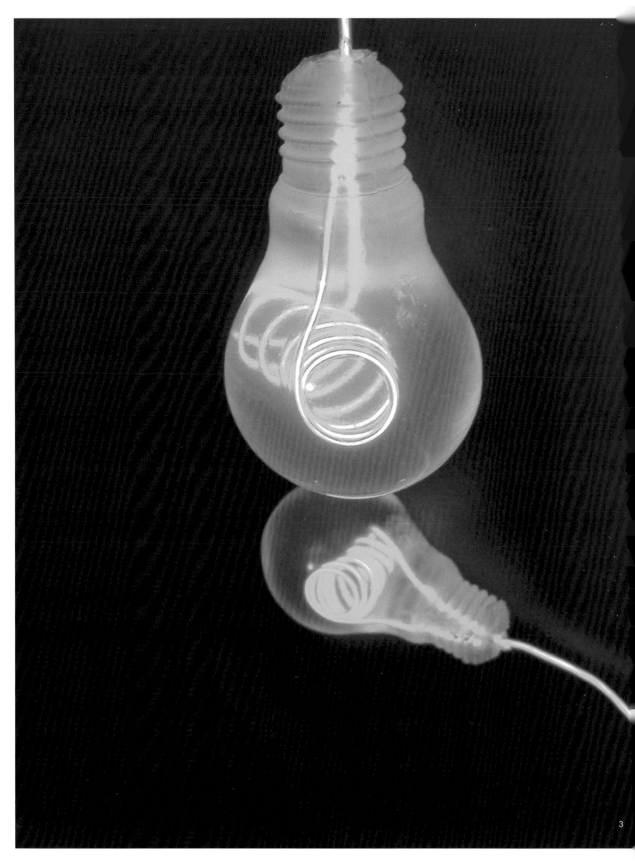

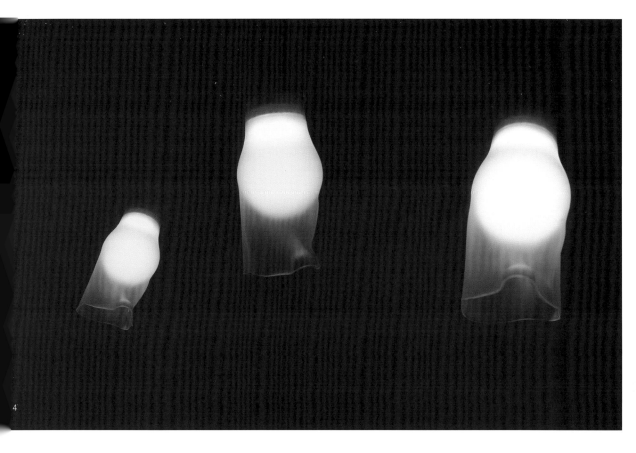

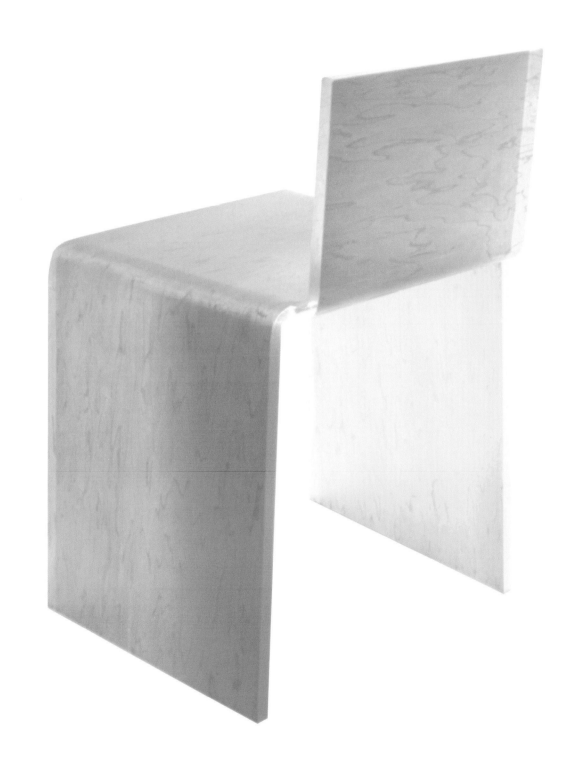

OFFICE OF MAKOTO YAMAGUCHI | TOKYO, JAPAN
Makoto Yamaguchi

Makoto Yamaguchi is an architect in Tokyo. His range of work includes architecture, interior design and product design fluctuating between enjoyment, function and simplicity.

www.ymgci.net

Ghost

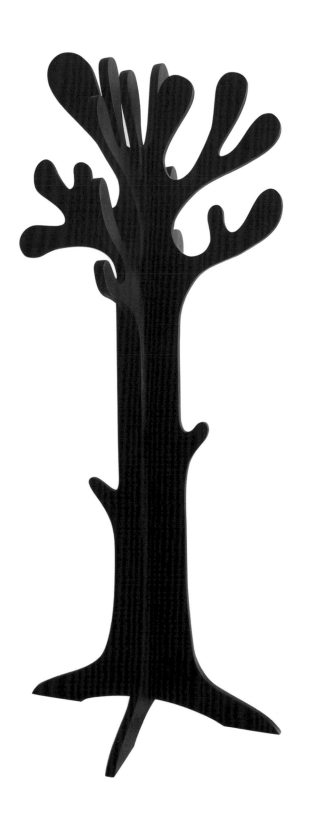

PANATDA MANU-RASDA | BANGKOK, THAILAND

The award winning designer Panatda Manu-rasda specially made industrial design, packaging, design management. Manu-rasda has received International recognition for her innovative design work.

www.studiobo.com

1 A grove
2 Pod & slam
3 Hole in love
4 Won pee

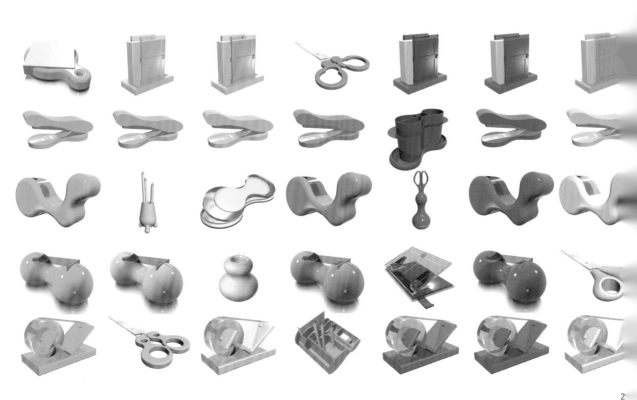

2

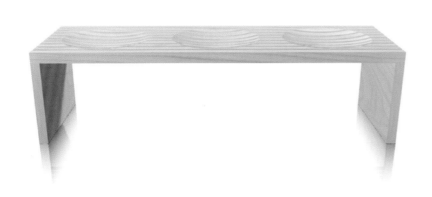

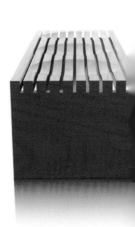

3

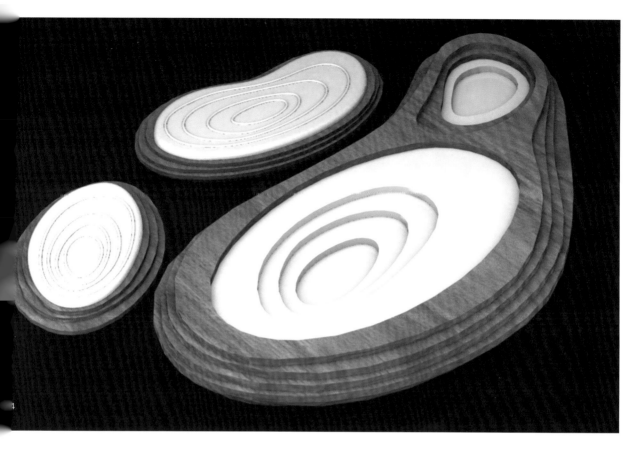

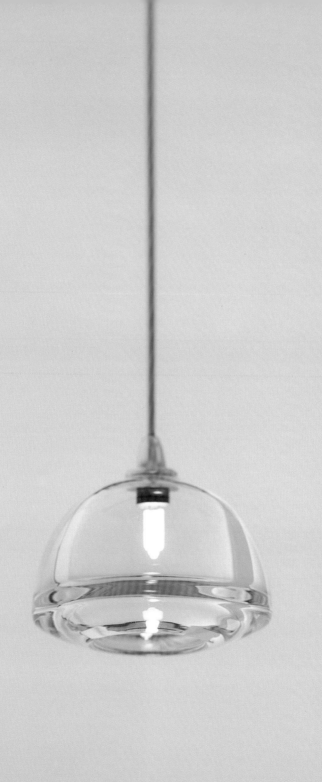

MAREI | TOKYO, JAPAN
Marcia Iwatate, Reiko Okamoto

Marcia Iwatate has been involved in art direction for fashion advertisements in Tokyo and New York. Reiko Okamoto worked at Super Potato, a studio headed by Takashi Sugimoto. The team began to collaborate in 1994 and they continue to explore new possibilities of traditional handcraft and materials.

www.marei-ltd.com

1 Miniature glass
2 HANA glass + rubber
3 HANA muslin + cast iron
4 HANA muslin + rubber
5 Bamboo clematis weave + intersected hexagonal weave

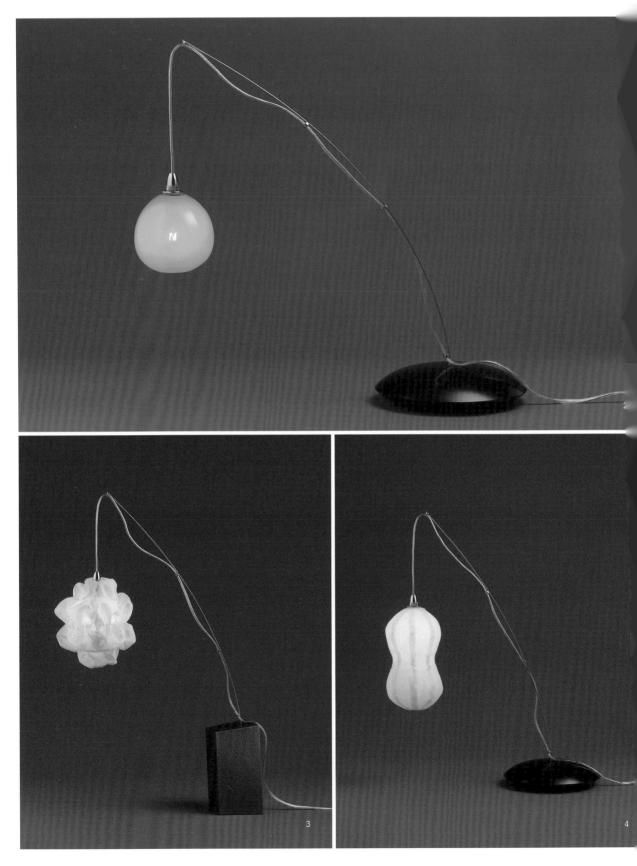

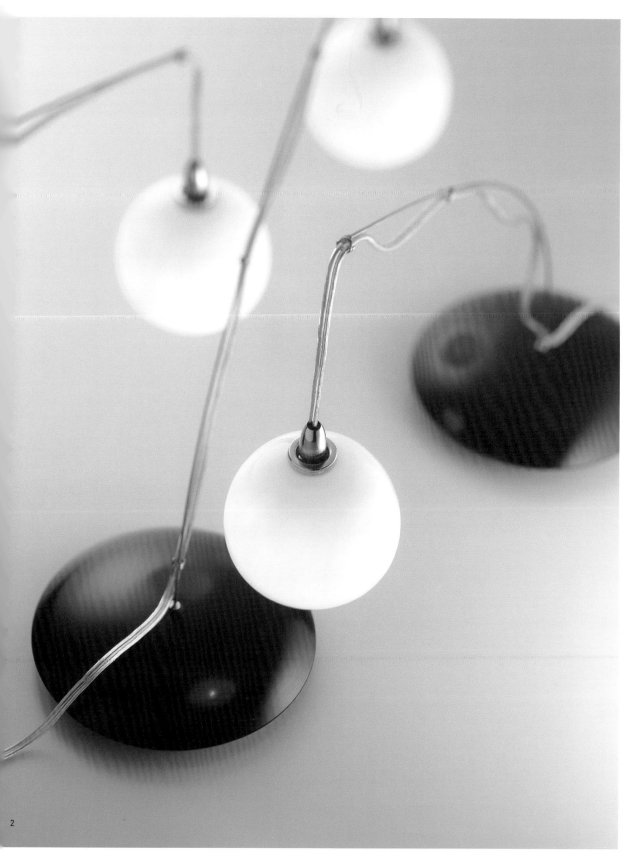

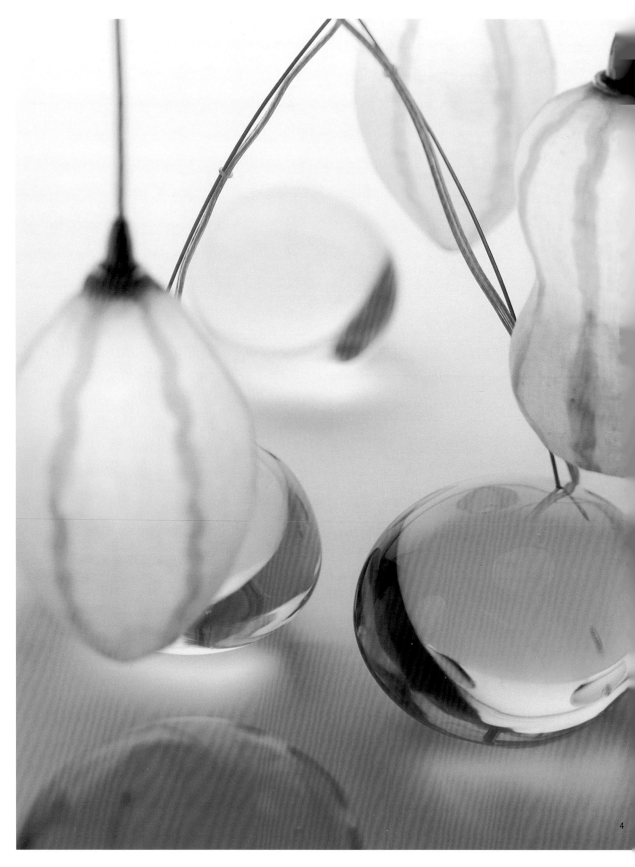

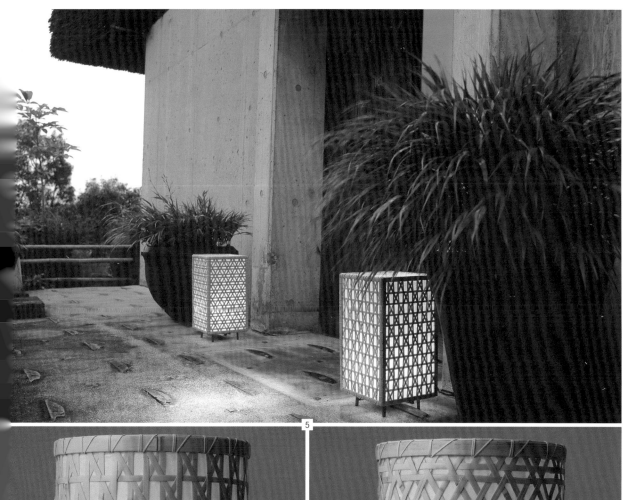

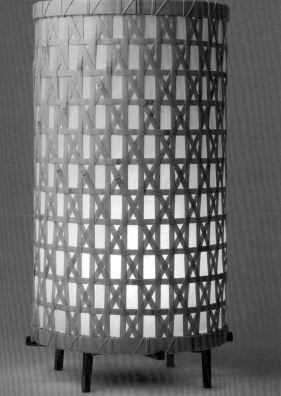

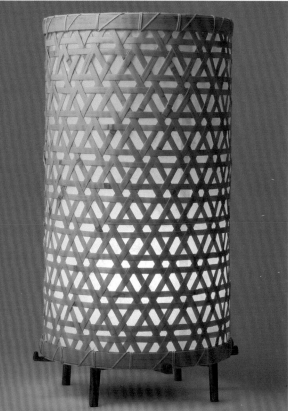

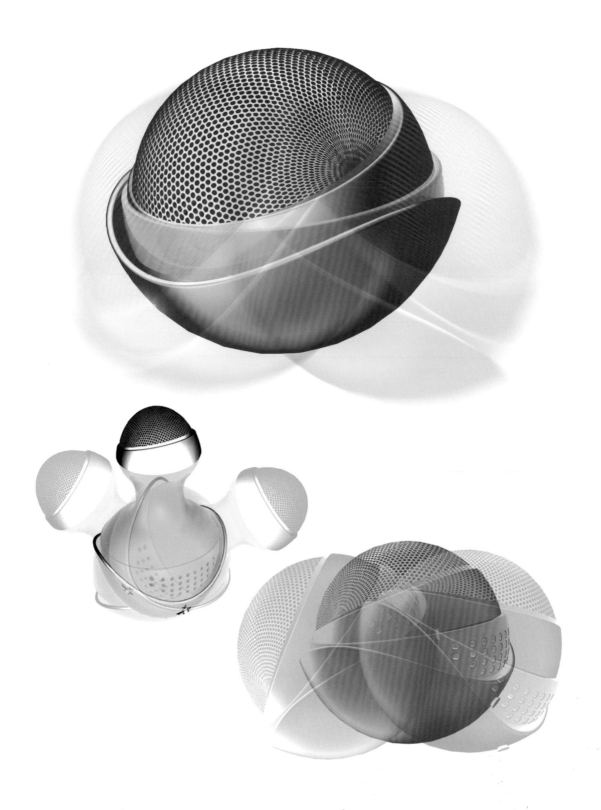

MENG LI, SUNING CHEN | BEIJING, CHINA

Meng Li and Suning Chen devote themselves in human-centered design innovation. They are enthusiastic to works varying from toys to transportation tools, from electronic products to furnishings.

lmxpy@hotmail.com
chensuning@vip.sina.com

1 Music player soundbox
2 Marilyn Monroe, *bicycle*
3 Juicer
4 Infant health detector
5 Electro pot

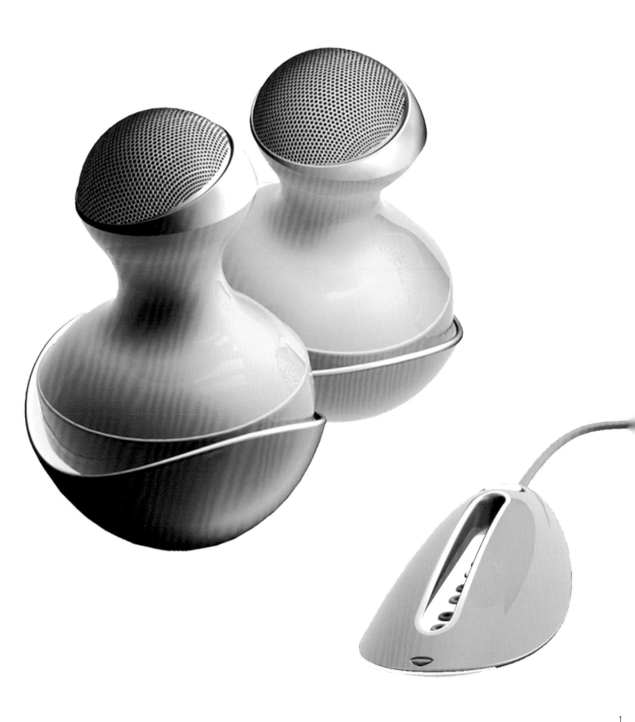

1

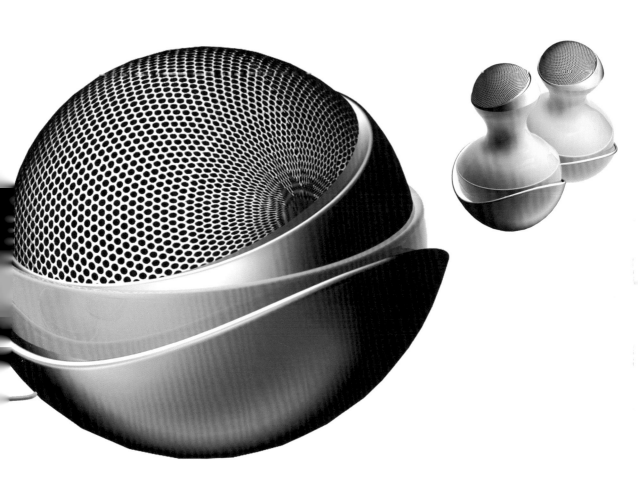

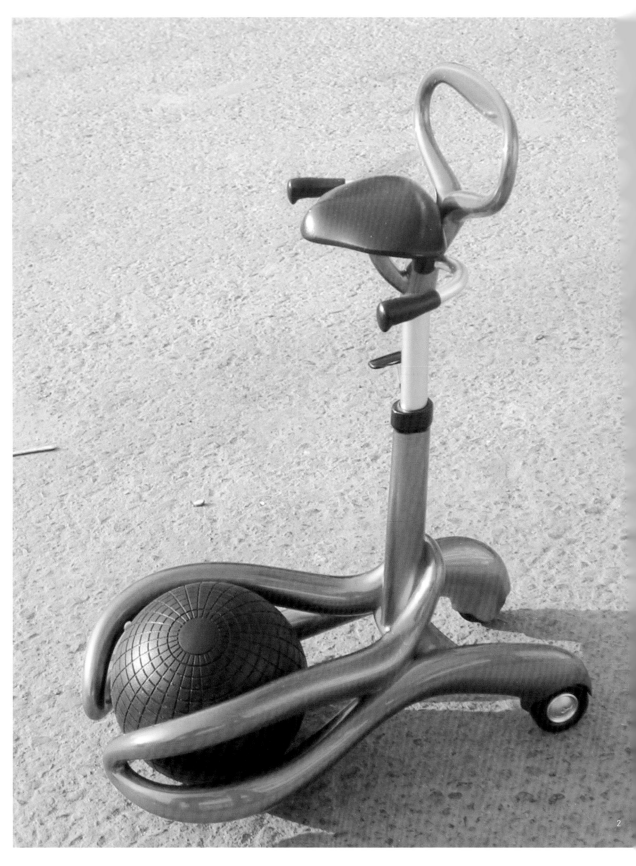

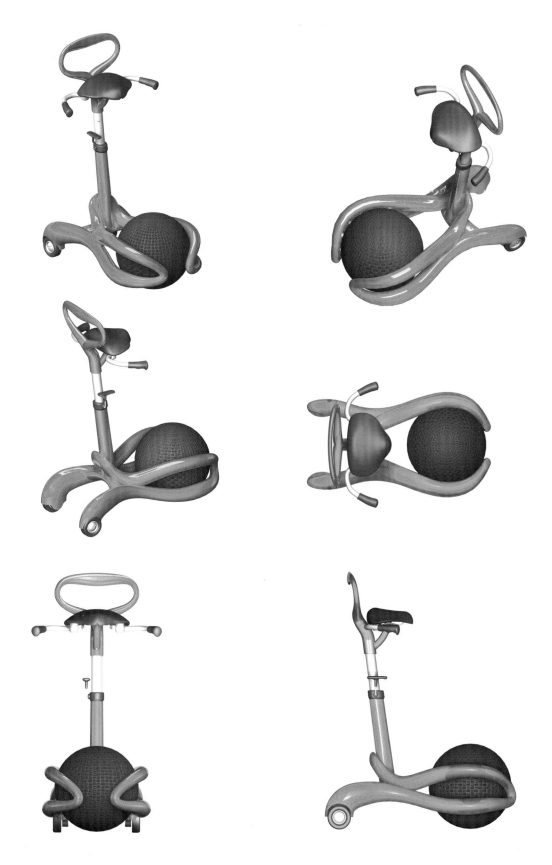

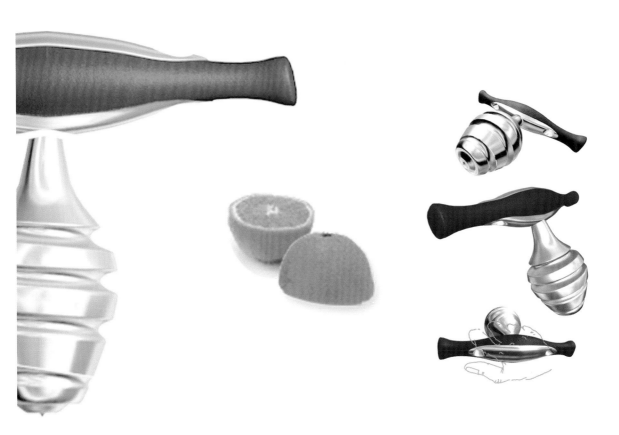

3

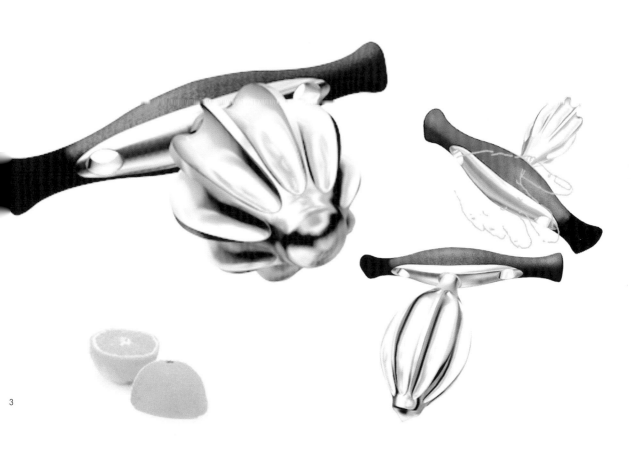

3

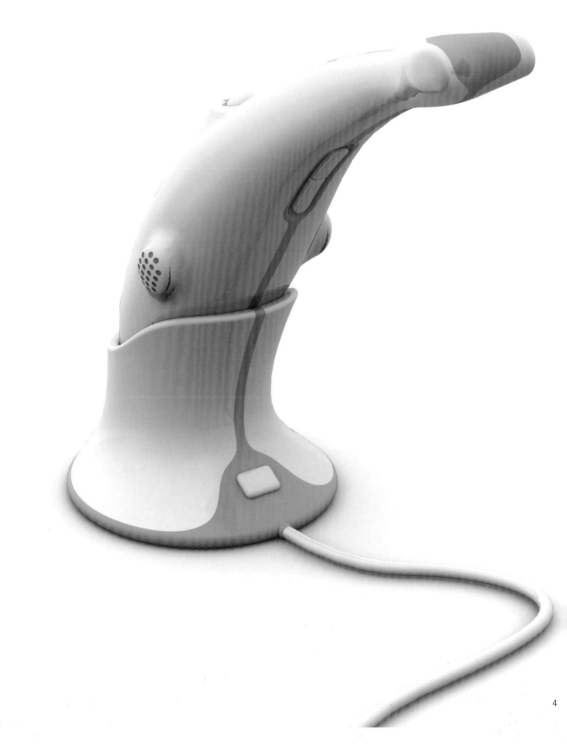

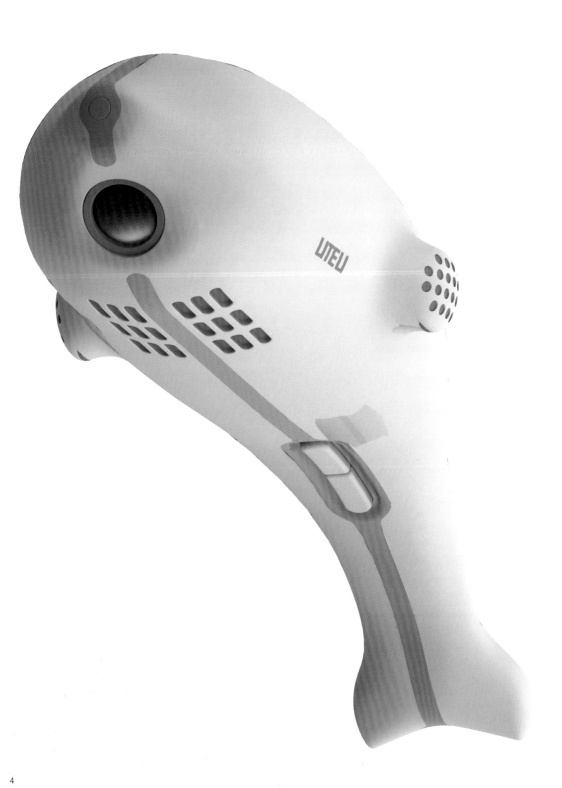

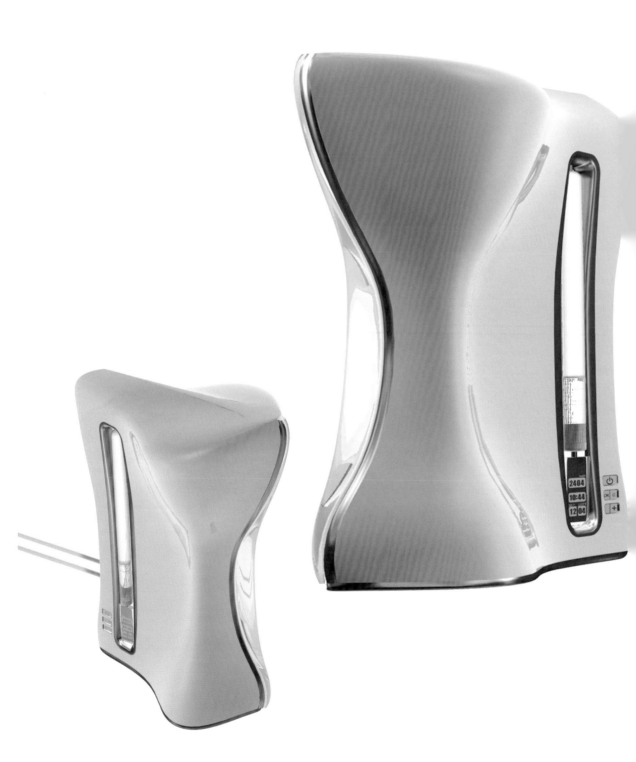

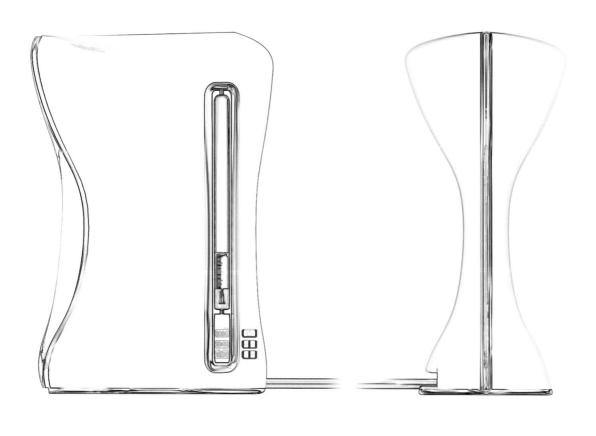

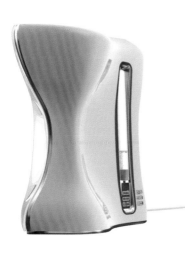

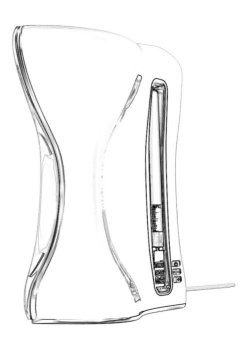

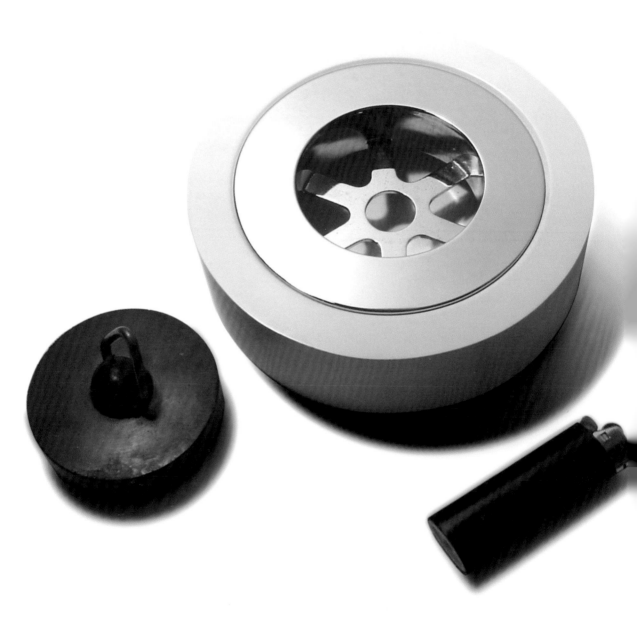

MIXKO | DEVON, UNITED KINGDOM
Nahoko Koyama, Alex Garnett

Mixko works on projects in the areas of furniture, accessories, lighting and interior design. Their goal is to provide a range of products that are both stylish and practical.

www.mixko.net

1 splASHtray
2 FUNkey
3 Chair + Lamp = ?
4 Delight
5 Unitelight
6 My Turn-ons
7 Pull Cord Lamp

2

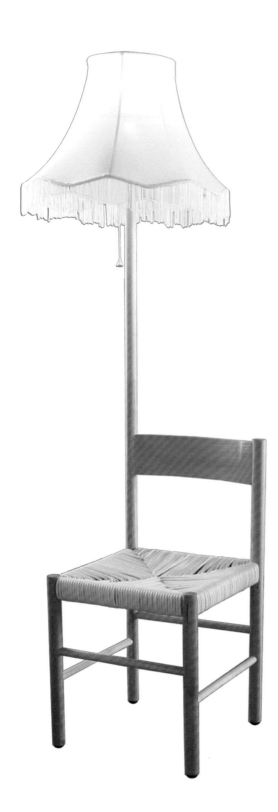

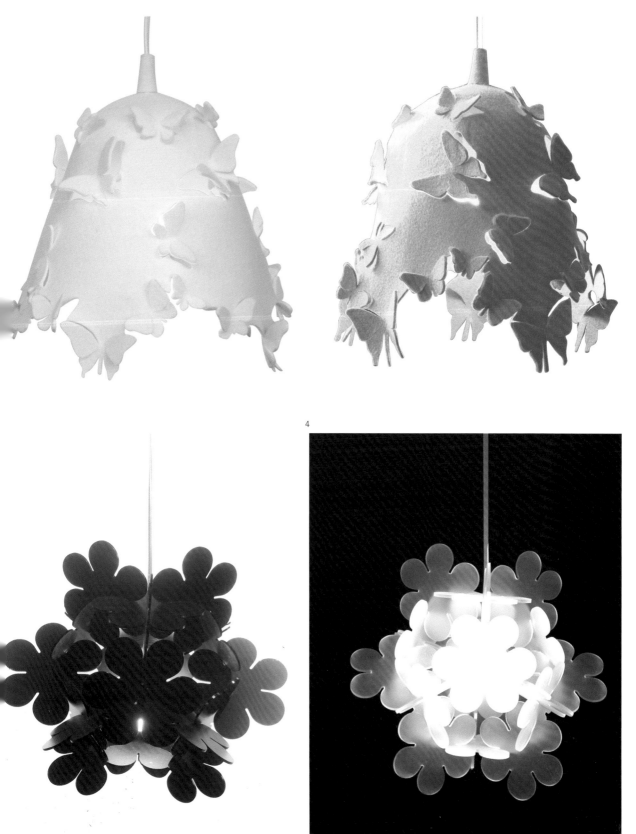

4

5

6

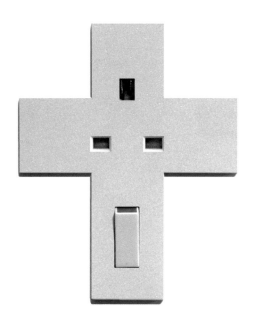
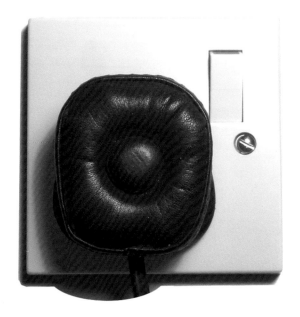

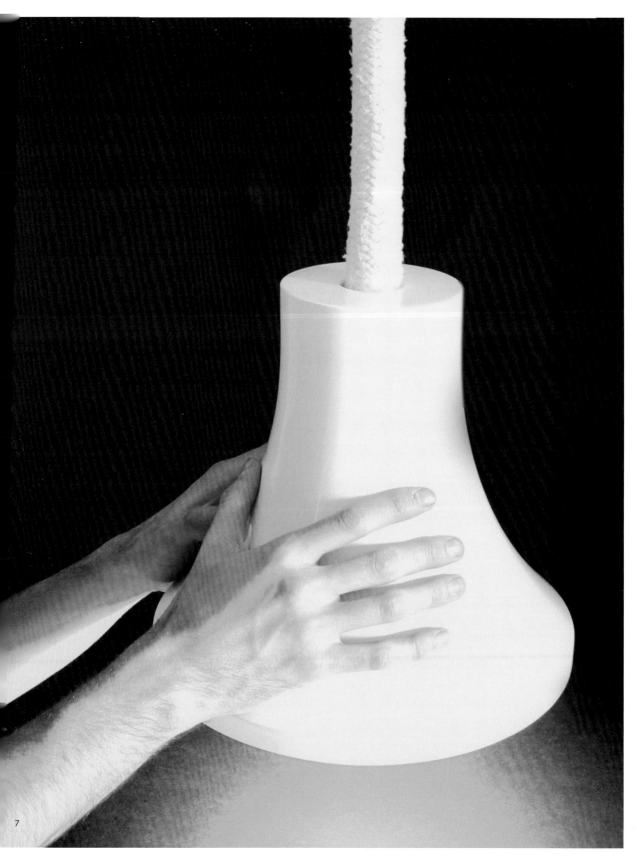

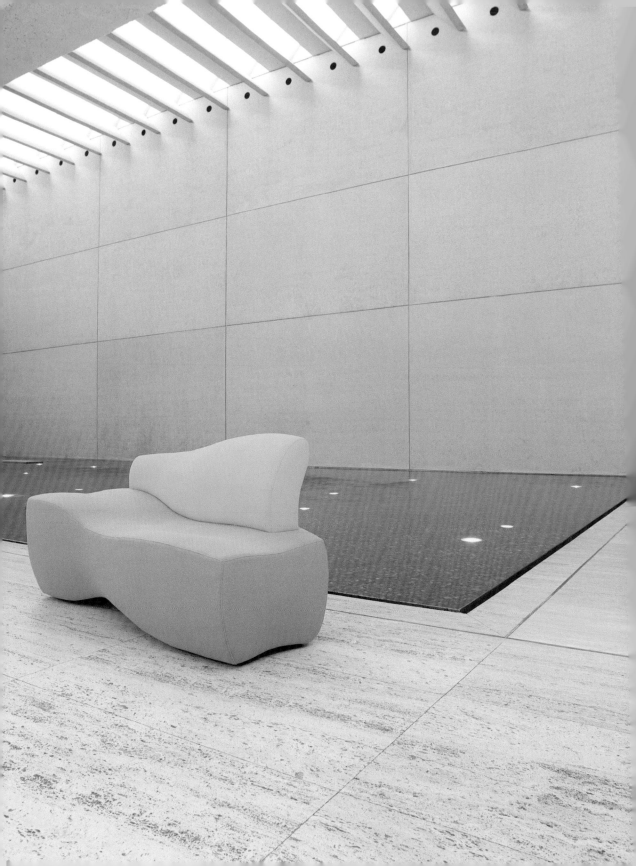

LUIS NHEU | SPRING HILL, AUSTRALIA

Luis Nheu is a cross-cultural and multi-disciplinary designer. He draws on his multitude of influences to create works that are at once culturally neutral and culturally enriched.

www.luisnheu.com

1 Organo indoor and Organo outdoor
2 Wingback chair
3 Coast table
4 Pure gravity

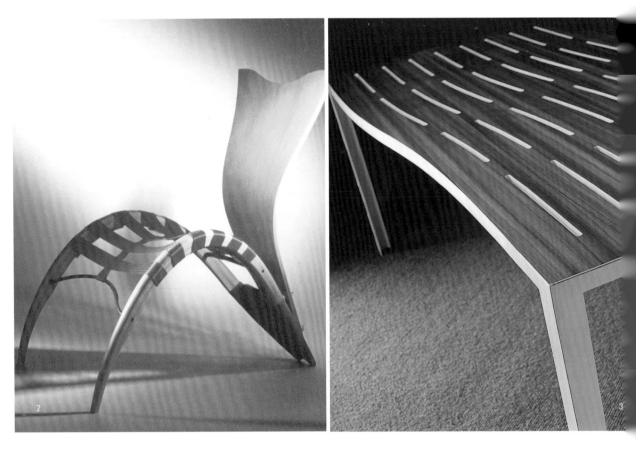

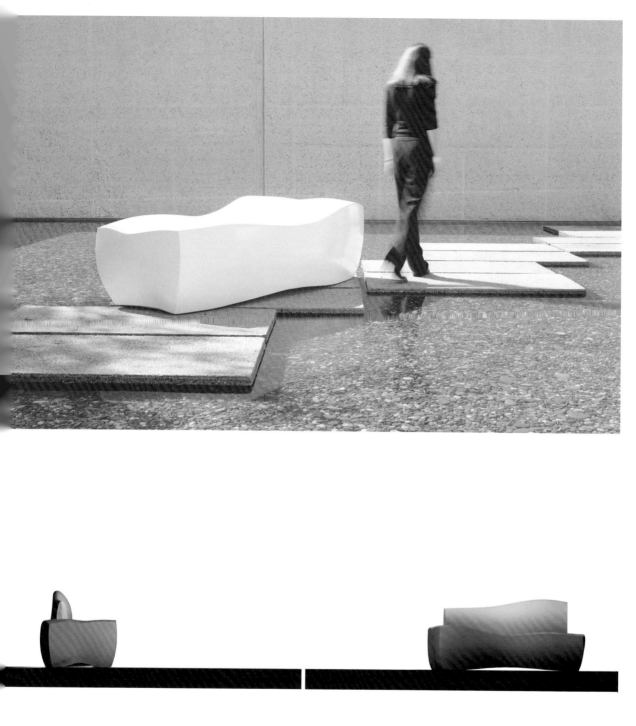

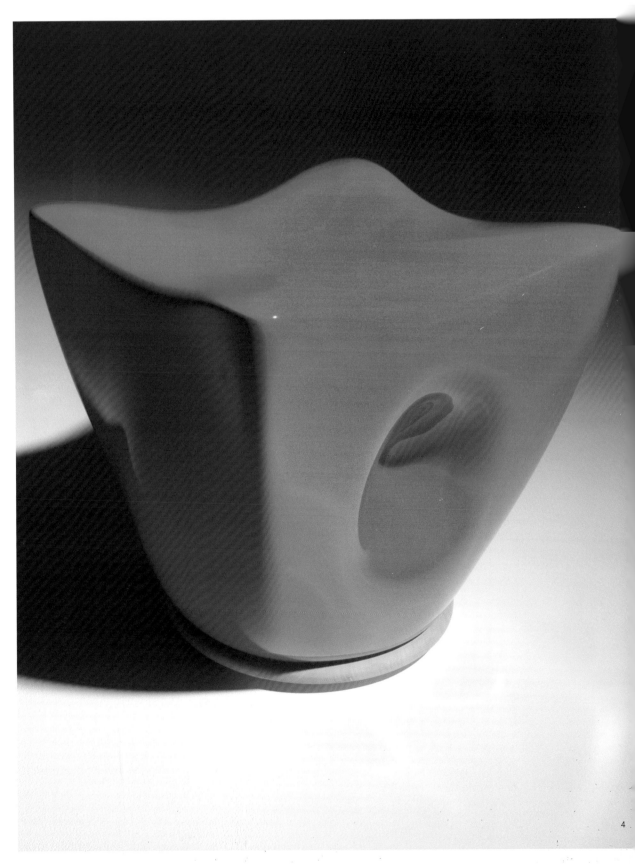

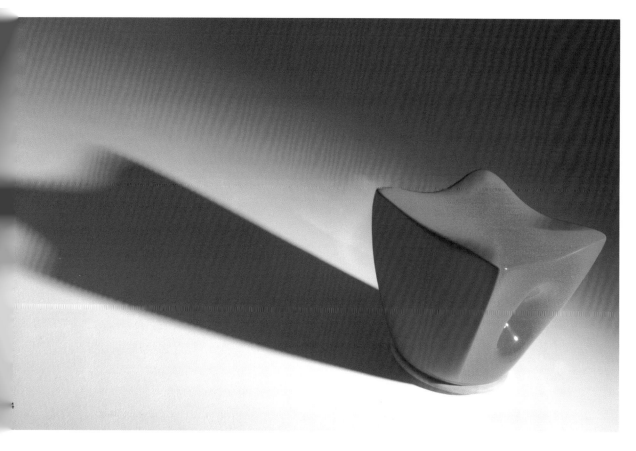

4

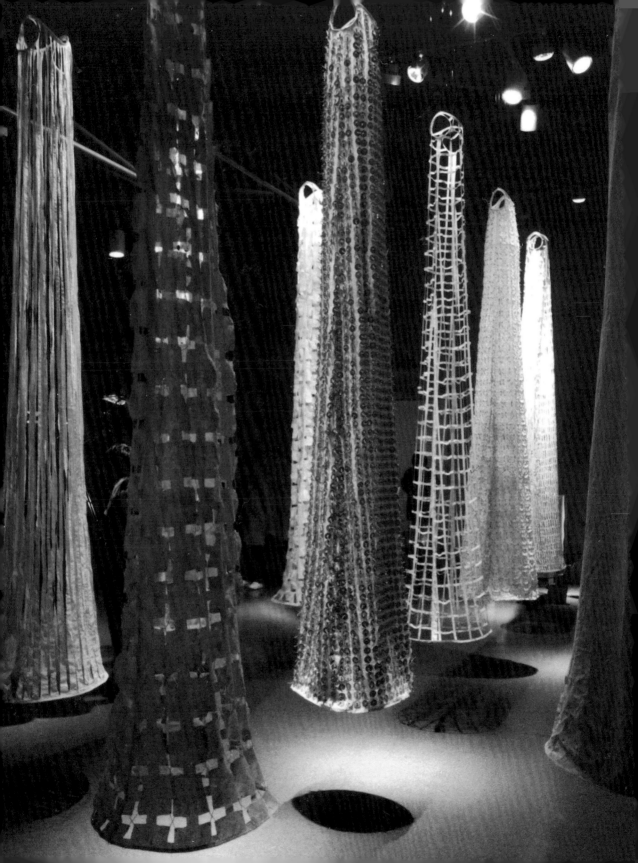

MAYUMI NISHIMURA | TOKYO, JAPAN

Graduated from the AICHI Prefectural University of Fine Arts and Music, Mayumi Nishimura completed a special course at China National Academy of Art and is now a full-time lecturer at Tokyo Junshin Women's College. Her fancy objects have Asian spirit and form.

www.geocities.co.jp/Milano-Cat/9996/

1 All things in nature
2 Square
3 The wind

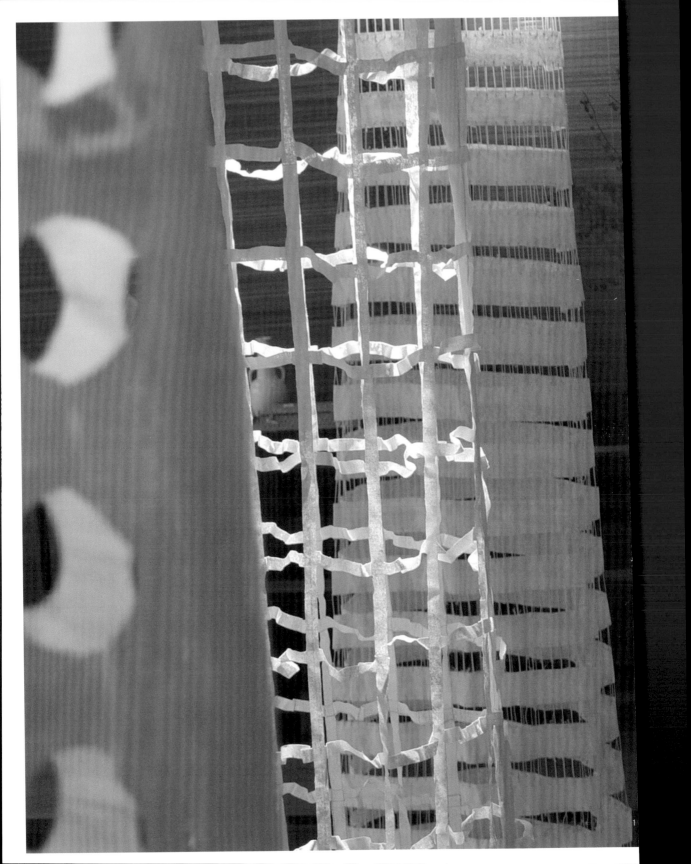

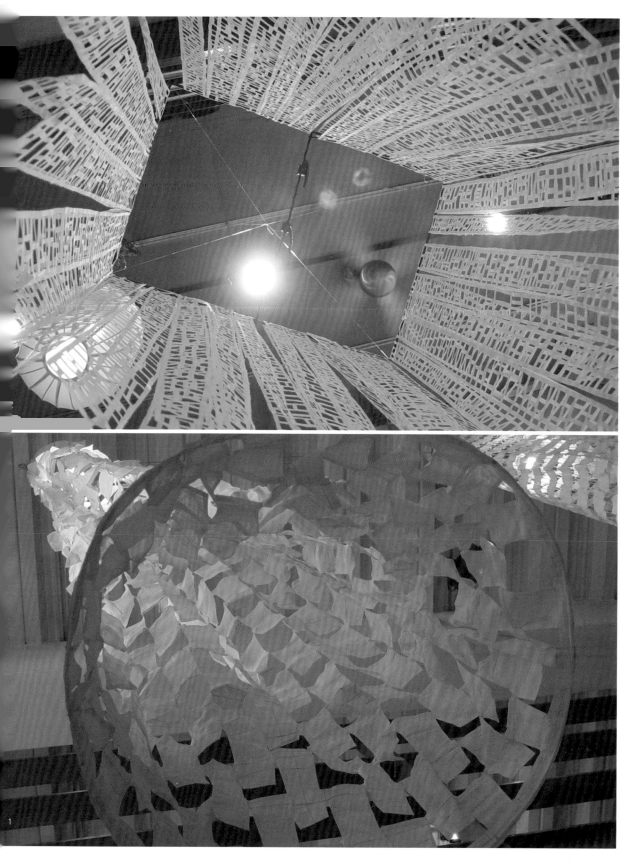

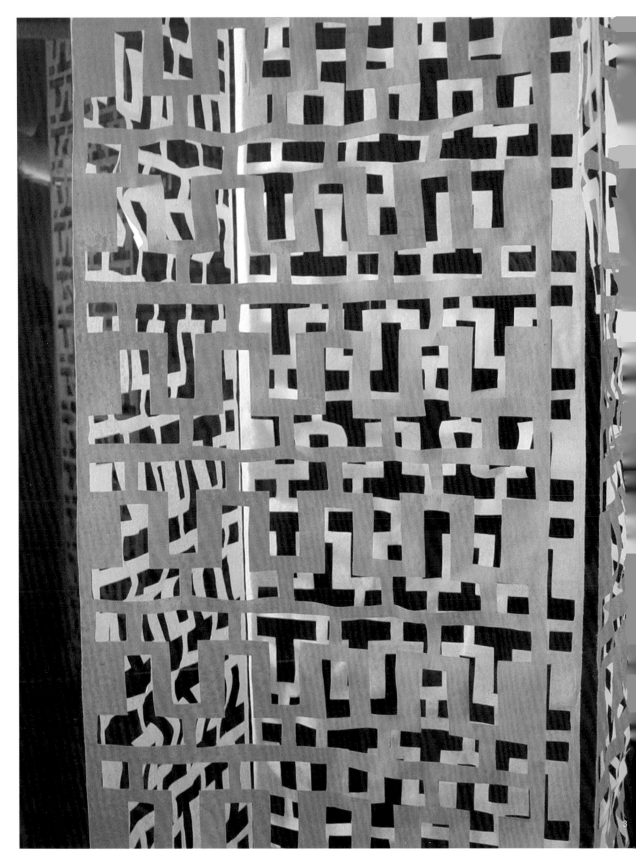

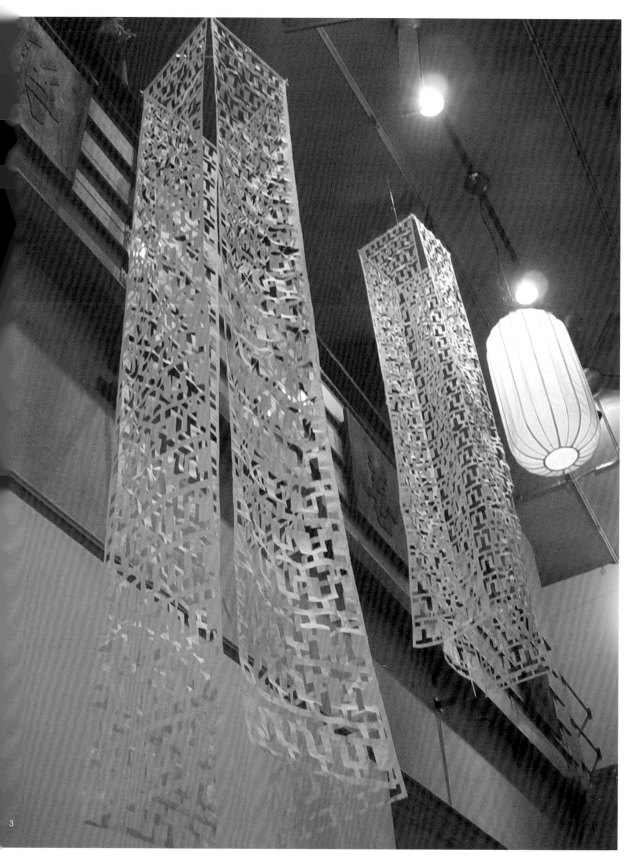

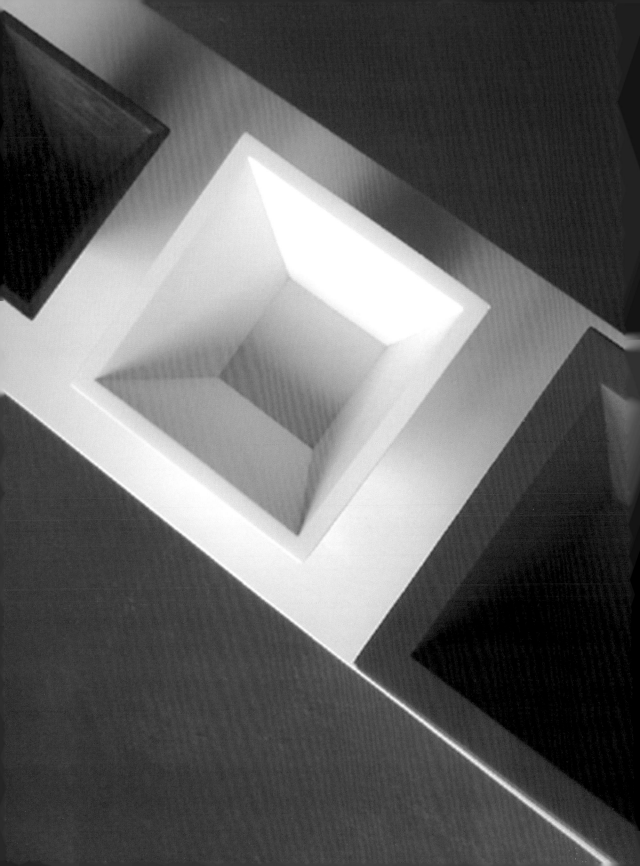

NUMBER D CREATION | SHANGHAI, CHINA
Jiang Qiong Er

Jiang Qiong Er, a former student in interior architecture, involved materials and technologies applied to objects. Beyond categorization, she ignores the constraints of genre and is propelled by a talent which has taken her into surprisingly creative areas.

www.numberd.com

1 Embrace
2 Cage
3 Flute
4 Glob
5 Calabash
6 YI

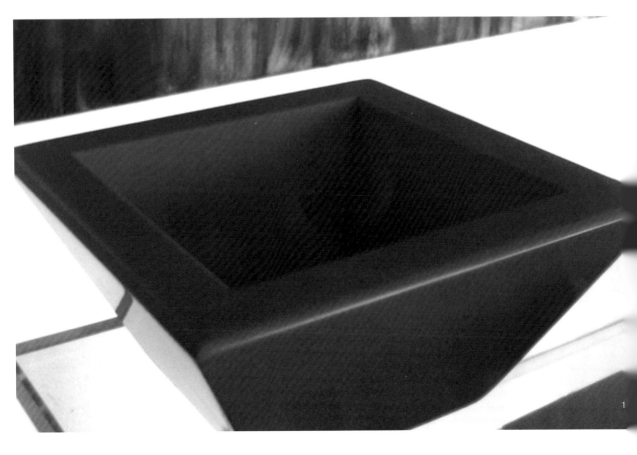

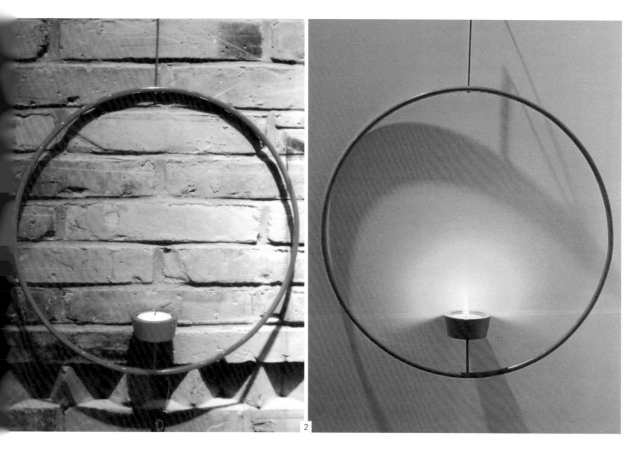

2

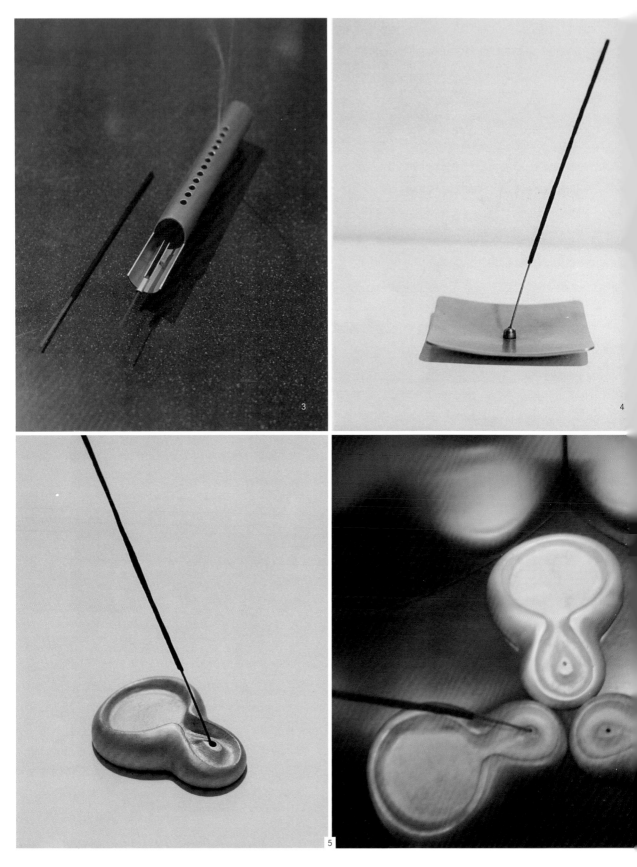

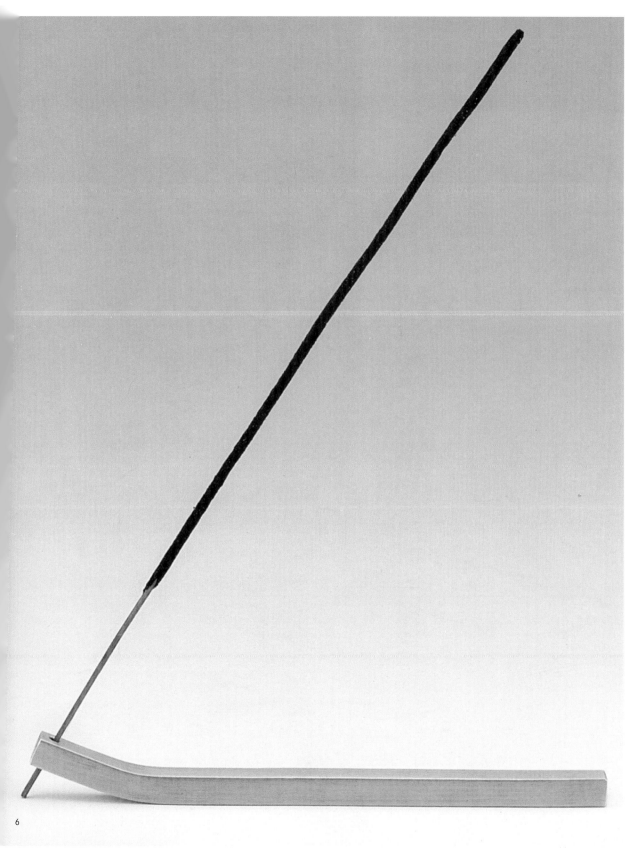

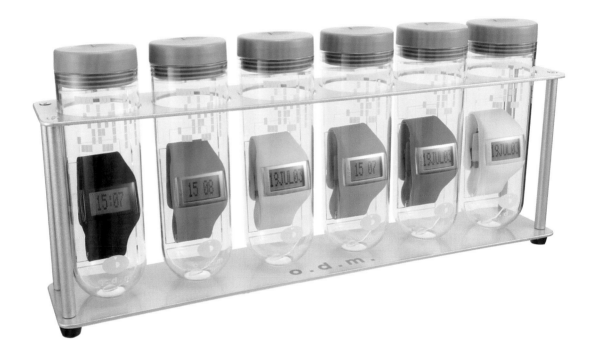

O.D.M. DESIGN & MARKETING | HONG KONG, CHINA

Jane L. C. Tang

Jane Tang is the chief designer of o.d.m. brand. Her design work – "Mysterious V DD99 watch series" was granted numerous international awards in 2004, including Red Dot Germany, iFdesign China, USA Good design and Japan Good design awards.

www.odm-design.com

Mysterious V DD99

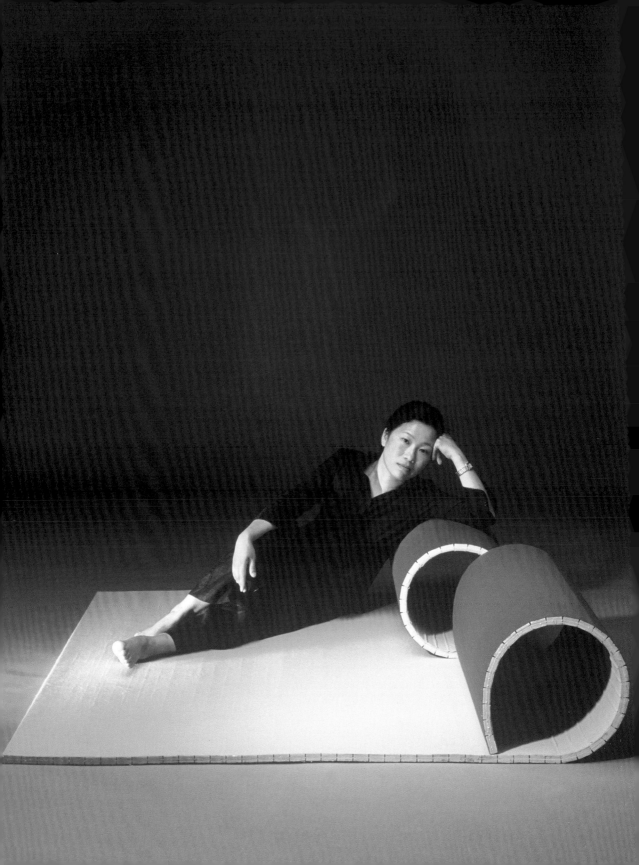

YOUNGJU OH | MILAN, ITALY

Architect and designer, Youngju Oh merges typically oriental aspects with use of new materials in interiors and industrial design.

www.opdipo.org

1 Doruru, *relax and informal seat*
2 Pado
3 Accordion, *transparent polypropylene diffuser*
4 Spoon, *armchair chaise-longue*
5 4tea4two, *modular relax pouf*
6 Namu, *chandelier*

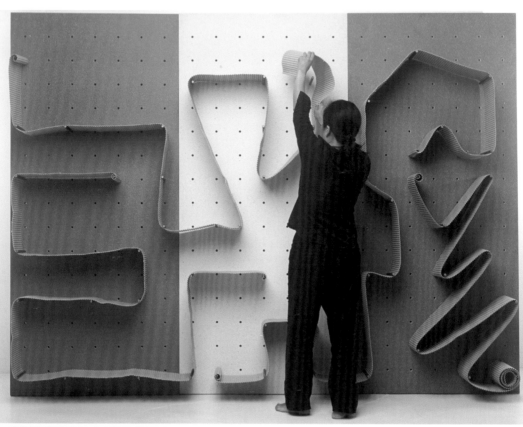
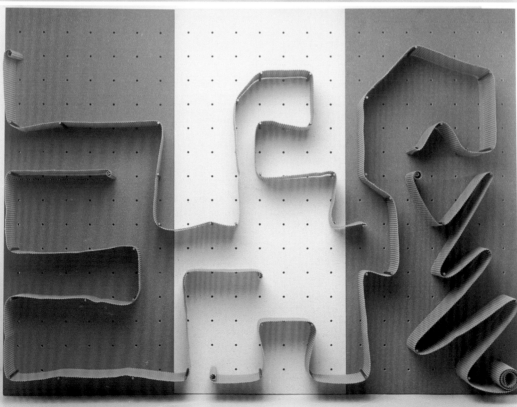

3

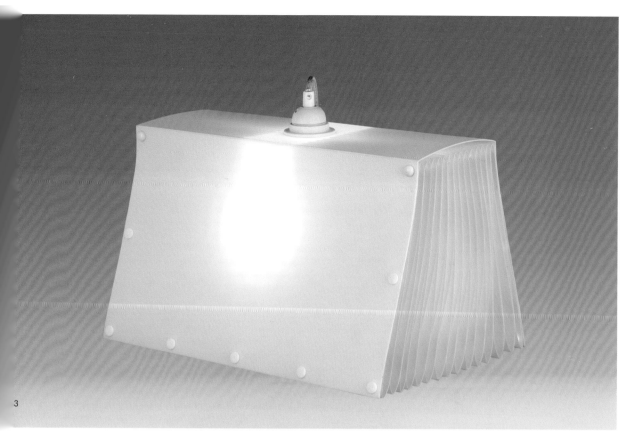

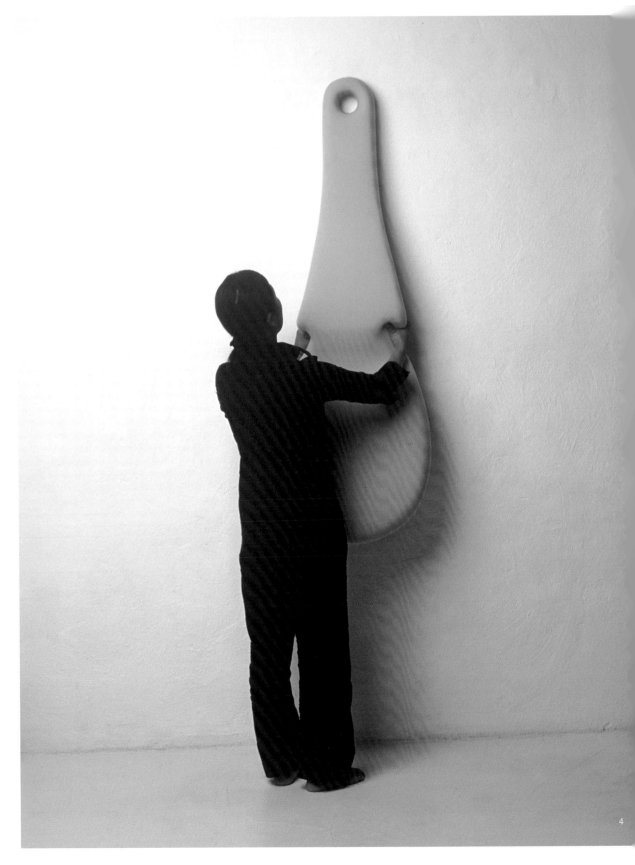

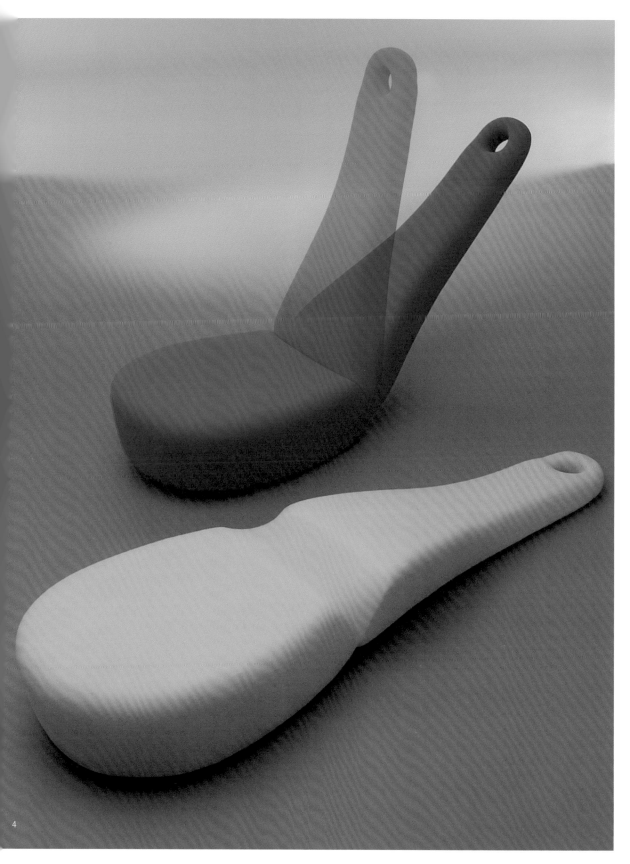

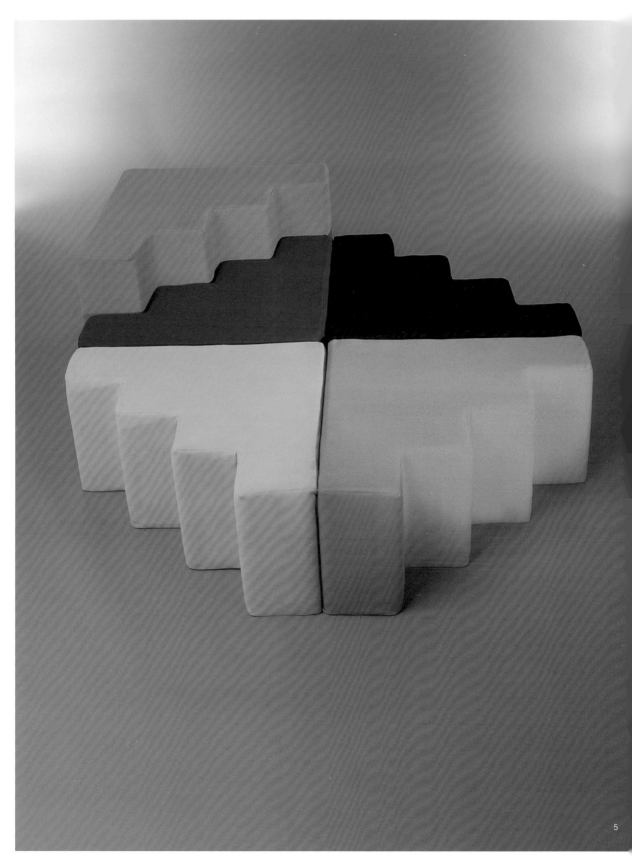

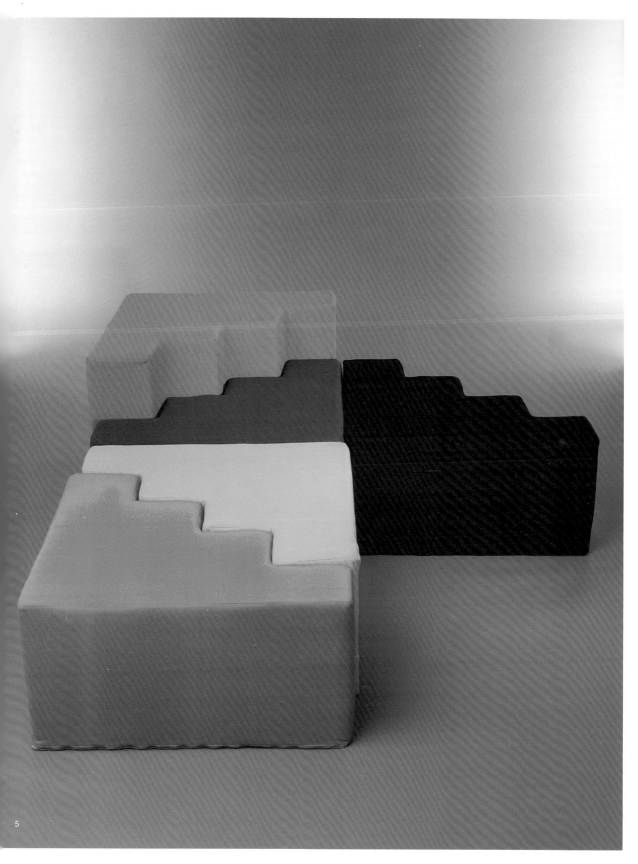

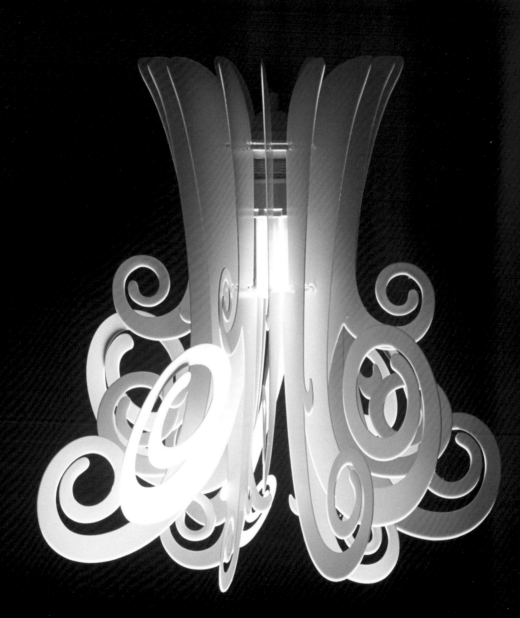

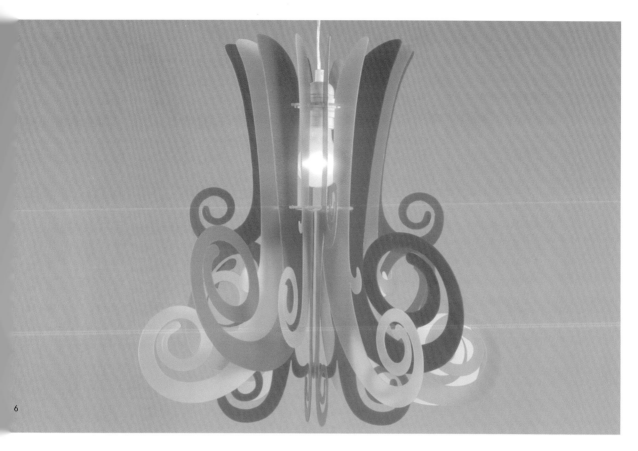

6

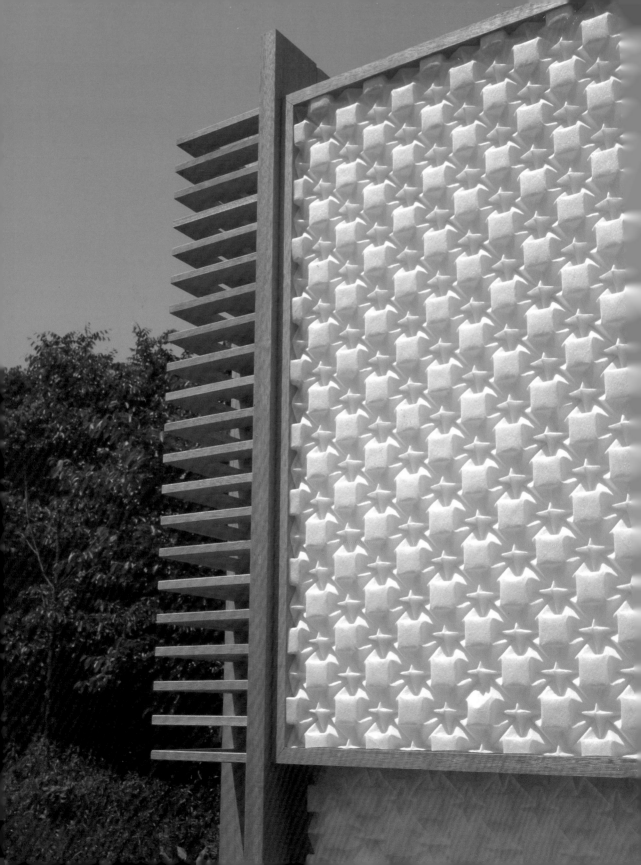

NORIYUKI OTSUKA DESIGN OFFICE INC. | **TOKYO, JAPAN**
Noriyuki Otsuka

Born in Fukui, Japan, Noriyuki Otsuka went to Europe after graduating from a design school. Back in Japan, she worked as an interior designer at Plastic Studio and Associates. She founded Noriyuki Otsuka Design Office Inc. in 1990.

www.nodo.jp

1 Pleatbox
2 Birdhouse

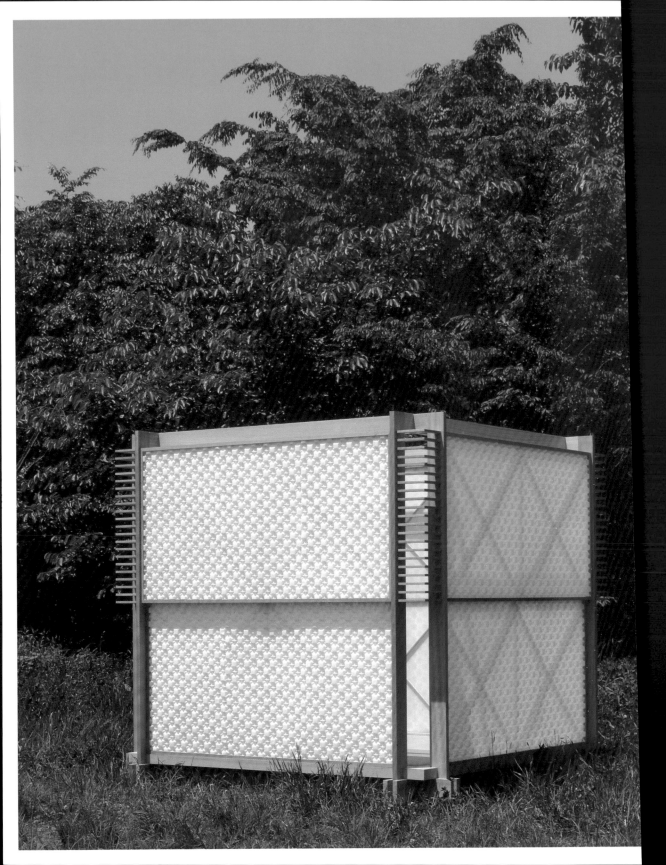

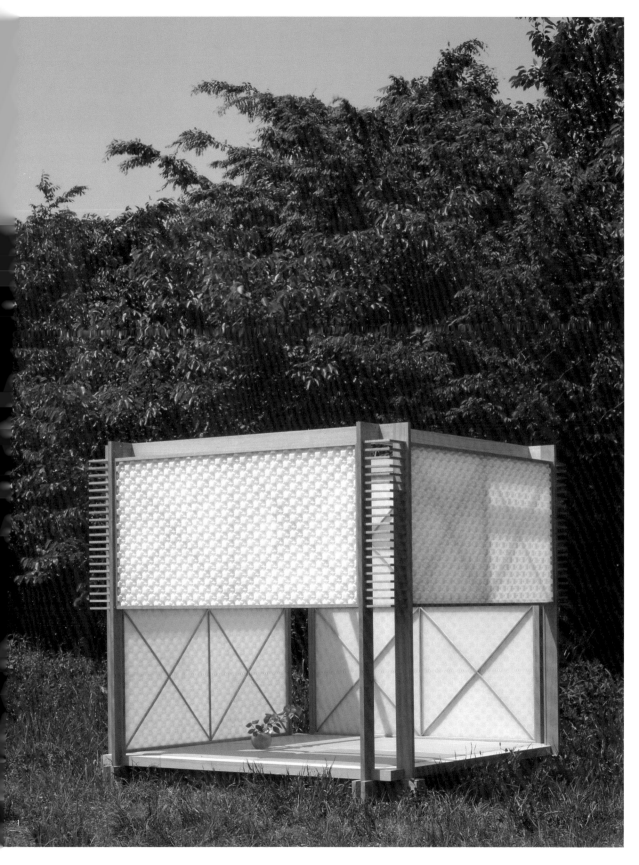

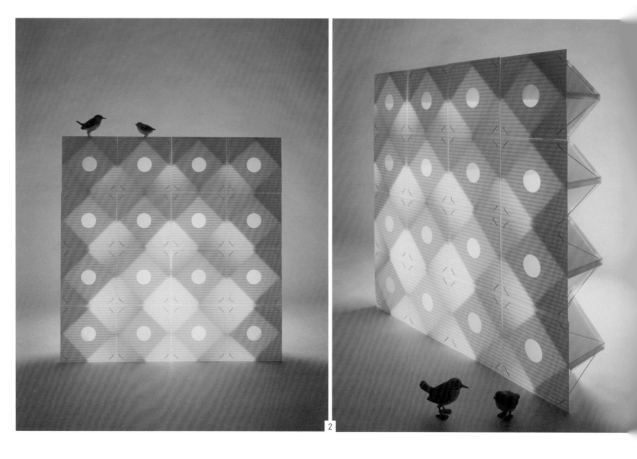

2

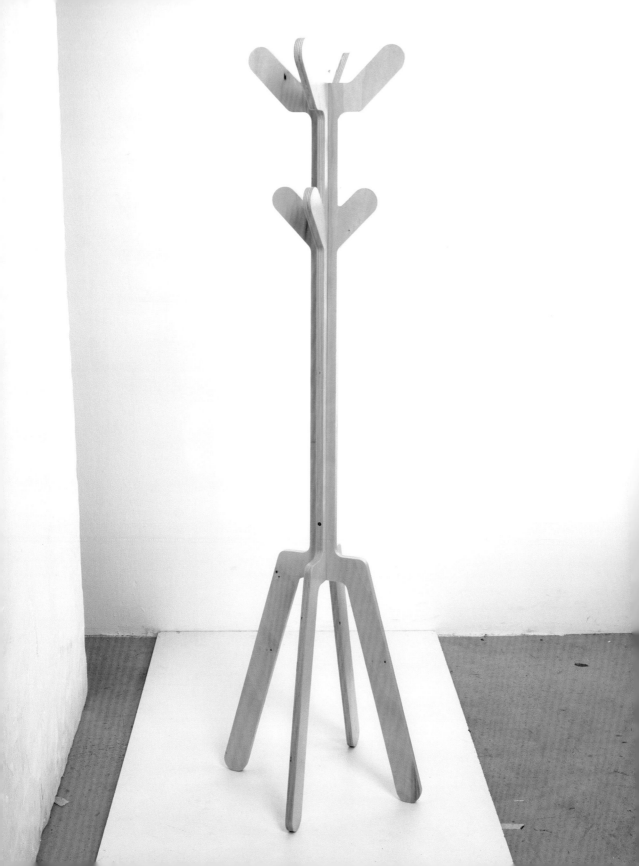

DESIGN BERTO PANDOLFO | **SYDNEY, AUSTRALIA**
Berto Pandolfo

Berto Pandolfo's designs call upon our memory of arche-
typal product forms, whether table or coat stand, which he
layers with a new interpretation based on new technology
and materials.

www.bertopandolfo.com

1 Rak, *coatstand*
2 Tav
3 Riv, *magazine rack*

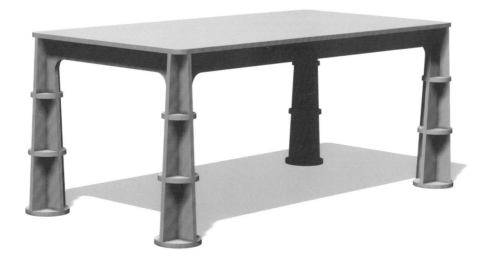

3

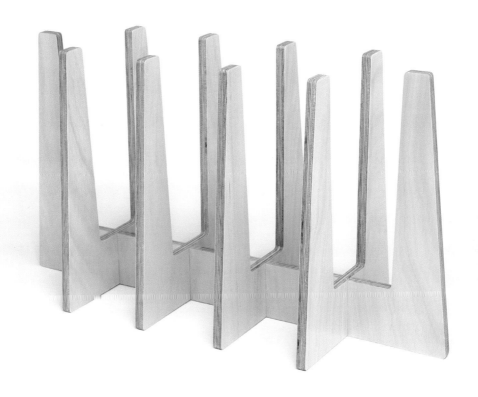

3

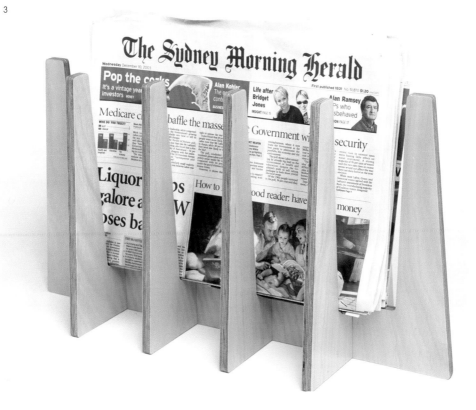

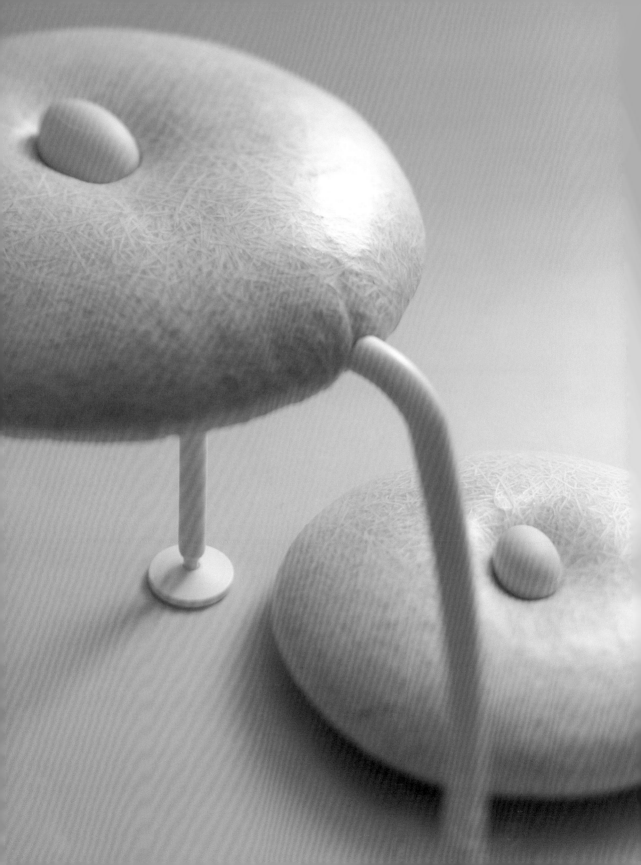

PD DESIGN STUDIO | KYOTO, JAPAN
Izumi Hamada, Hideo Hashimoto

pd Design Studio has been two styled works as "a design studio" and "a design duo". Their purpose is to affirm all the possibilities, and face everything flexibly from a free angle.

www.pd-design-st.com

1 Nest chair
2 My shade
3 Green day
4 Skin light/bulb
5 Skin light/mam

1

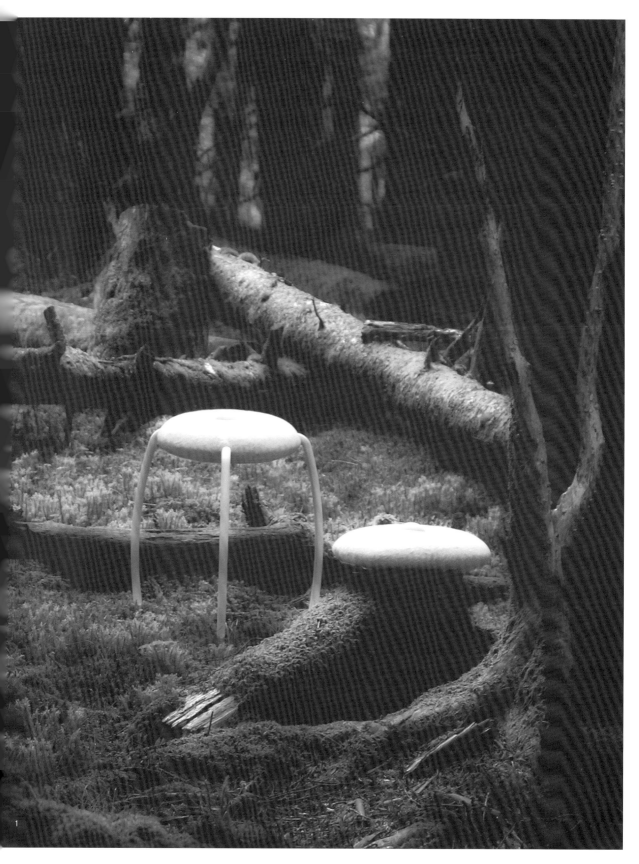

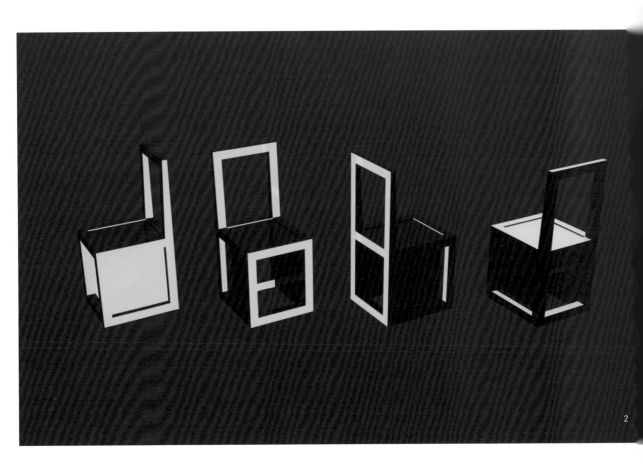

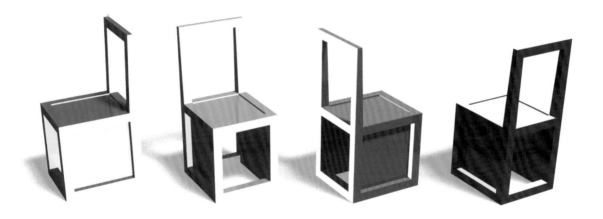

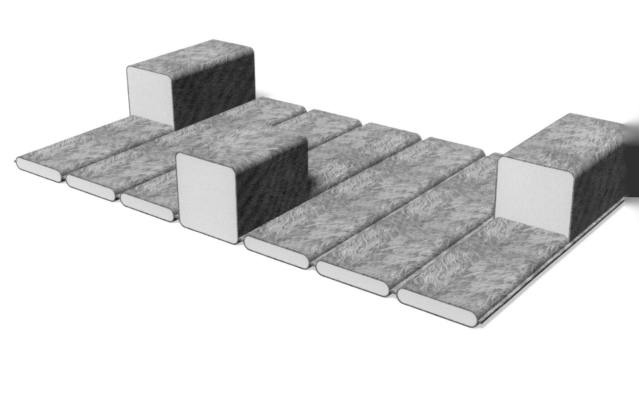

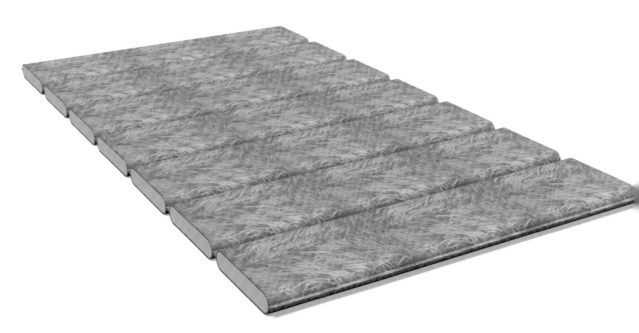

5

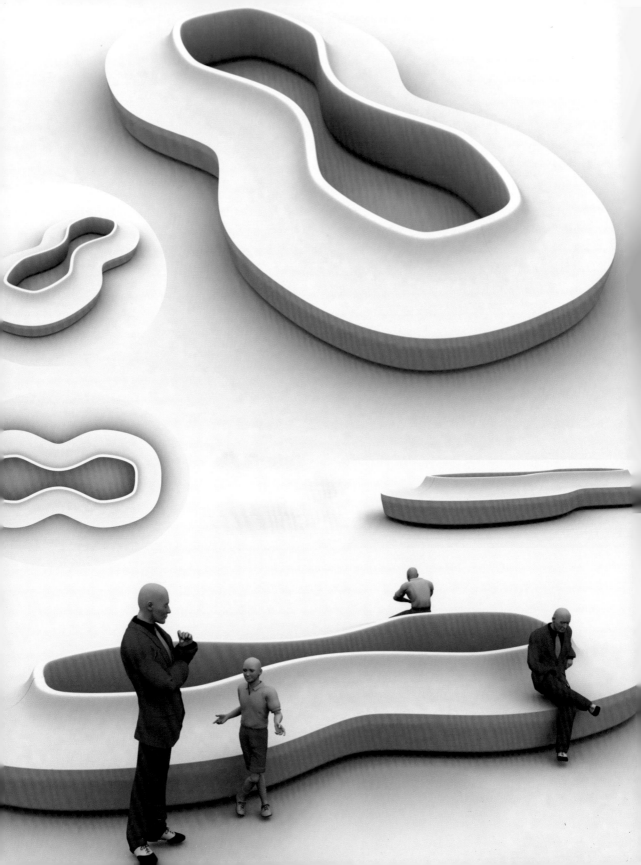

TEERAYUT PENGCHAI | UDONTHANI, THAILAND

Teerayut Pengchai, an aspired industrial designer, combines product concept, design and visual identity with a focus on usability.

teerayutta@yahoo.com

1 Eight
2 Sitting
3 Cycle

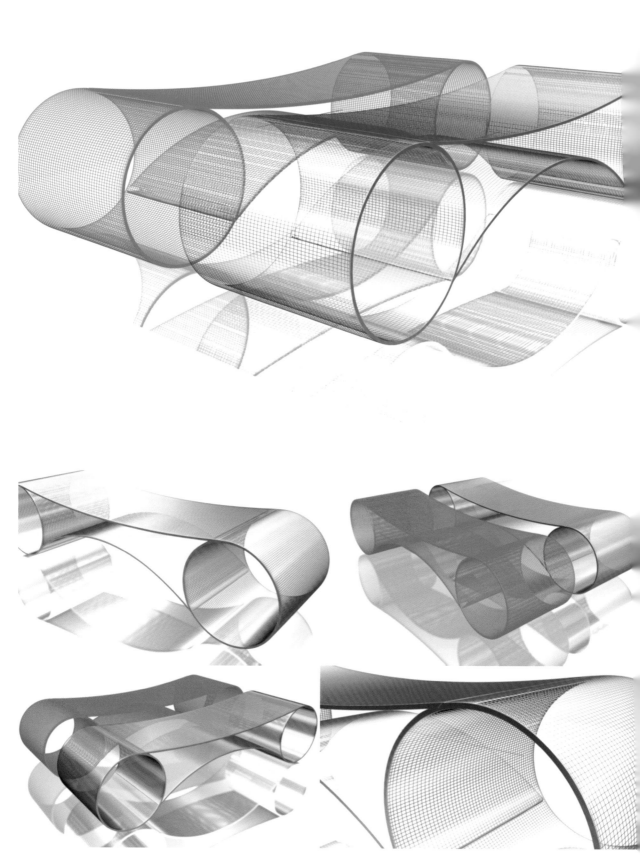

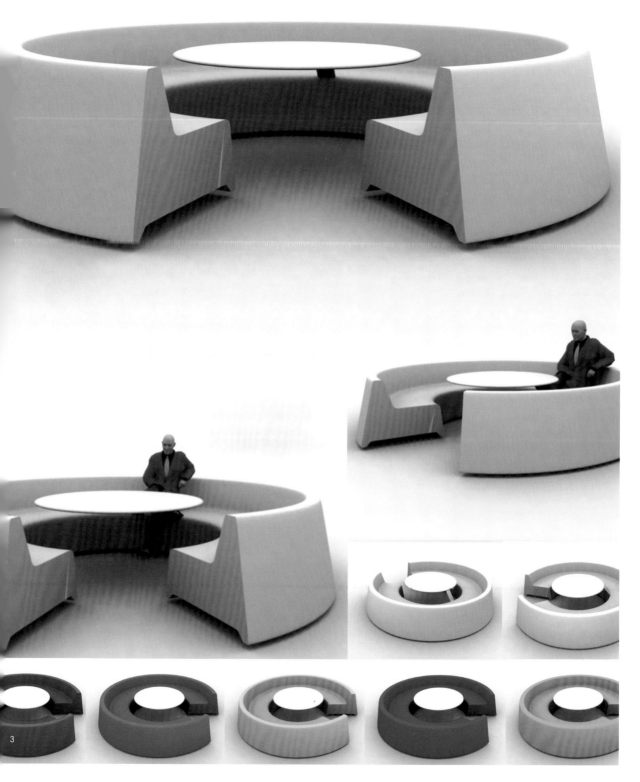

PLUSMINUSZERO | TOKYO, JAPAN
Naoto Fukasawa

In 2003, Naoto Fukasawa established Naoto Fukasawa Design. He is a lecturer at Tama Art University Tokyo, also the director of Tokyo AAD Studios, as well as a member of both the advisory board for quality design and the Ministry of Economy, Trade and Industry Strategic Design Research Society.

www.naotofukasawa.com

1 DVD/MD *stereo component*
2 8-inch LCD TV
3 A light with a dish
4 A4 *light*
5 22V LCD TV
6 Humidifier
7 R2.5 *portable cd player*

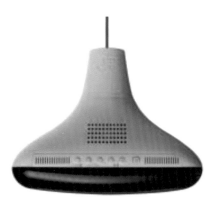

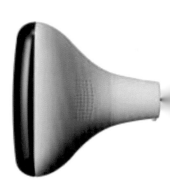

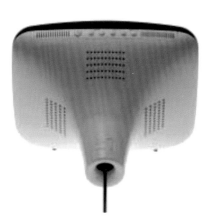

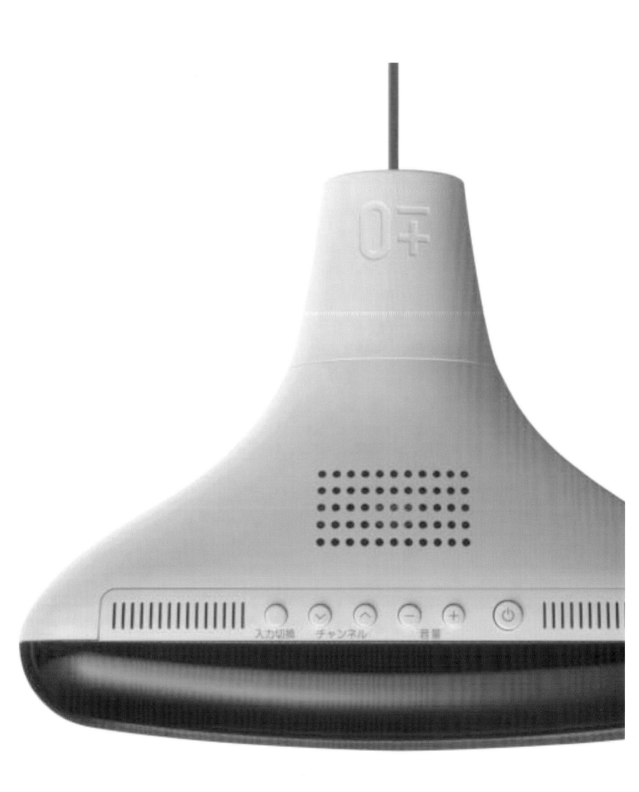

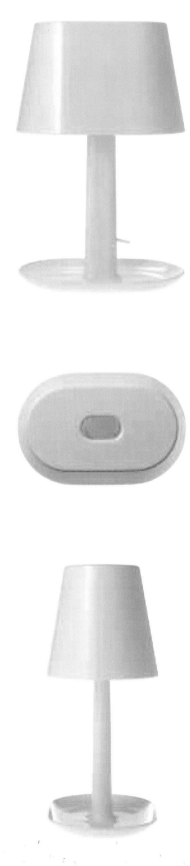

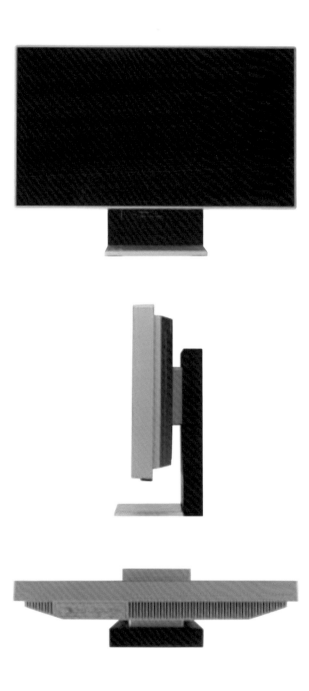

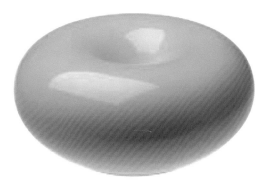

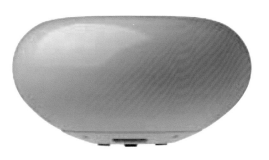

6

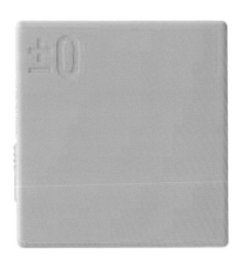

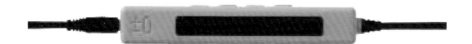

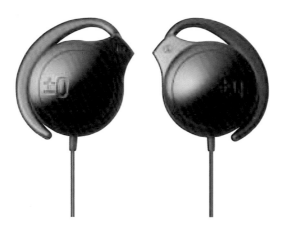

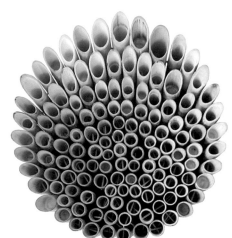

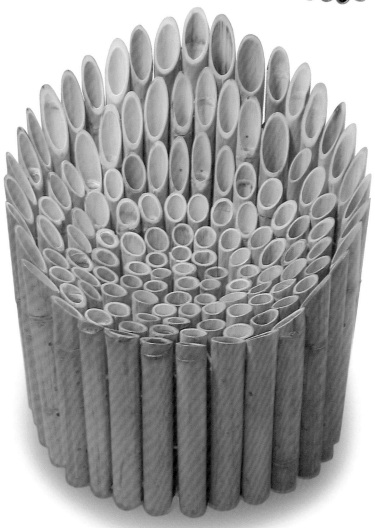

PRINCE DESIGN STUDIO BANGKOK | THAILAND

Sirote Bamrungsri He

Sirote Bamrungsri He is one of the "young & talented Thai designers". His design studio is a young and dynamic creative resource operating in the most varied design markets and creating industrial design and product development for modern lifestyle.

www.princedesign.com

1 Bee, *chair*
2 Istyle, *mobile phone*
3 Bathroom

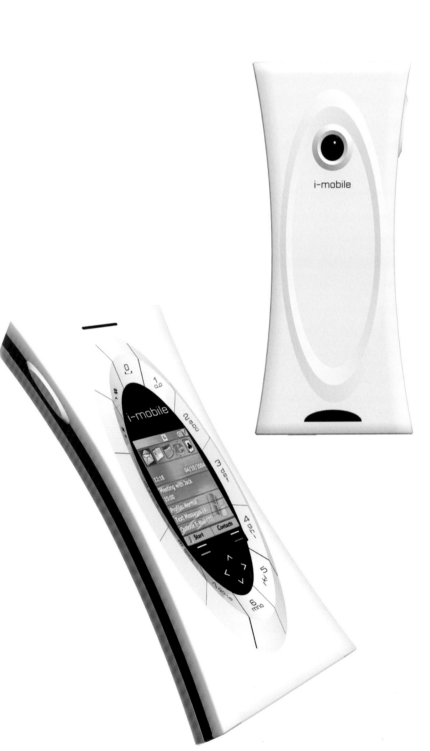
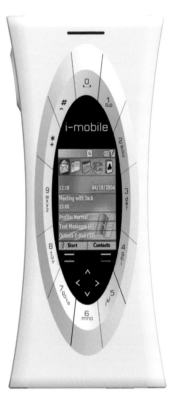

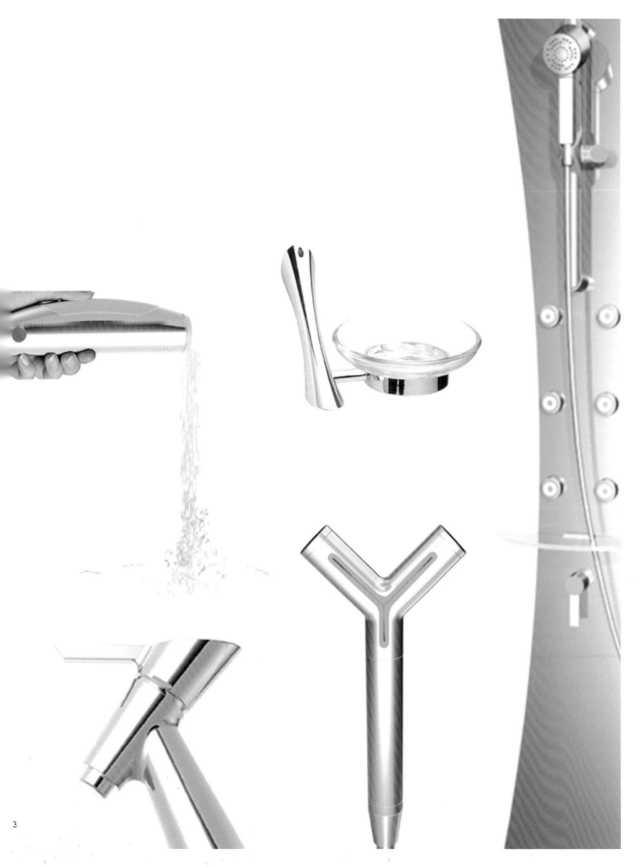

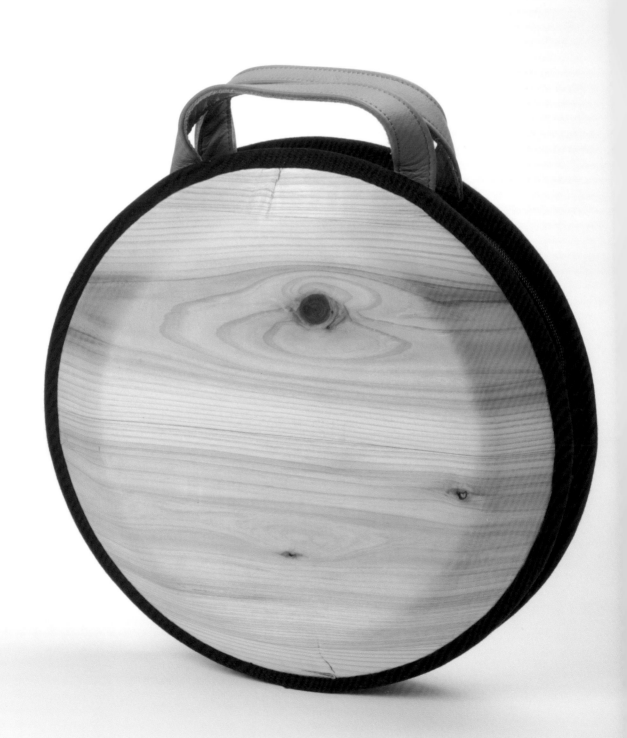

QURZ | TOKYO, JAPAN
Takumi Shimamura

Engaged in a broad range of activities; Takumi Shimamura received his works opens industrial product design such as PDA, furniture design, vehicle design such as cars and busses, as well as small house design.

www.t-shima.com

1 Bag Maru
2 Zaisu
3 Chair-r2
4 Zabuton
5 Light

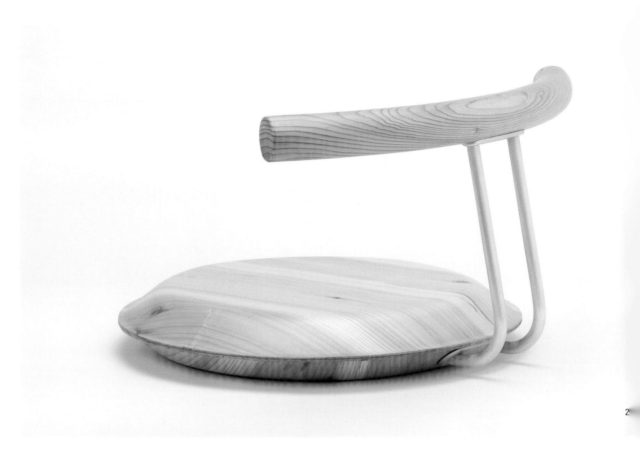

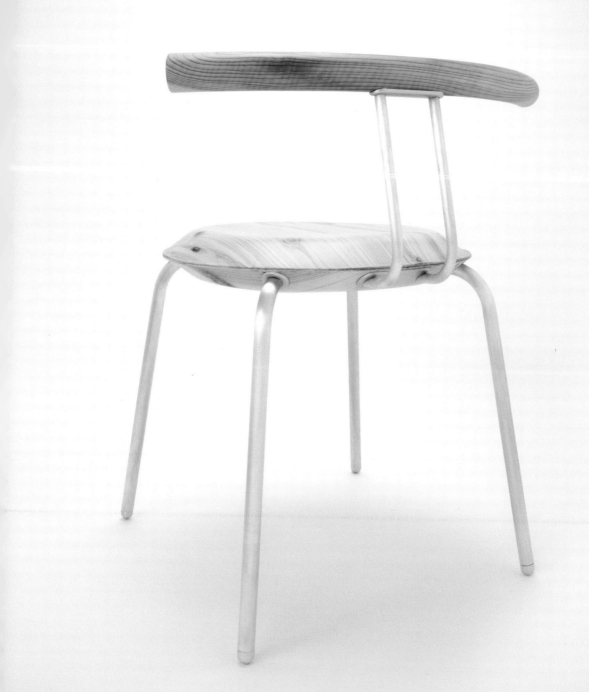

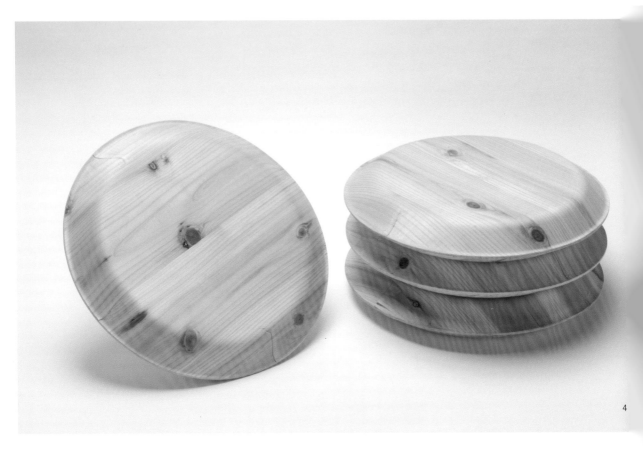

4

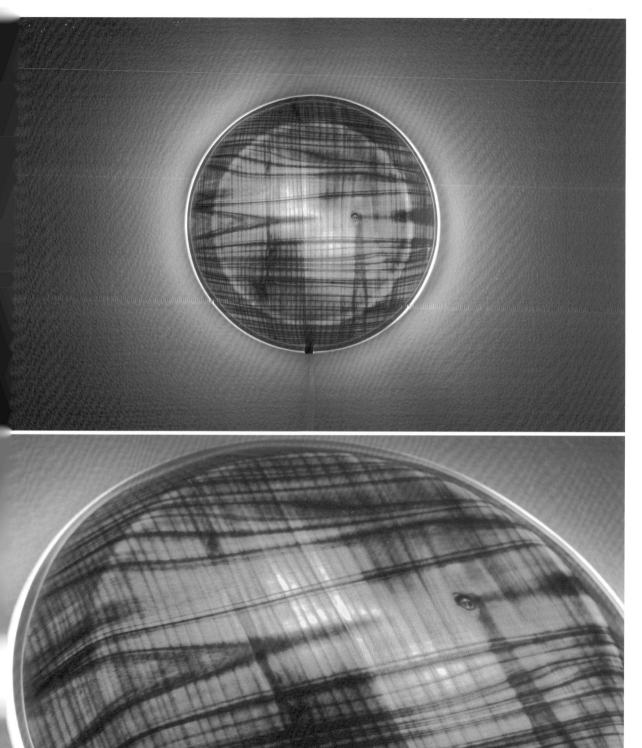

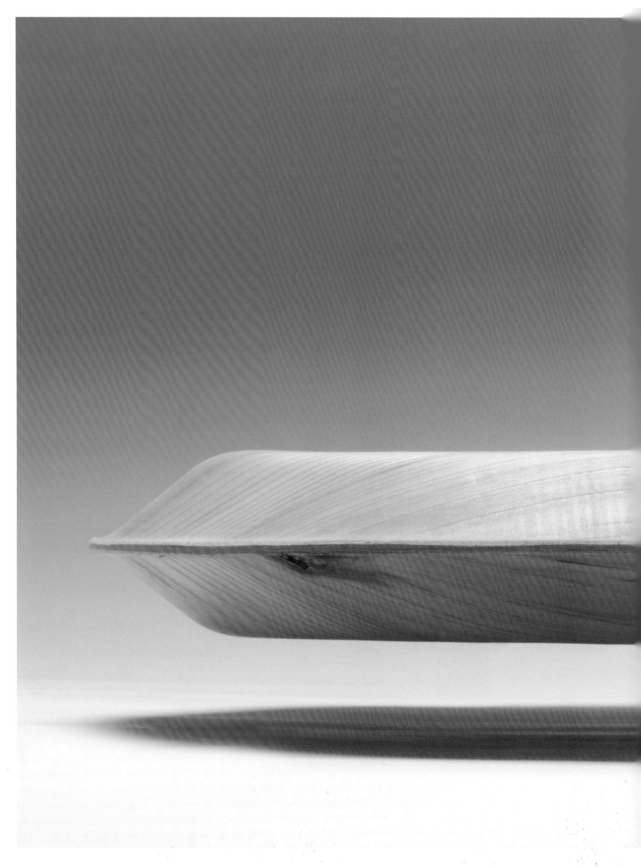

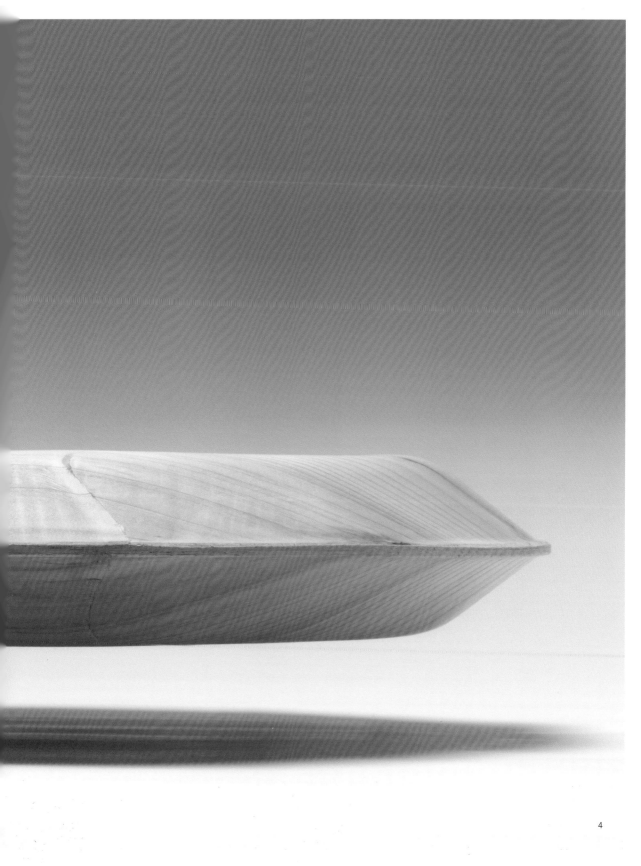

NARIAKI SATOH | YOKOHAMA, JAPAN

Nariaki Satoh is an up-and-coming industrial designer. He works in different fields of design, such as product design, interior and furniture. He participates design competitions both in Japan and Overseas.

naria-ilc.com

1 TT, *thermometer*
2 Cart-T-Cycle, *bicycle design concept*
3 SSS Six Stow Stocker

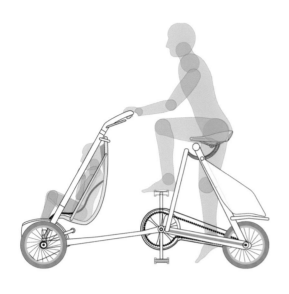

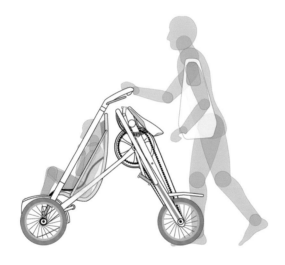

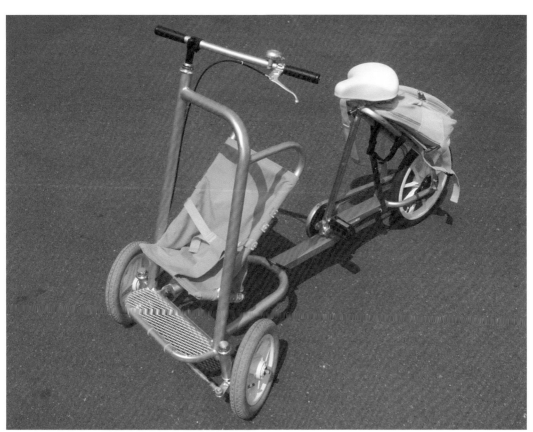

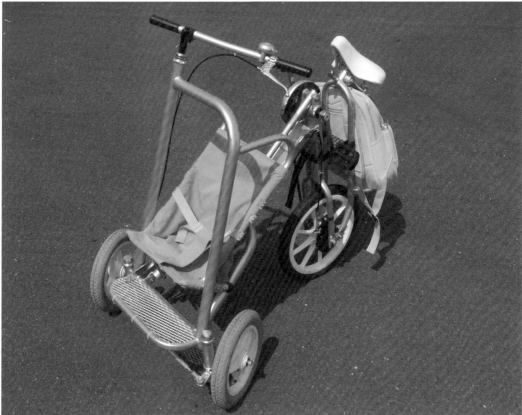

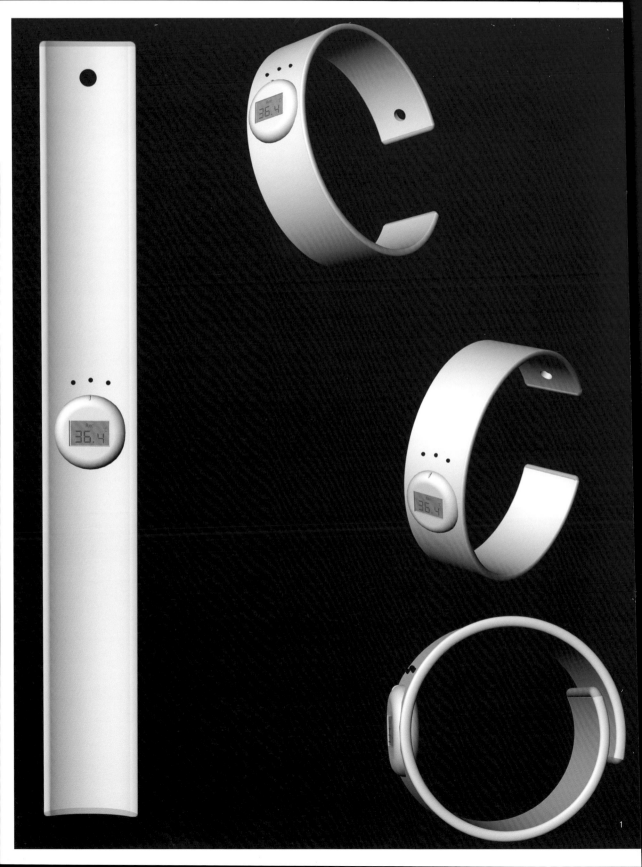

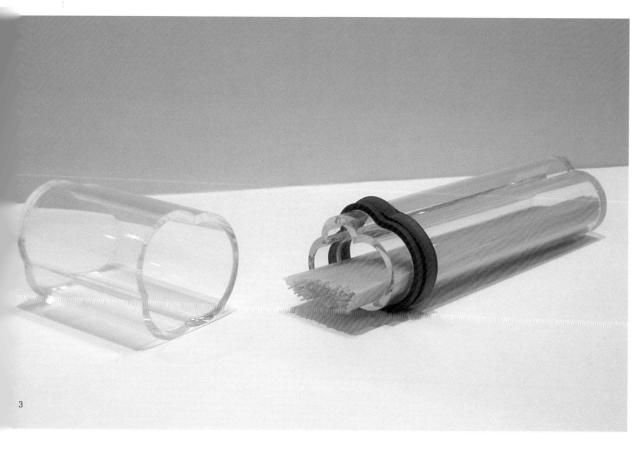

3

STIKFAS™ | SINGAPORE, SINGAPORE
Ban Yinh Jheow

Stikfas™ is the brand that has defined a new genre in toys with the concept of Action Figure Kits, and also the first and only international toy brand from Singapore.

www.stikfas.com

Action Figure Kits

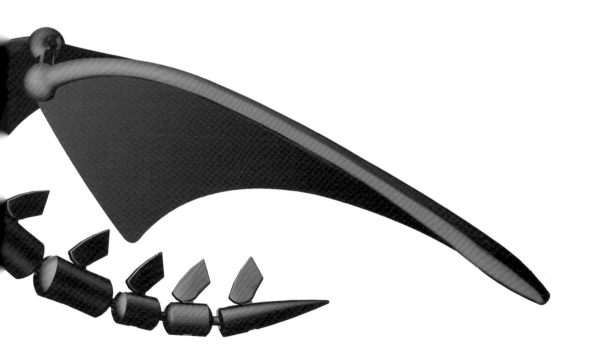

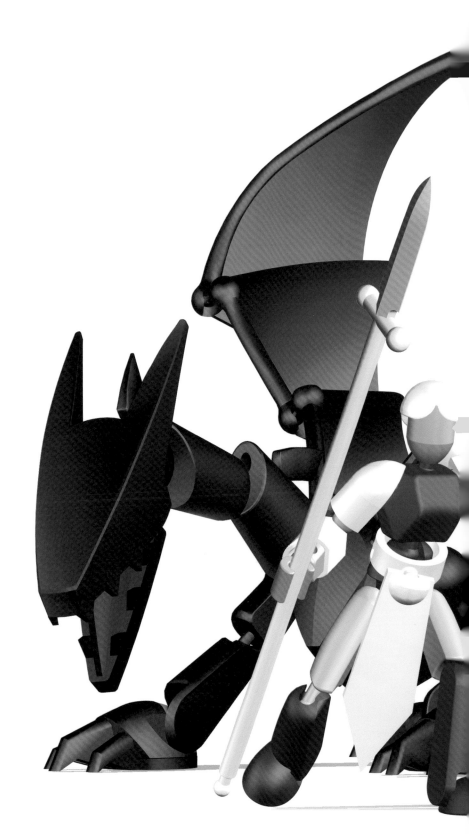

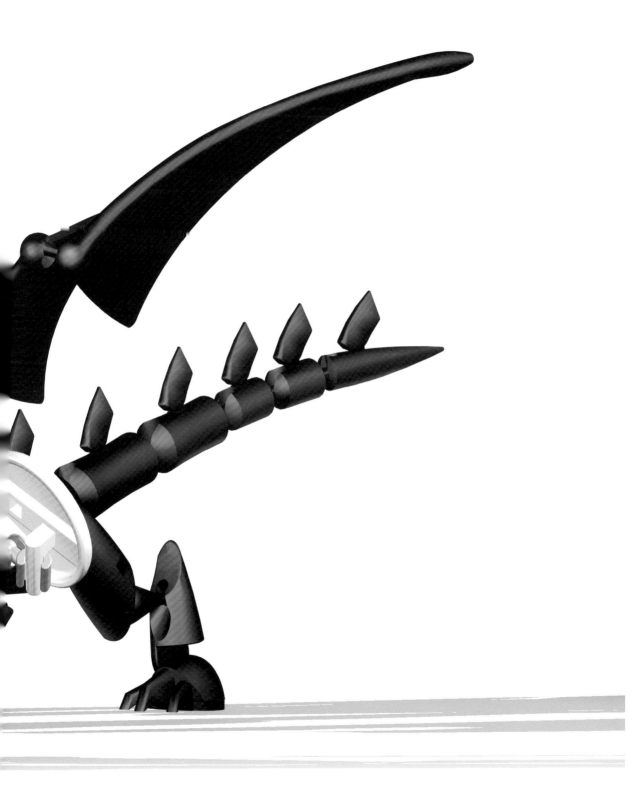

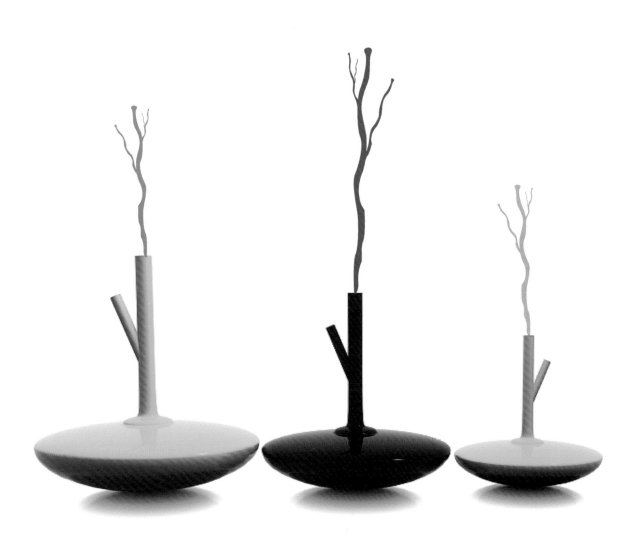

STUDIOBO | SAMUTPRAKARN, THAILAND
Chaiyapruk Tongcham

After graduating from Srinakarinwirot University, Chaiyapruk Tongcham worked as an product designer at the Aesthetic Studio, Bangkok. He took part in many projects with the Product Development Ministry of Thai Commerce.

www.studiobo.com

1 Xen, vase
2 TIMERind
3 Front
4 Cassetto

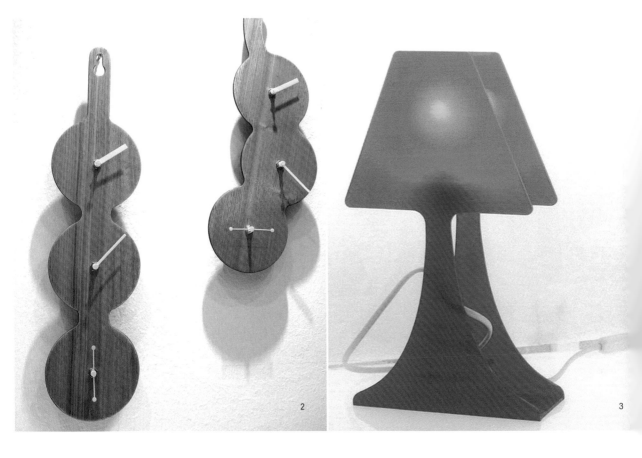

2

3

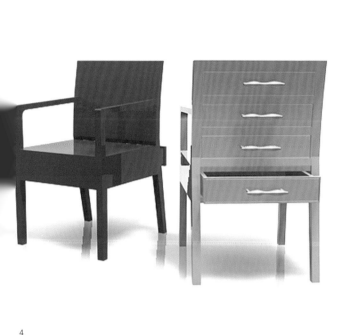

4

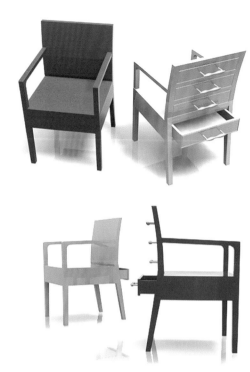

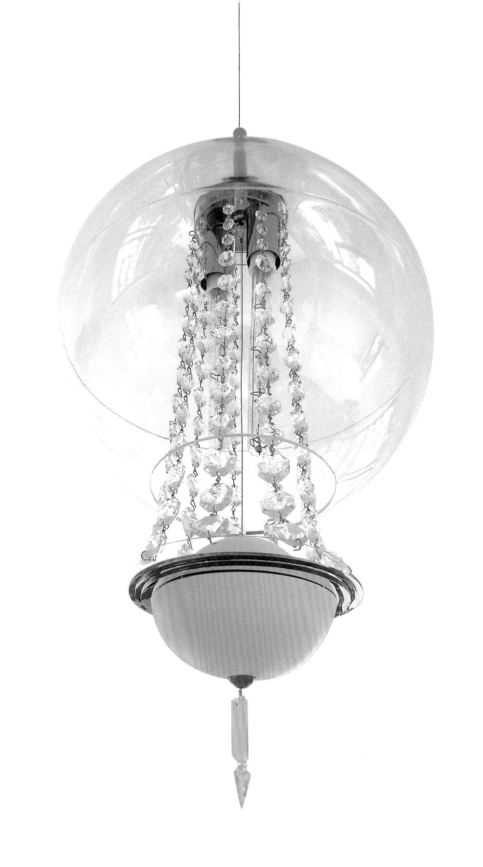

ISSEI SUMA | NEW YORK, USA

He is interested in things that transcend the scale of "what it is". His credo: "It is about what is in your hands, yet never in your hands; what you never expected however so obvious."

www.poq.nu

1 Chandelier
2 Purse / RC car / Stadium

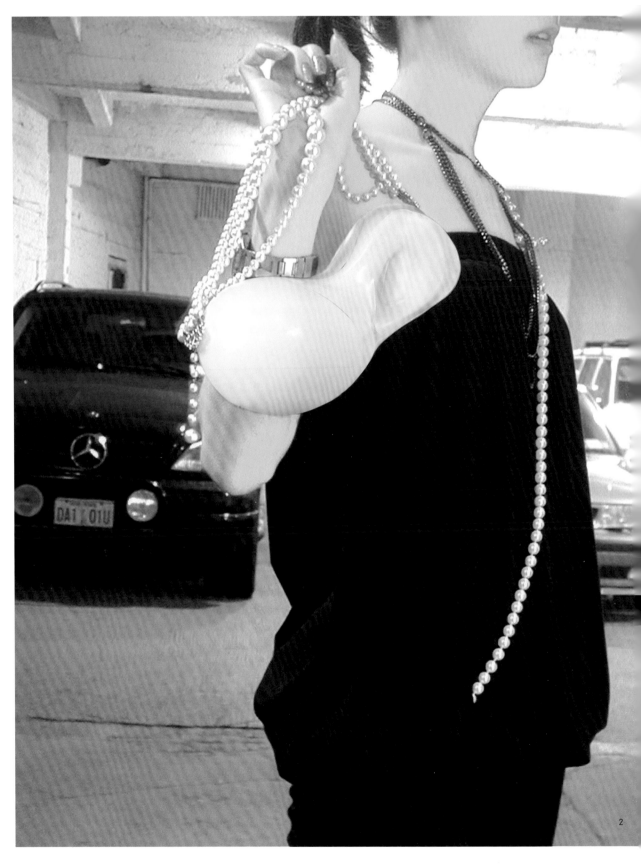

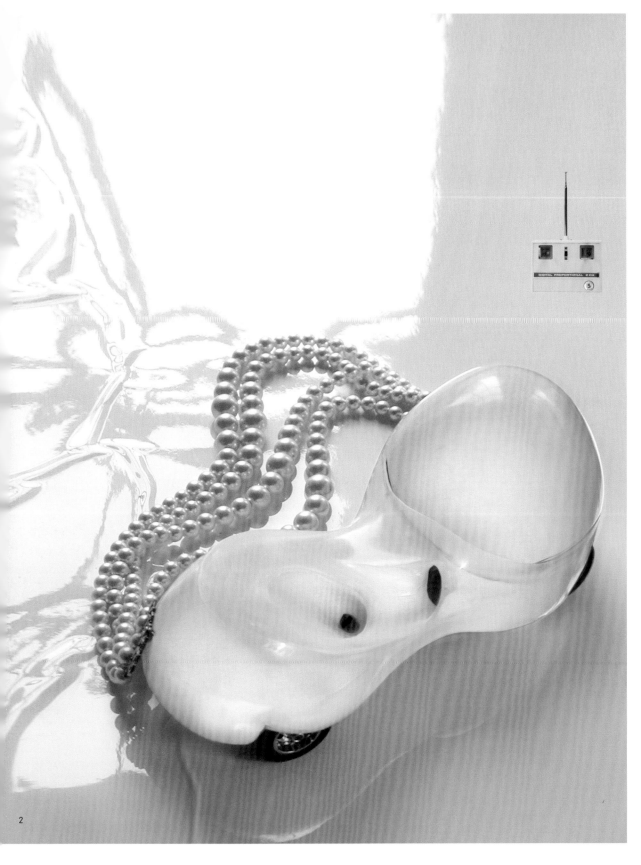

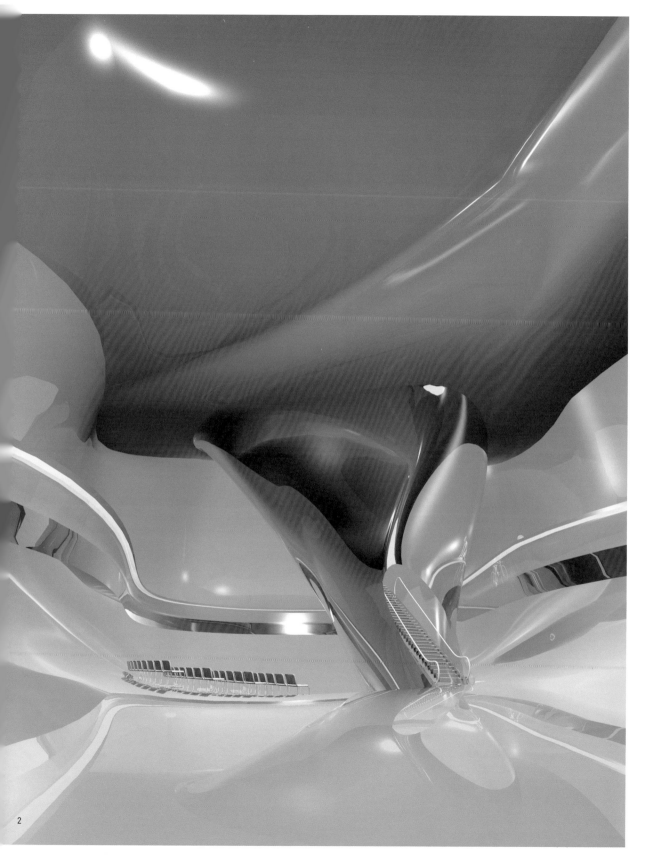

SUMAJIN | SINGAPORE, SINGAPORE
Marcus Ting

Sumajin is a design studio based in Singapore. Marcus Ting's main focus is on industrial design services. Sumajin started creating their own line of products and have won awards for some of them.

www.sumajin.com

1 Flex champion, *bag accessory*
2 Smartwrap & Syncwrap, *cable management*
3 Clouds, *candle*
4 The Crown, *stool*
5 Little rascal, *cushion*
6 Loop, *ipod shuffle case*
7 Flex, *earphone / cable accessory*

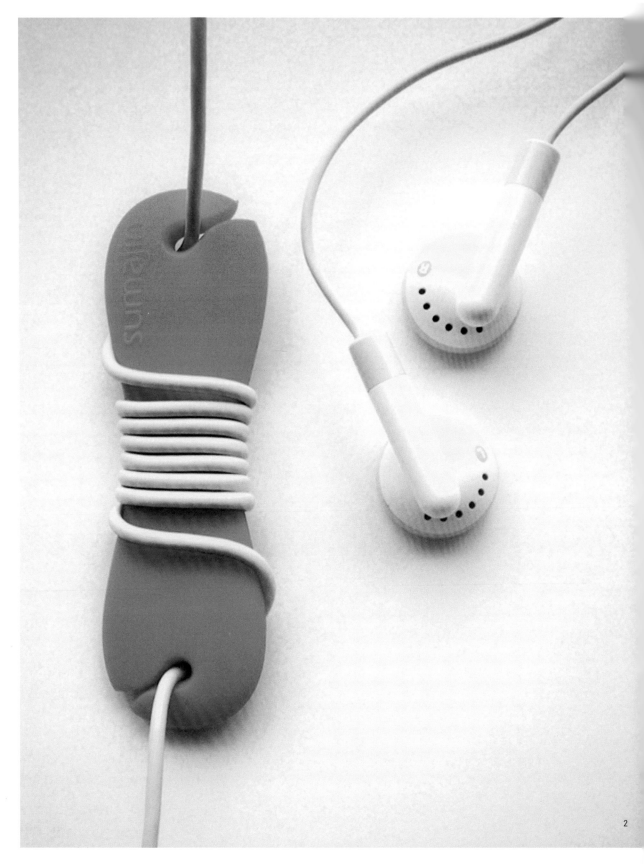

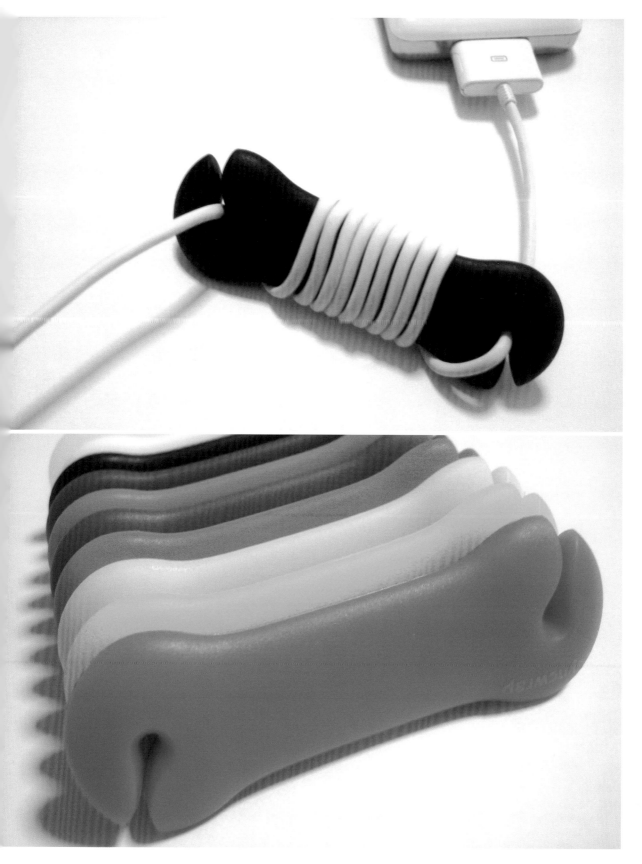

3

4

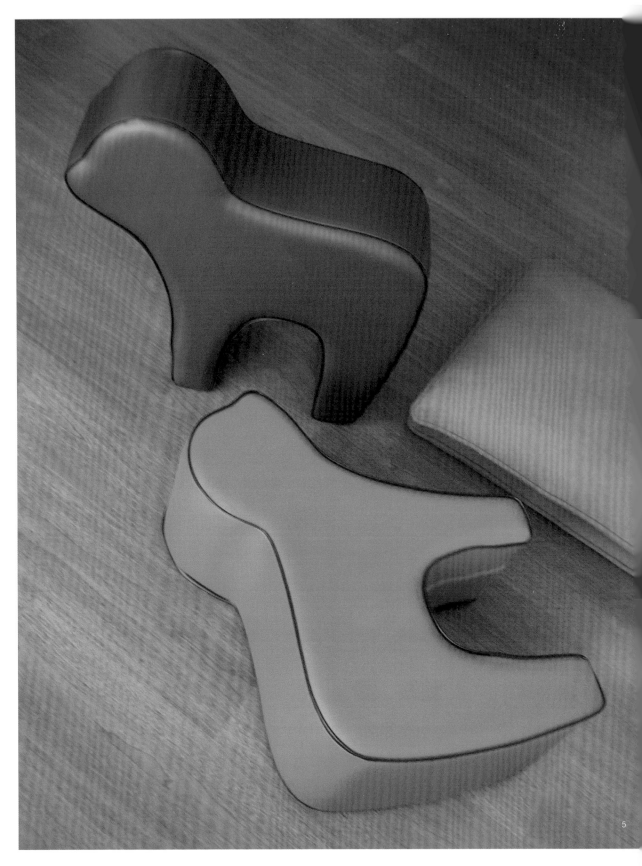

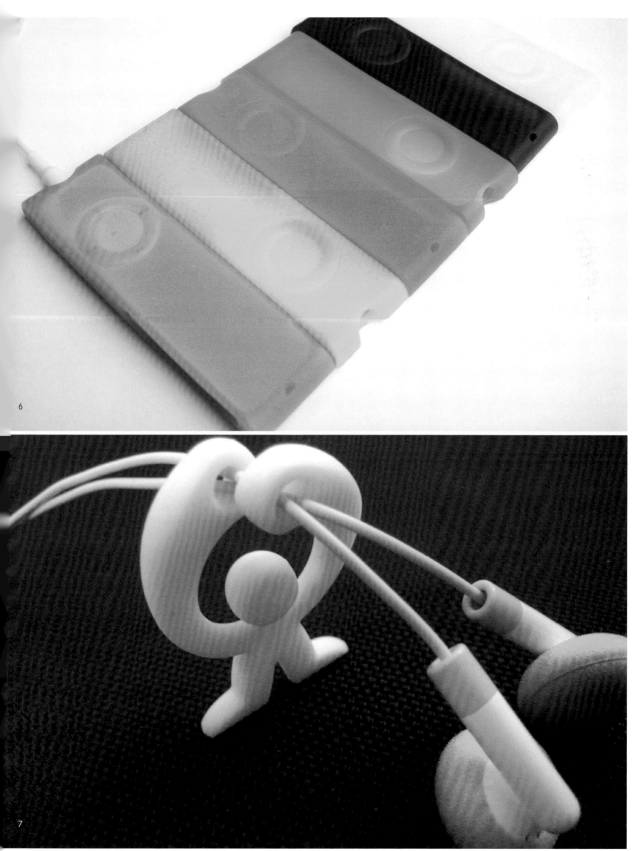

6

7

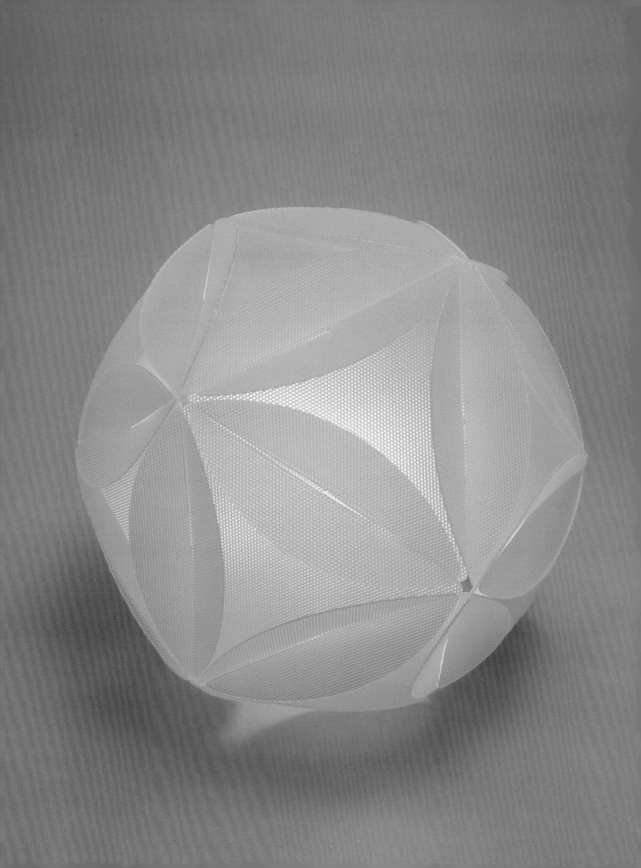

TAIDESIGN | KANAGAWA, JAPAN
Tai Hayakawa

After studying carpentry and furniture design while enrolled at Musashino Art University and working for a design office, he became a freelance designer in the field of interior products. At the same time, he established the designer facility "Lab-CLEAR" to sell his own products.

www.taidesign.jp

1 Flake, *lamp*
2 Icosa, *salt* & *pepper shaker*
3 Cymbals-SUS

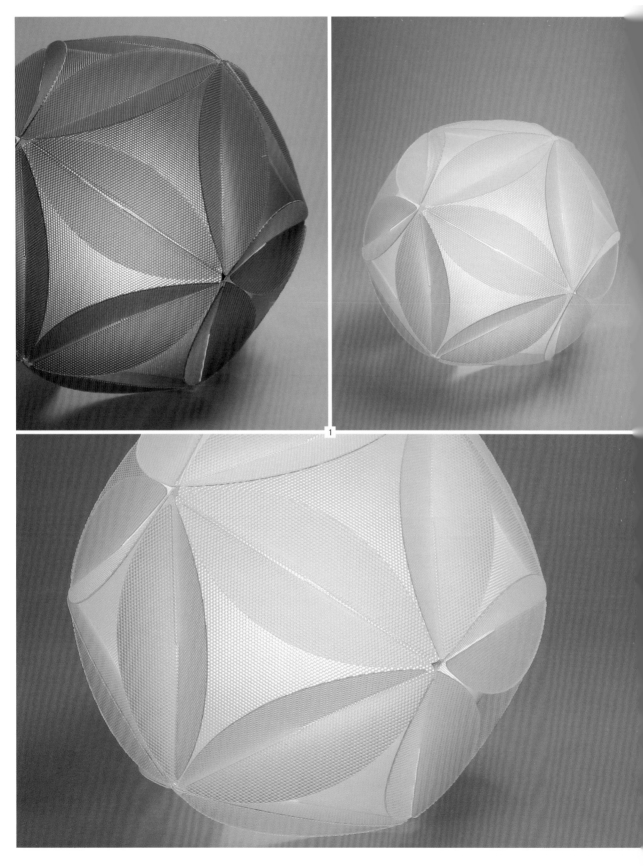

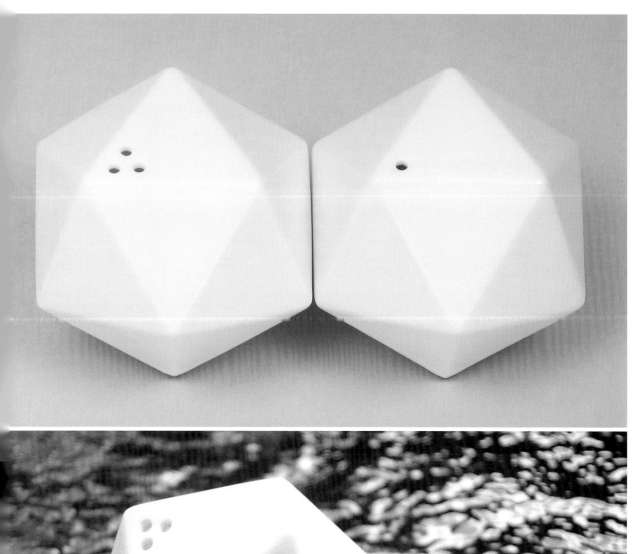
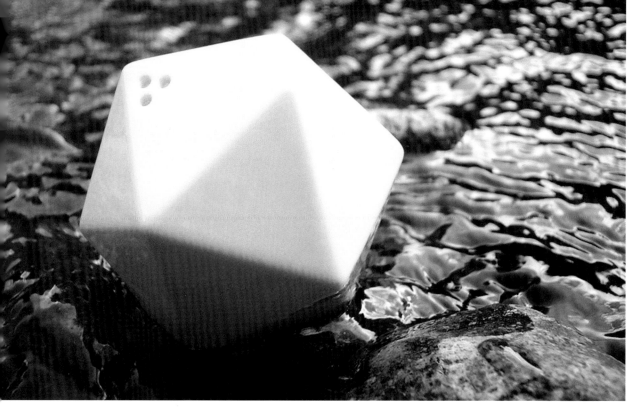

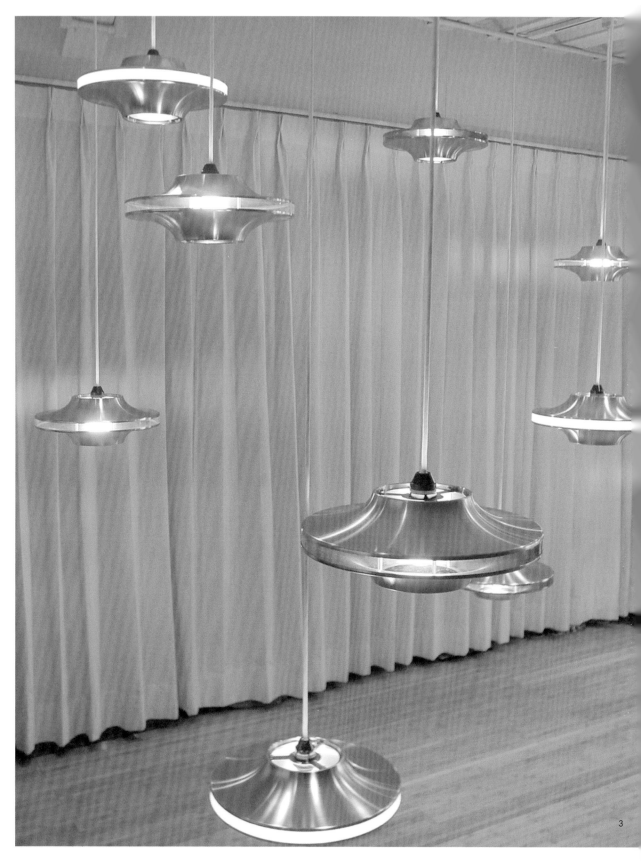

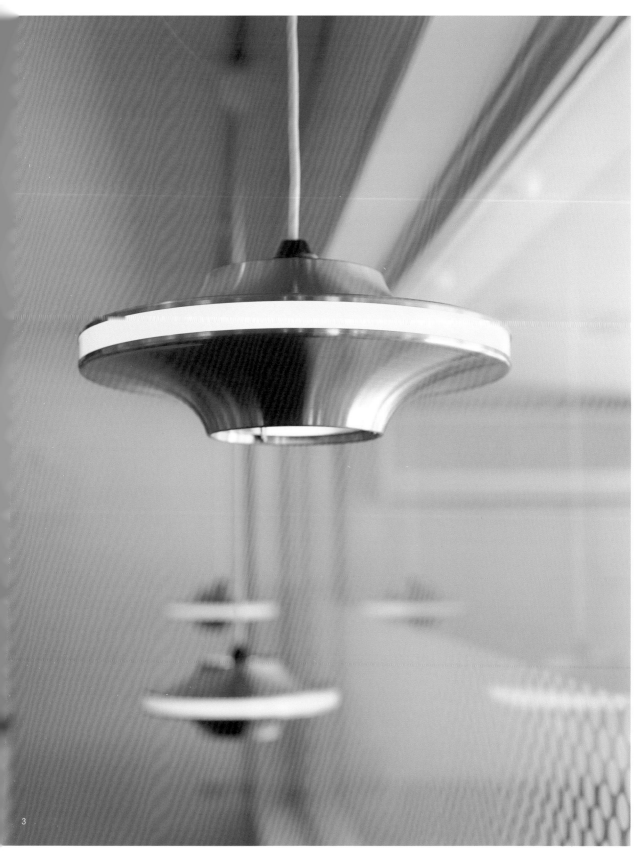

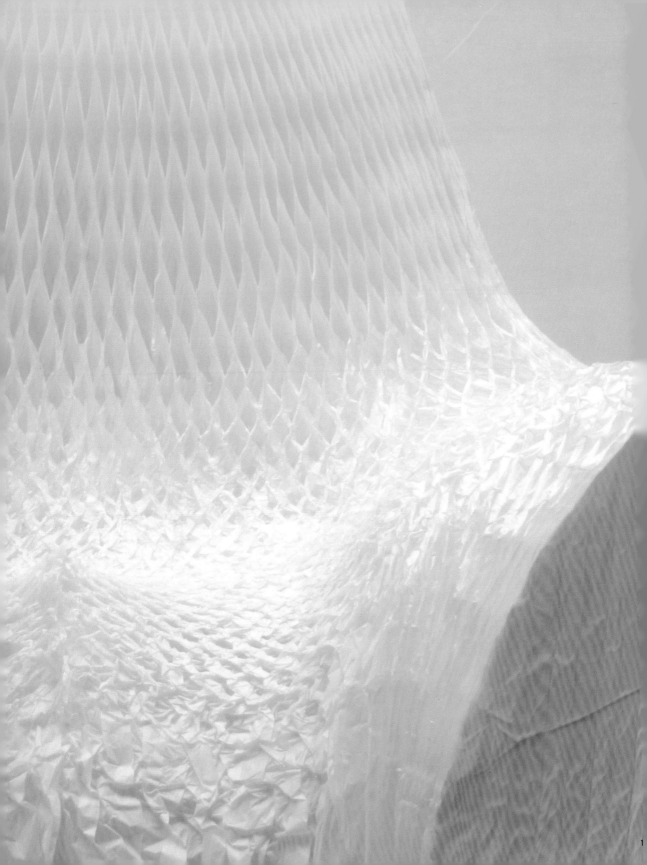

TOKUJIN YOSHIOKA DESIGN | TOKYO, JAPAN
Tokujin Yoshioka

After graduating from the Kuwasawa Design Institute,
Yoshioka joined a prominent studio headed by Shiro Kura-
mata, one of post-war Japan's more influential industrial
designers.

www.tokujin.com

1 Honey-pop, *honeycomb structured paper*
2 Streetscape Project
3 Tokyo-pop

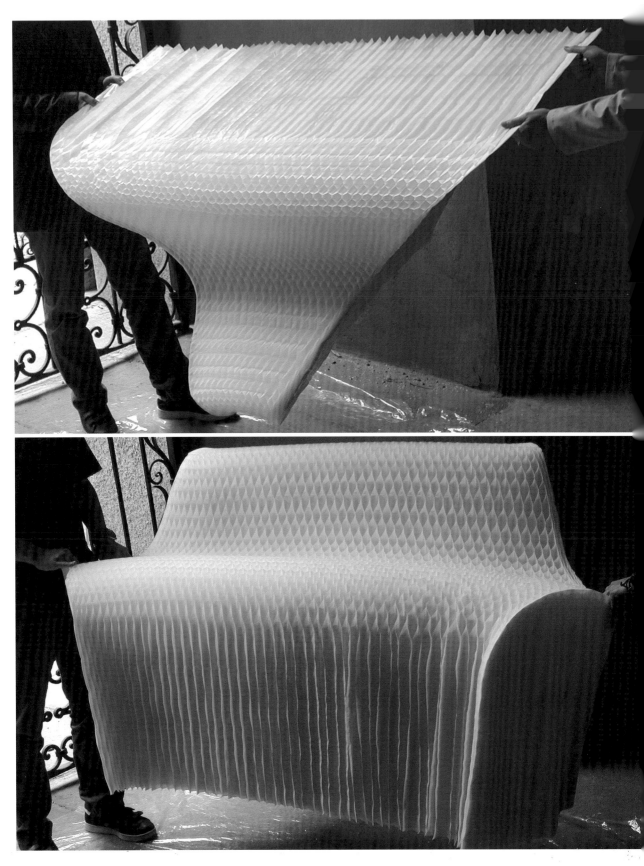

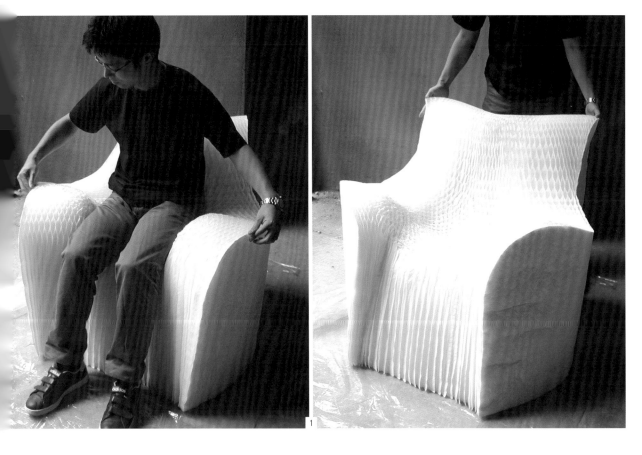

1

333

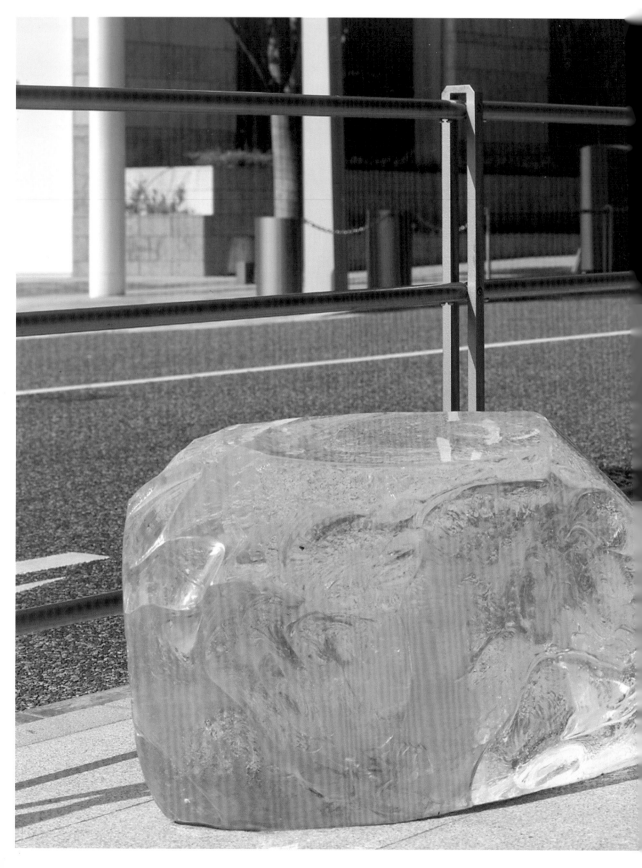

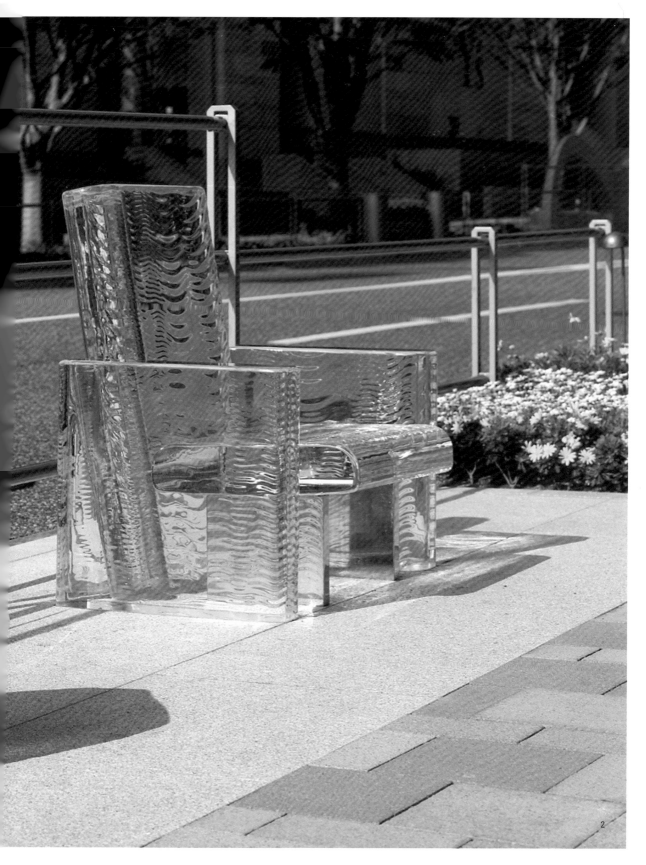

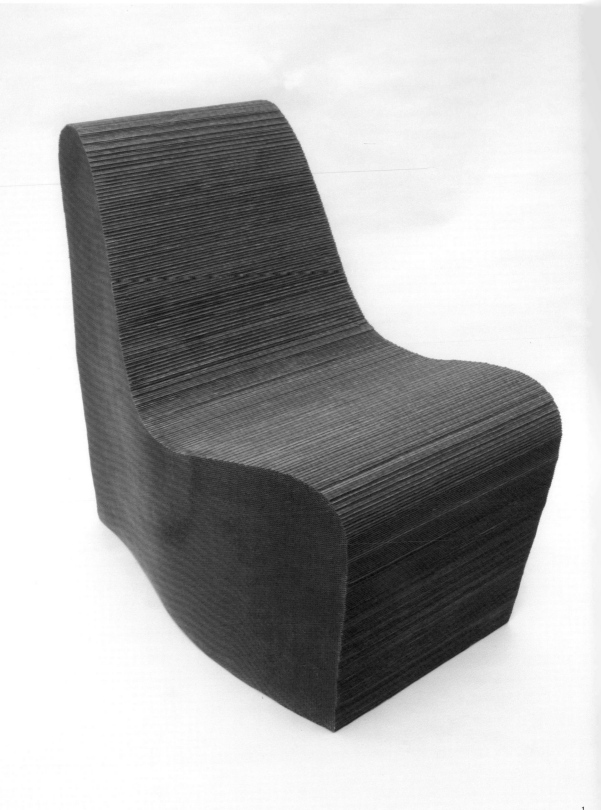

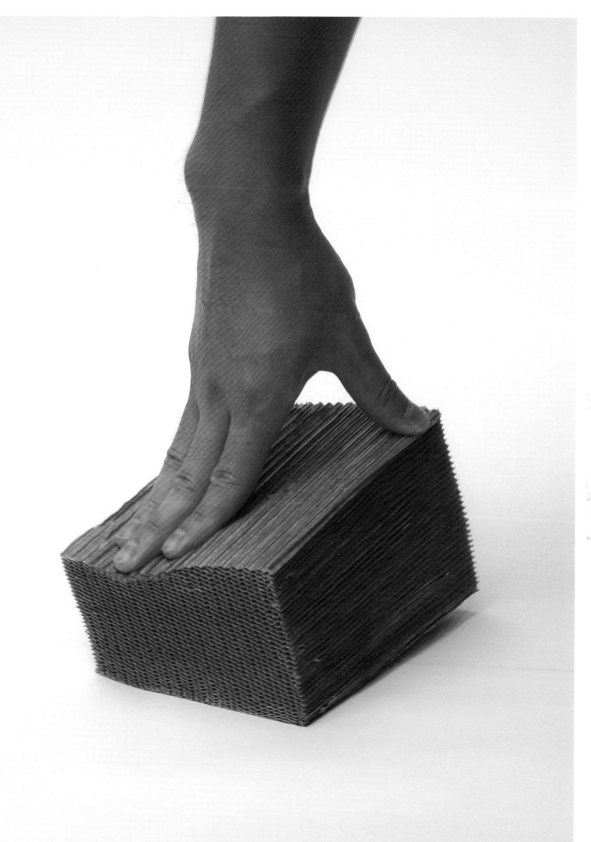

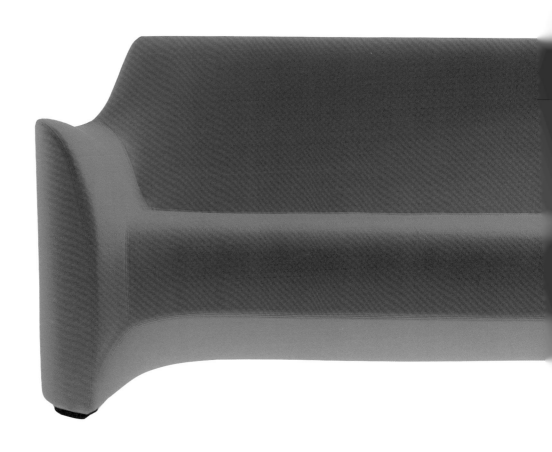

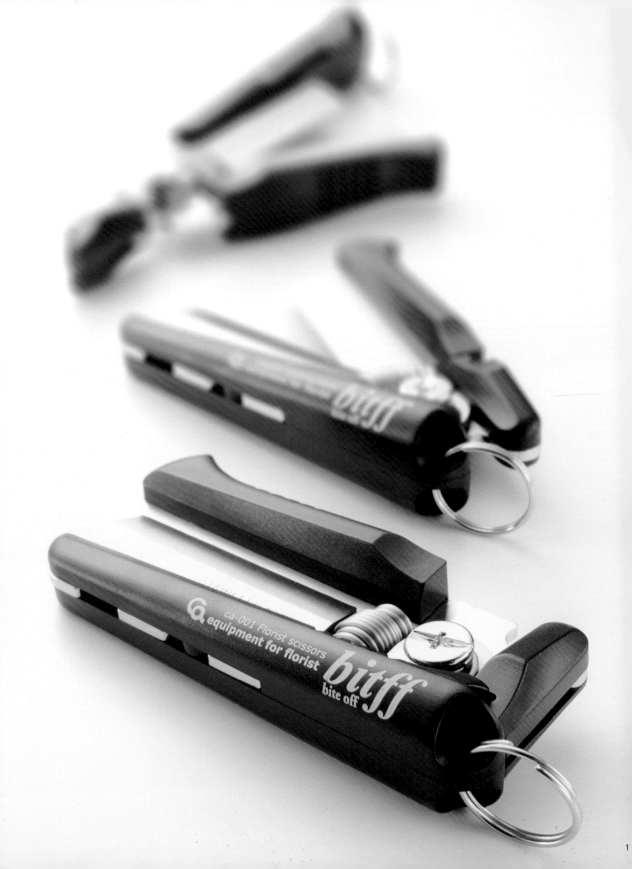

HIROSHI TOMITA DESIGN WORKS | NIGATA, JAPAN

As a graduate from Tokyo Designer Gakuin College Hiroshi Tomita creates products pursued of functional and simple structure, based on professional relationships between local designers, groups and companion

http://schwalbe.nisaku.co.jp

1 Bitff, *flowlist scissors*
2 Cuttanets, *flower arrangement tool*
3 Cogatana, *knife*
4 Live seasoning, *table top hydroponics pod*
5 Twig, *fruits served tools*

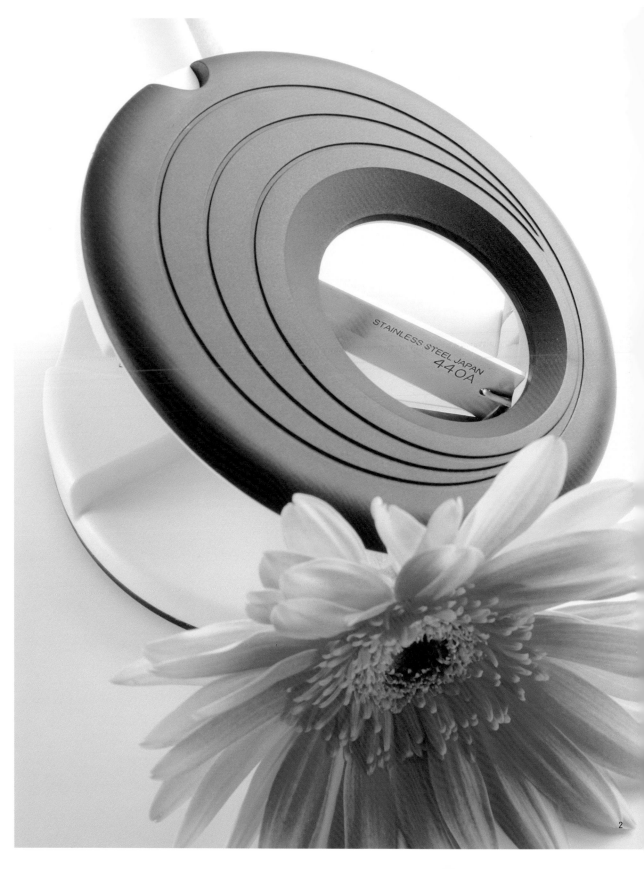

STAINLESS STEEL JAPAN
440A

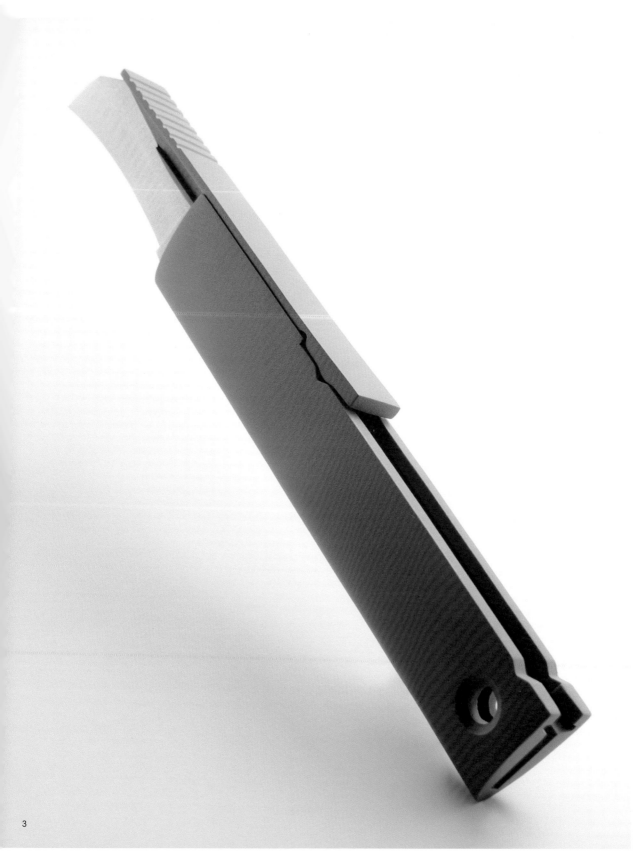

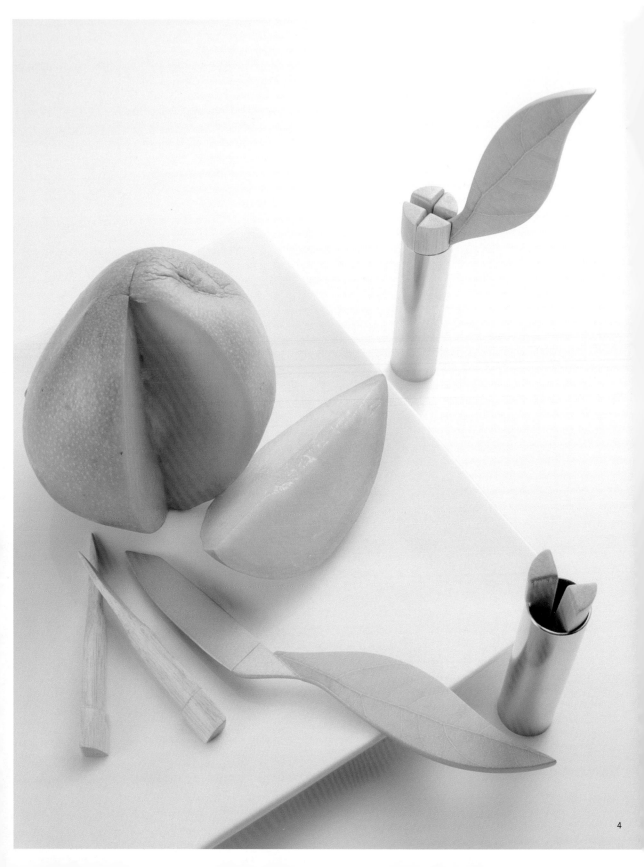

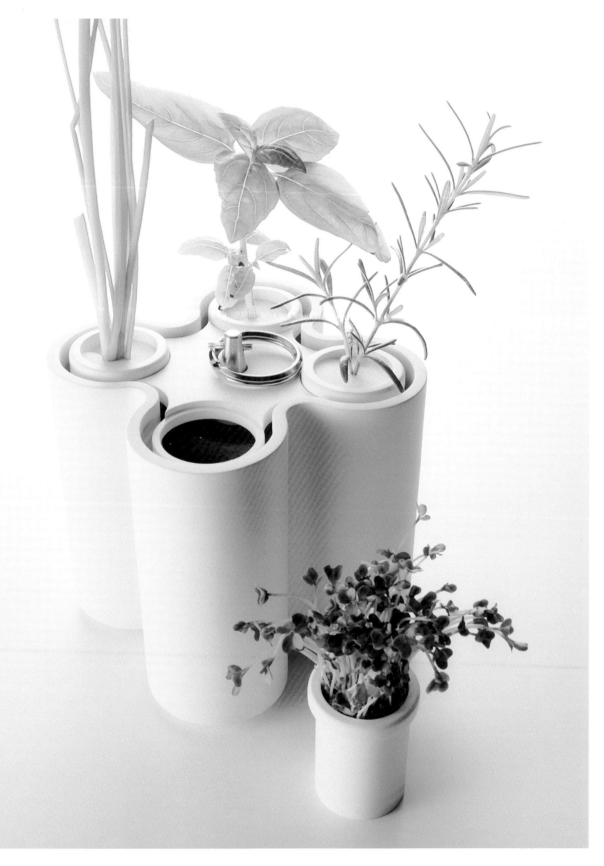

TONERICO:INC. | TOKYO, JAPAN

Yumi Masuko, Hiroshi Yoneya, Ken Kimizuka

Concentrating on interior design, furniture and industrial design, Tonerico:Inc's activity began in spring 2002. They have been a top prize winner in the CaloneSatollite2005· design report award.

www.tonerico-inc.com

1 MEMENTO *SaloneSatellite2005*
2 GUSHA, *side chair*
3 GUSHA, *stool*

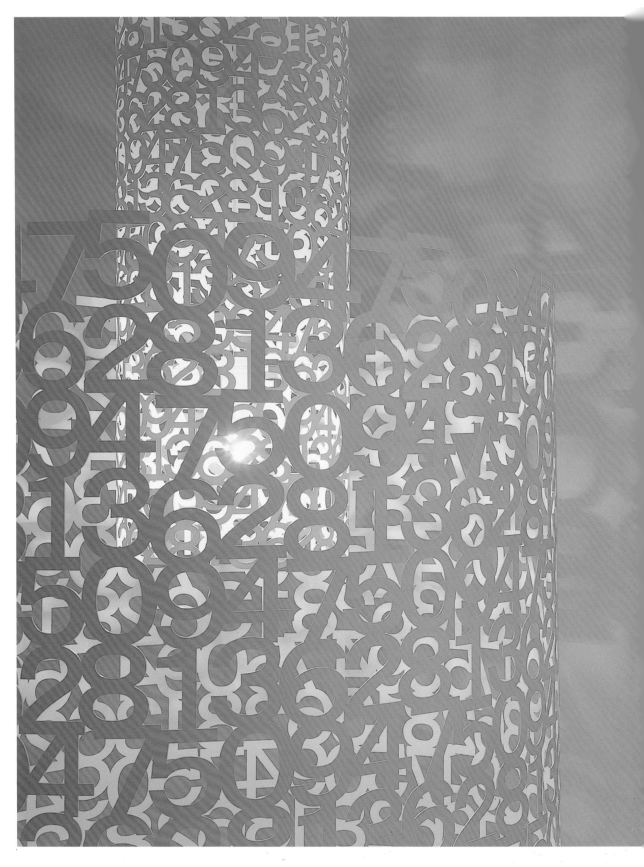

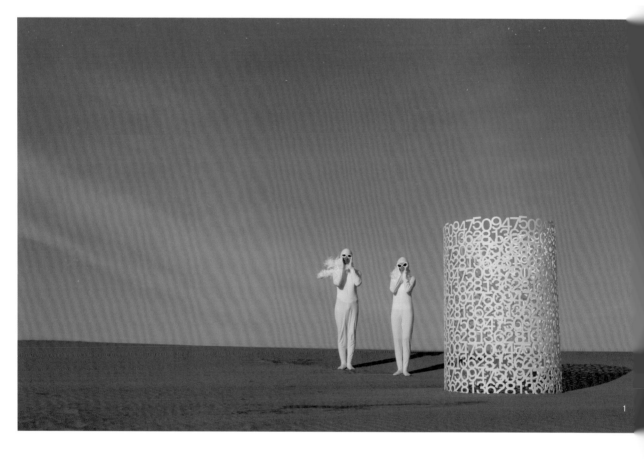

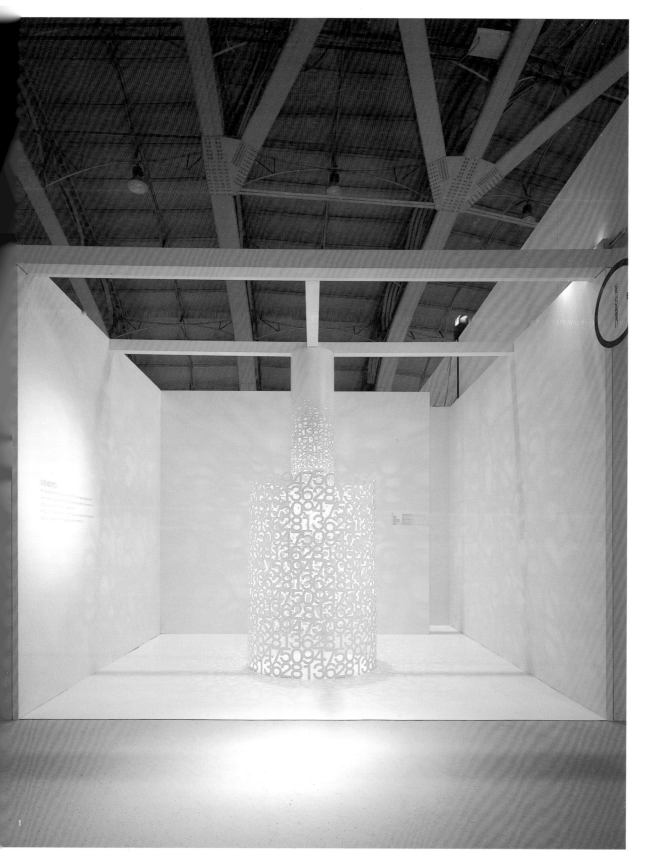

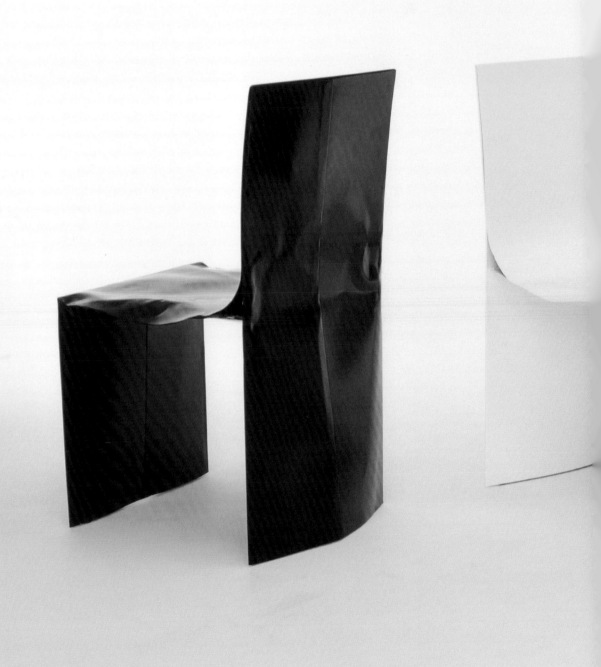

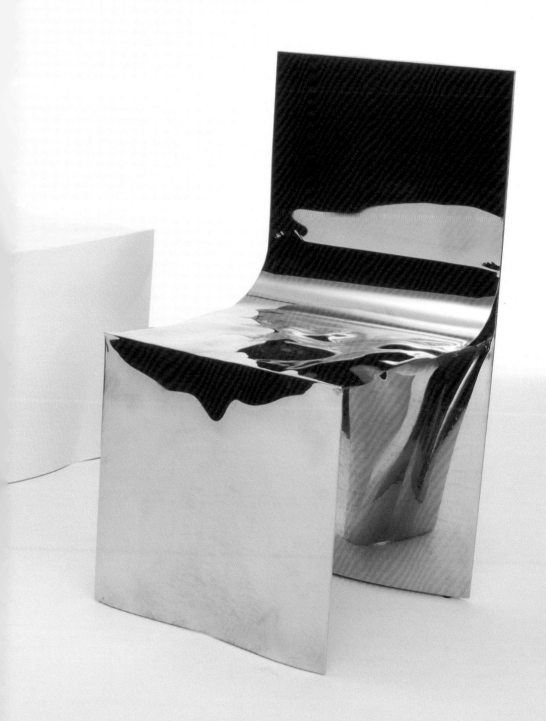

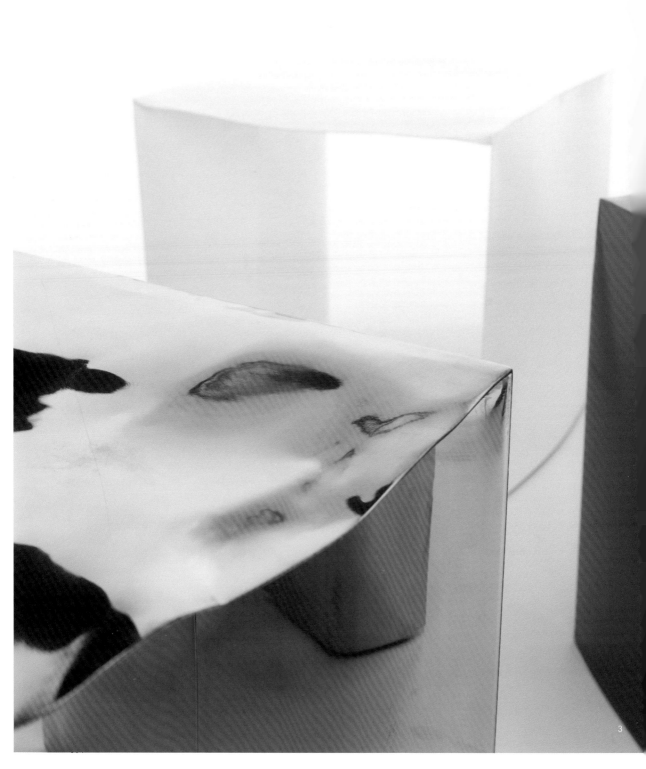

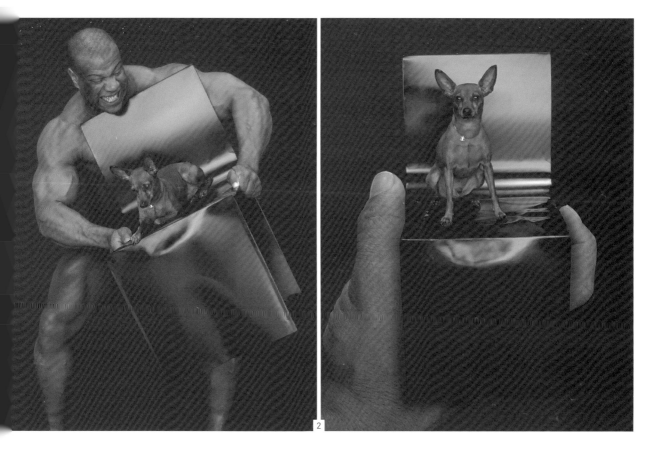

2

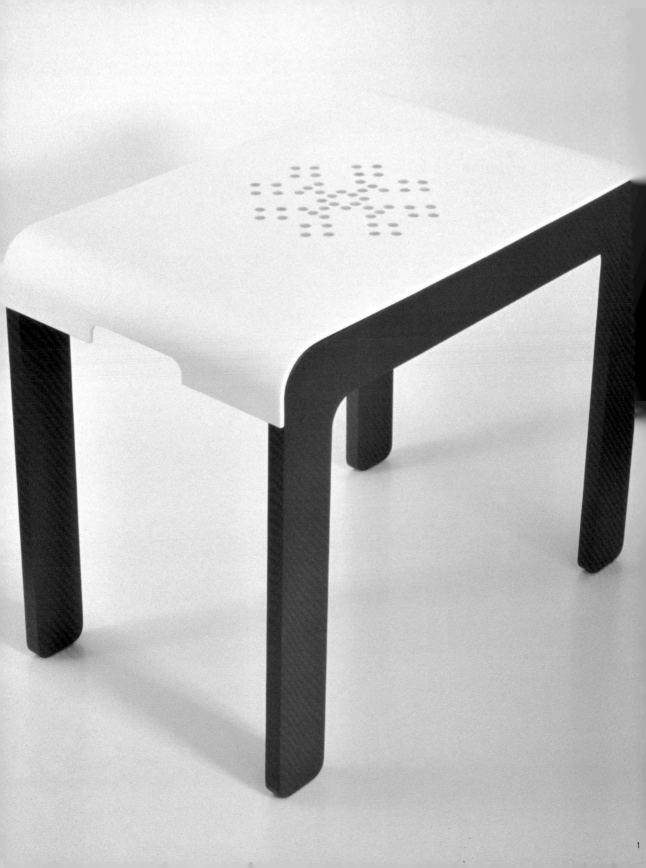

VILDE FORM | CAMBERWELL, AUSTRALIA
Louisa Vilde

Design studio vilde form produces a range of innovative products including furniture, lighting, homewares and jewelry. The studio emphasizes the exploration of form and the experimental use of materials, with high regard being paid to environmental responsibility and sustainability.

www.vildeform.com

1 Ziema, *tray table*
2 Luna, *table lamp*
3 Raksti, *dining table*
4 Snow, *bool & spoon*
5 Tealight

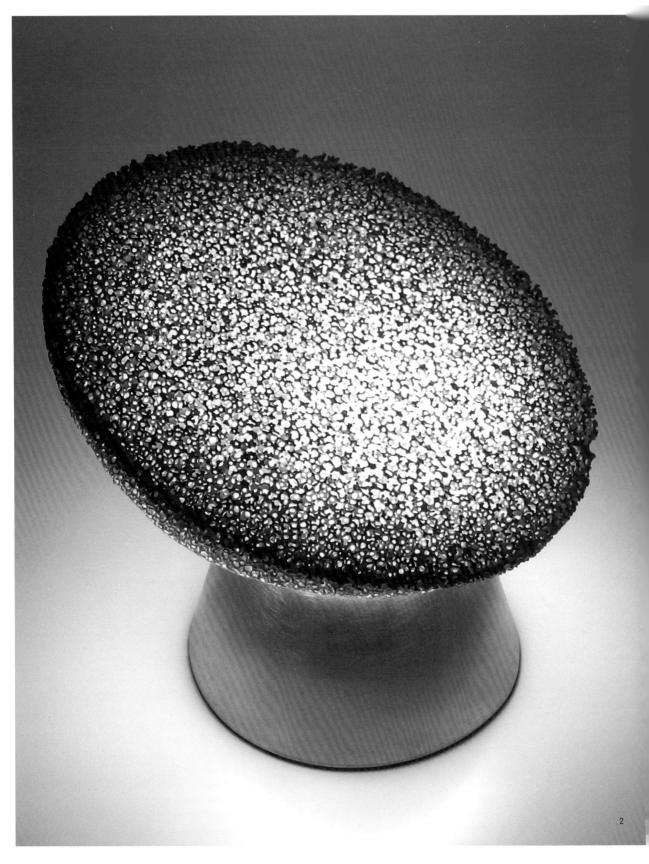

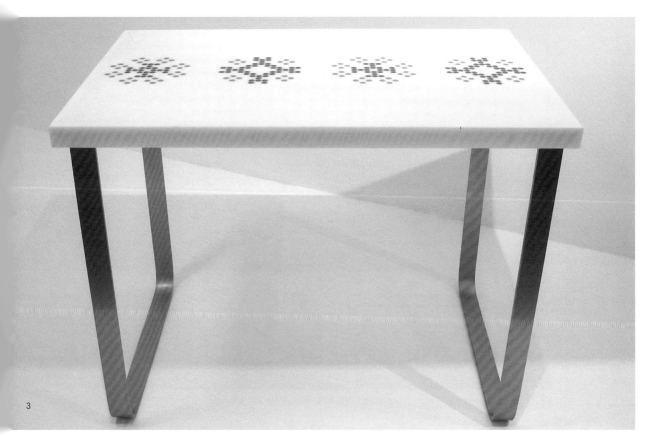

3

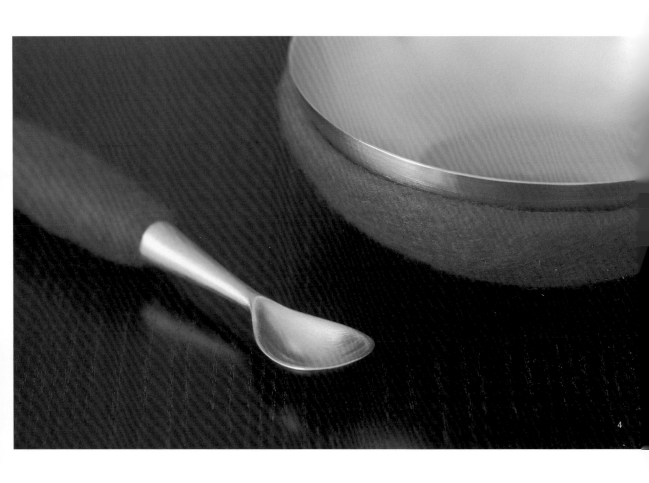

4

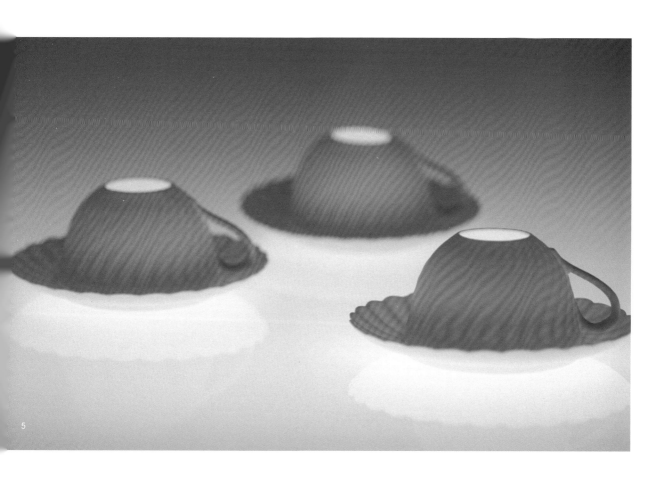

5

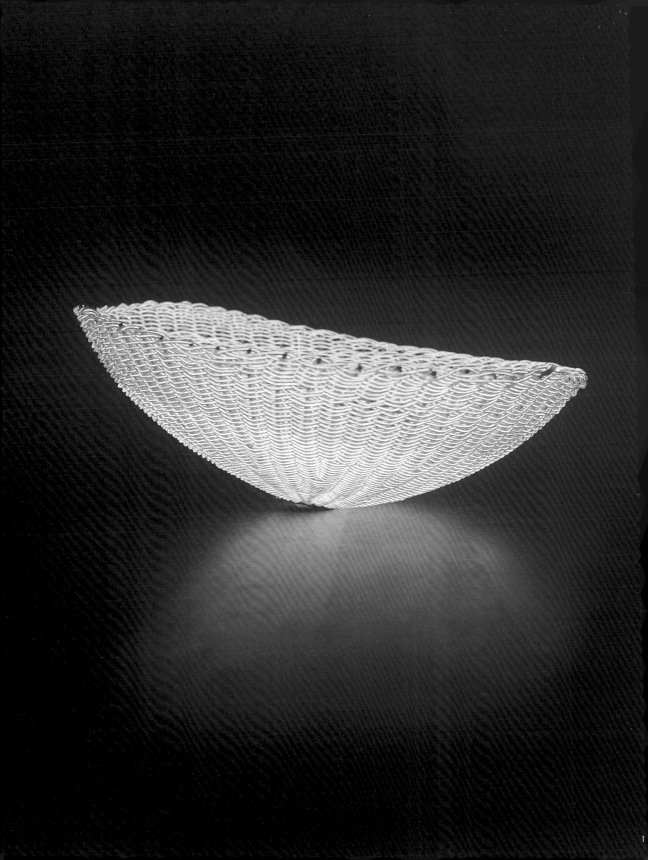

VOONWONG & BENSONSAW | LONDON, UNITED KINGDOM
Voon Wong, Benson Saw

Voon Wong and Benson Saw are London-based designers who began collaboration in September 2001. They draw upon their different backgrounds in architecture, engineering and product design to lend a unique perspective to furniture, lighting and product design.

www.voon-benson.com

 1 ELvin
 2 ELton
 3 ELsie
 4 ELma
 5 Landscape, *vases*
 6 Fragment, *tea light holders*
 7 TWIG 900 + 700, *vases*
 8 Loop, *lamp*
 9 Ribbon, *coat rack*
10 Tube, *vases*
11 Slicebox

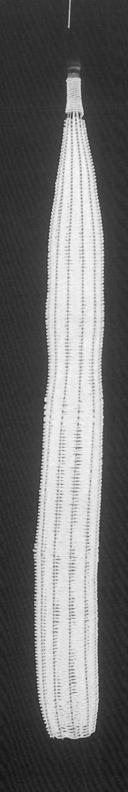

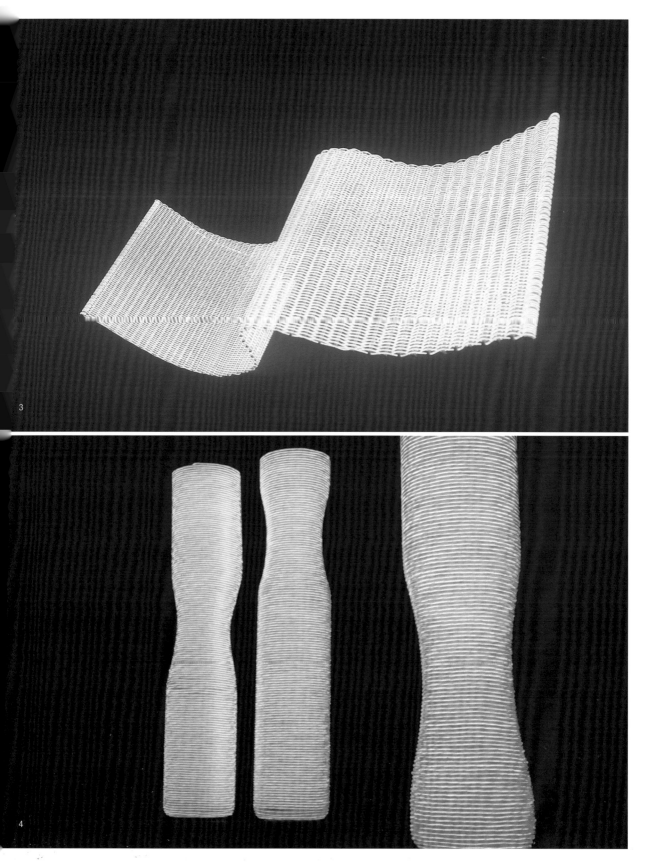

3

4

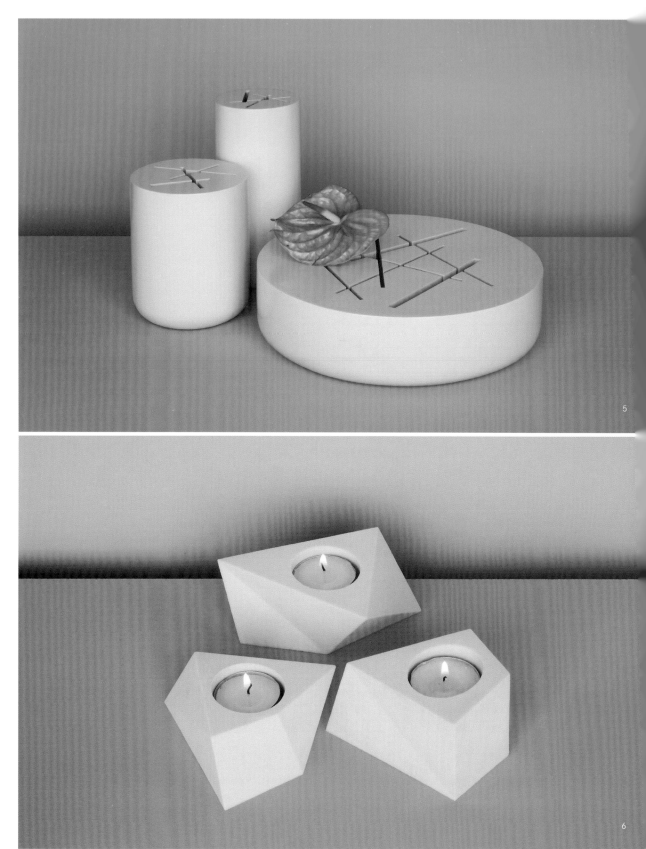

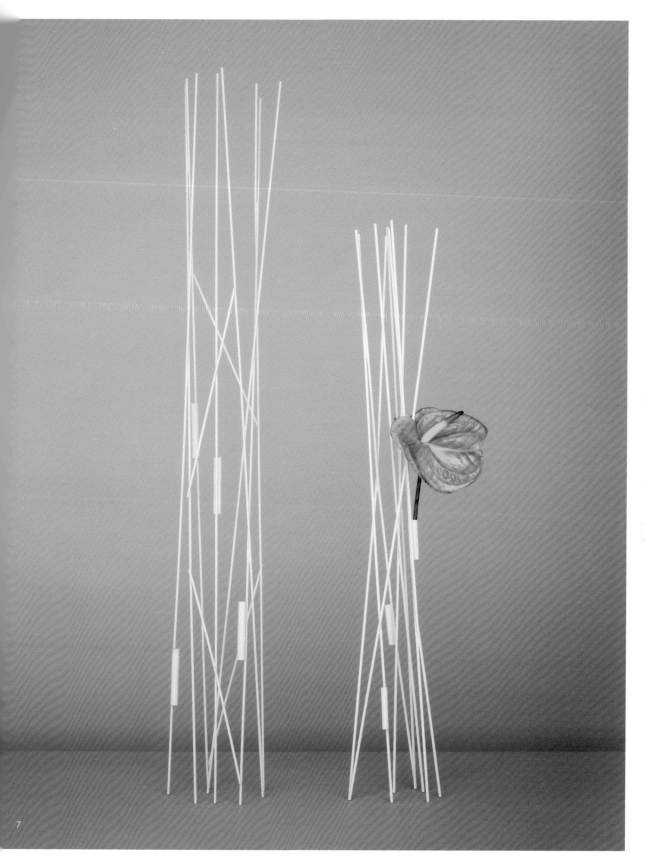

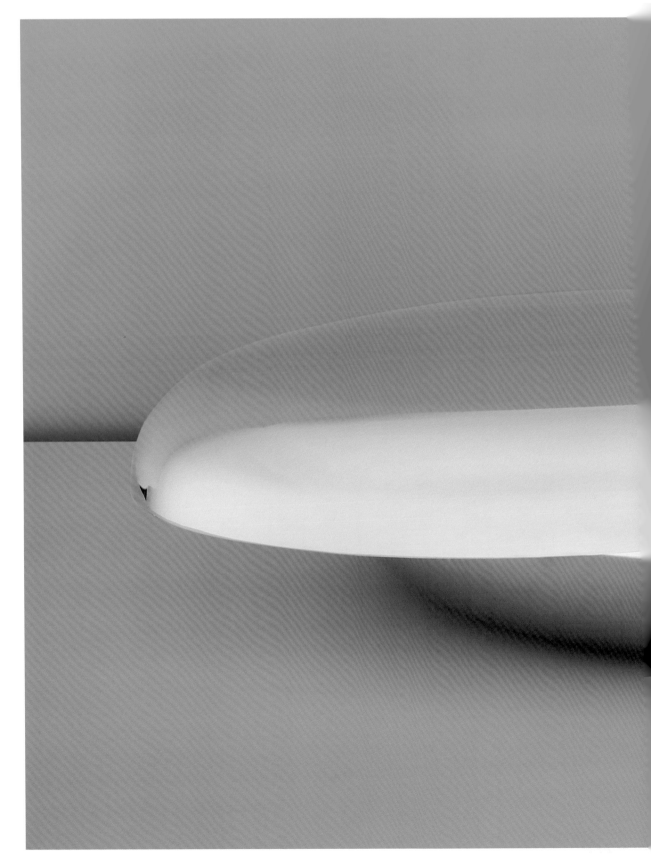

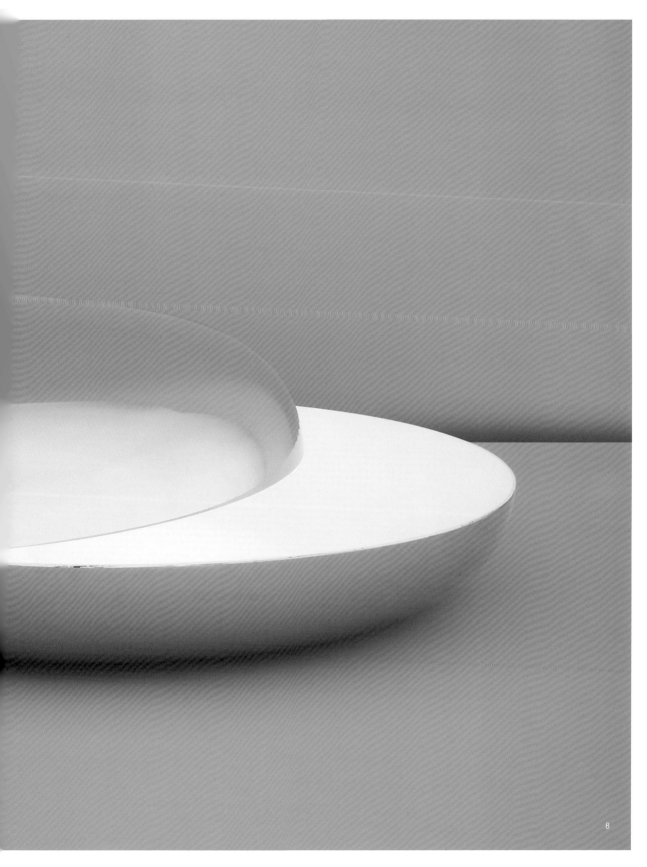

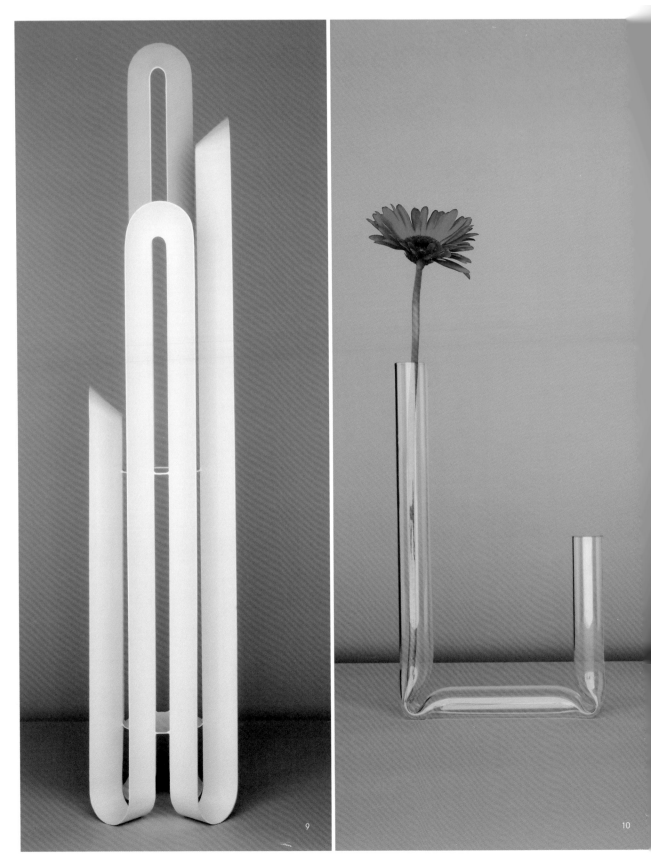

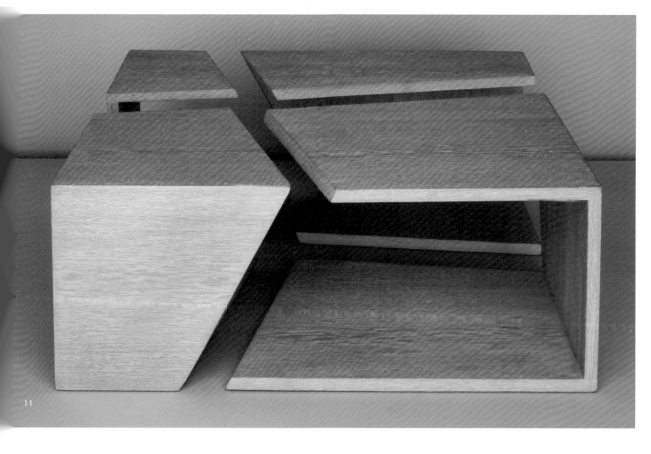

11

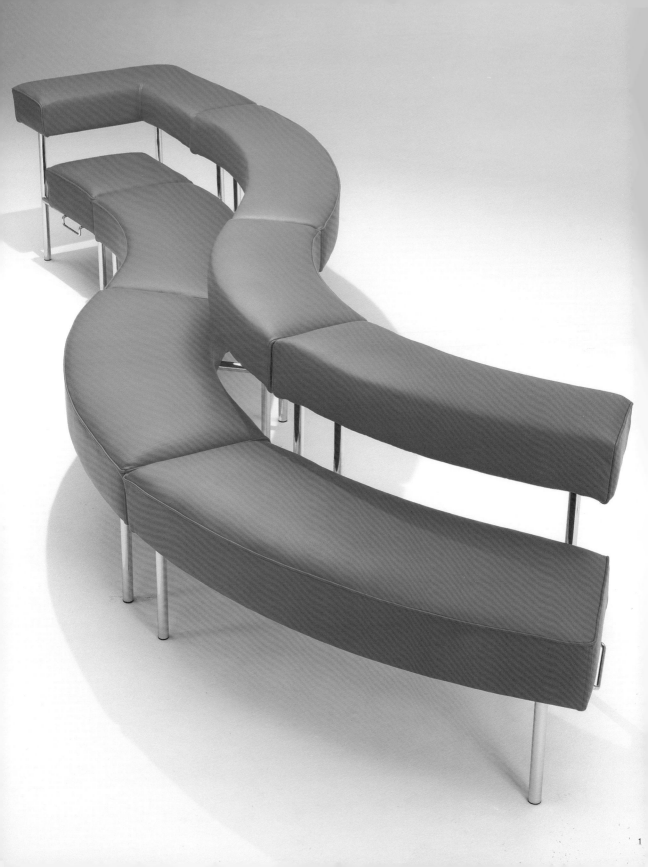

YAMAKADO | PARIS, FRANCE
Hiroyuki Yamakado, Agnes Yamakado

Yamakado proposes specific solutions with specific technology for each specific issue. They feel a sense of incongruity about the design for a wide range of applications based on the principle: Solutions for the client.

www.yamakado.com

1 Bancoquine serpentin
2 Malabar
3 Clam
4 Arima
5 Bunny
6 Josephine
7 Champignons de paris
8 Yam
9 Stick

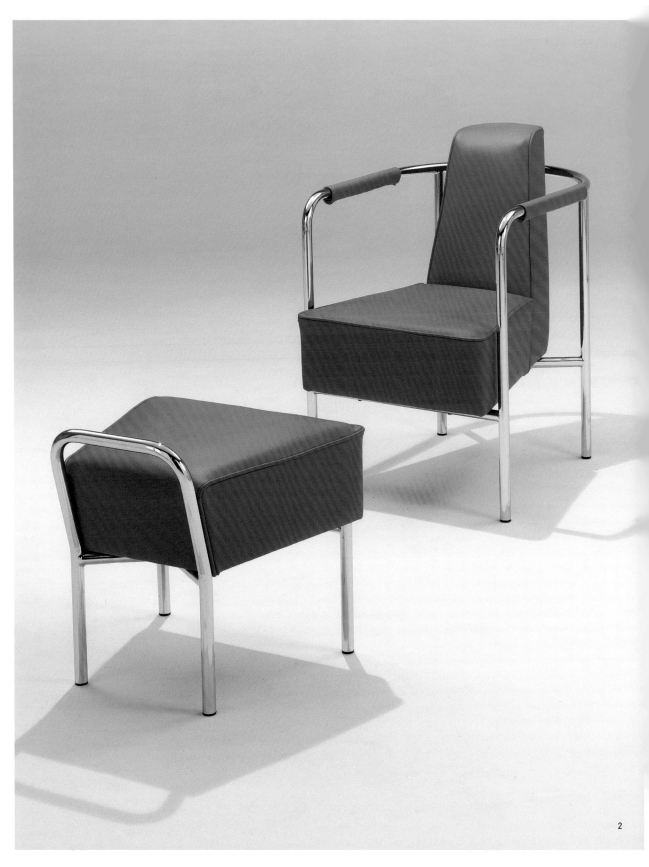

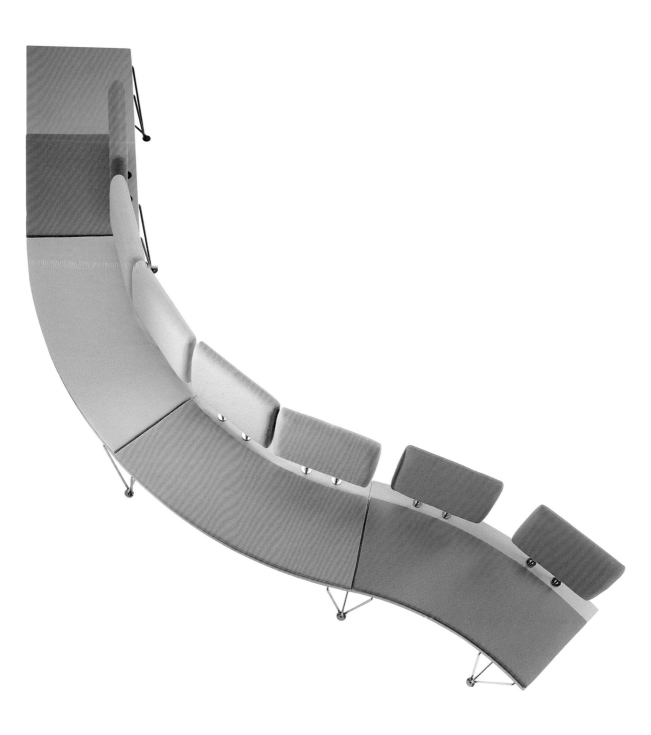

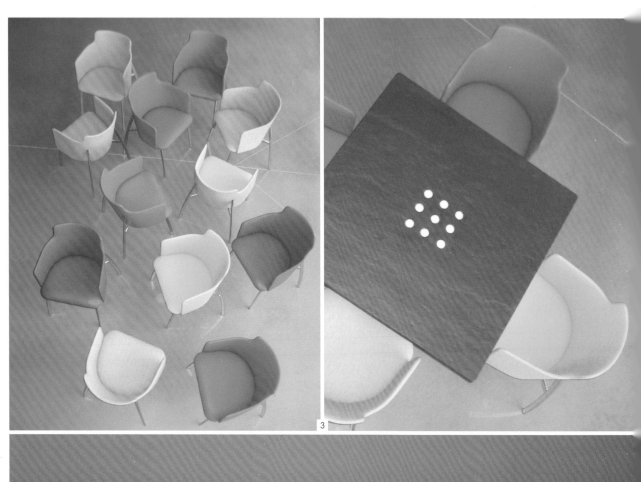

3

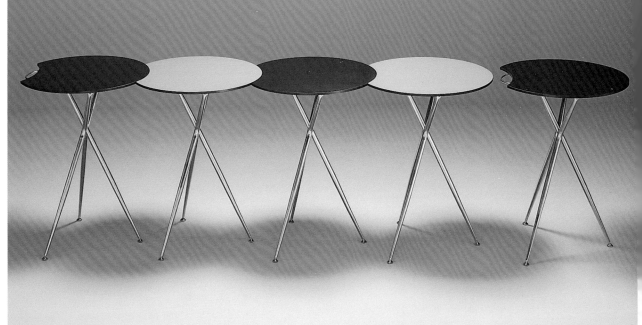

4

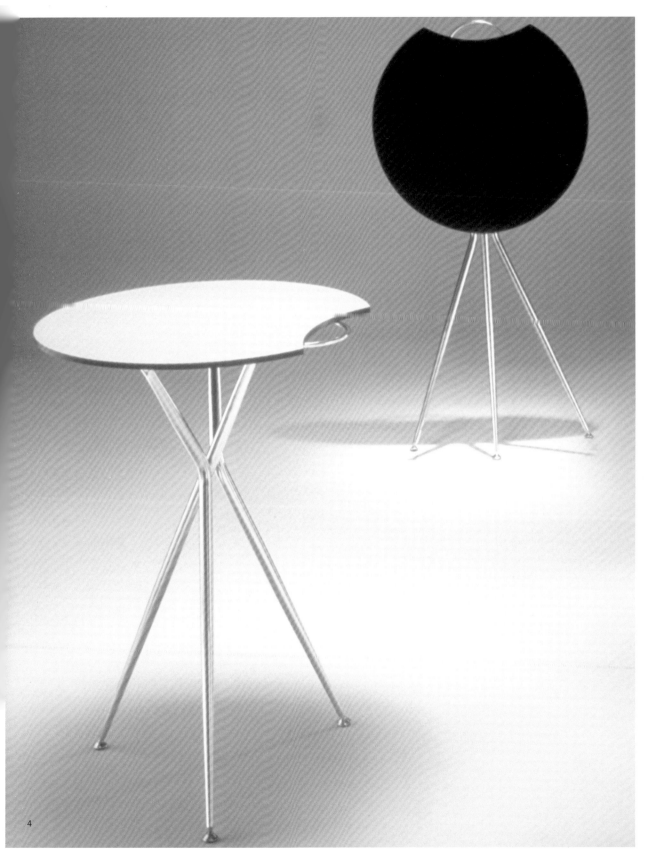

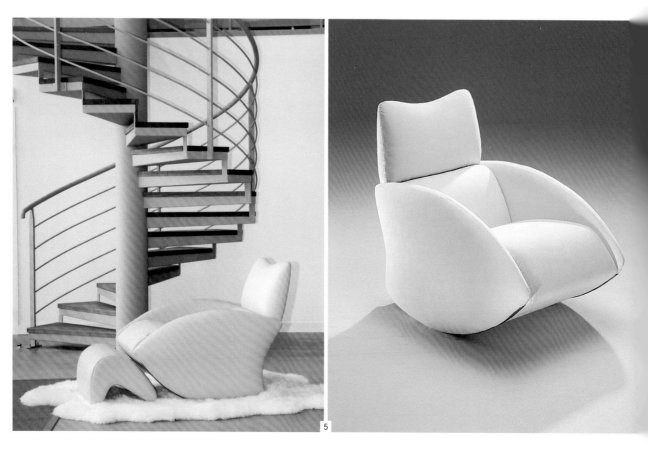

5

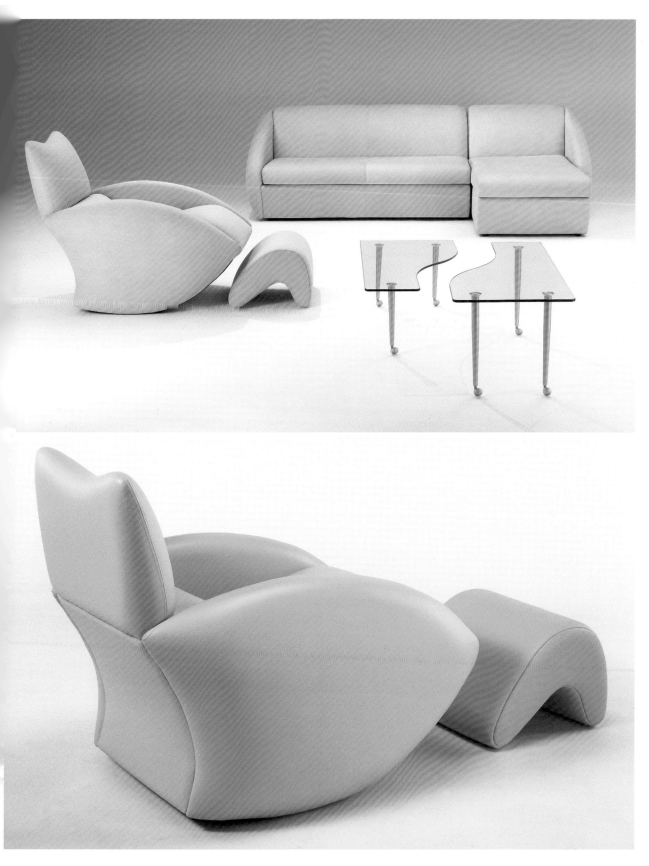

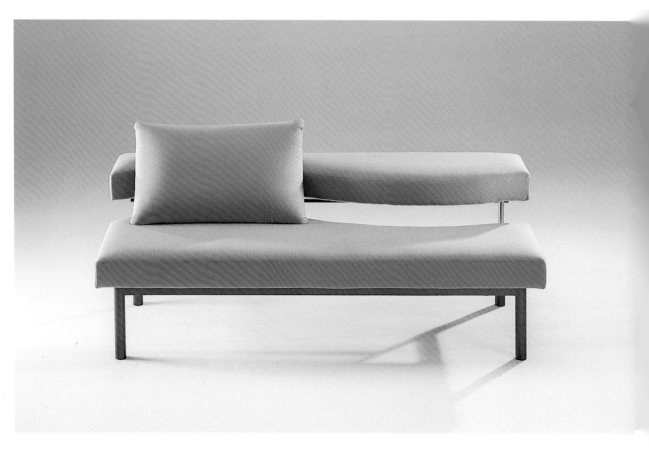

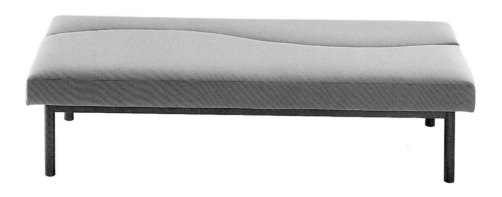

7

8

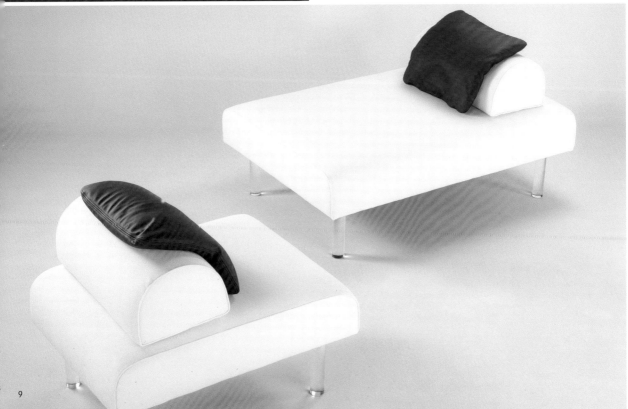

9

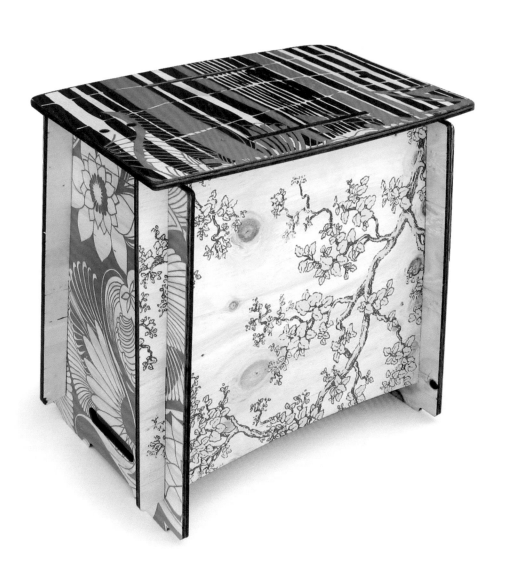

ZAISHU | RICHMOND, AUSTRALIA
Matthew Butler

Inspired by 16th century Japanese design the Zaishu, a small portable seat/table/storage box is constructed without tools, nails, screws or glue. Treated like a project the Zaishu involves a growing network of designers, artists and community groups around the world to create the artwork and host Zaishu assembly and installation events.

www.zaishu.com

Zaishu, *small seat*

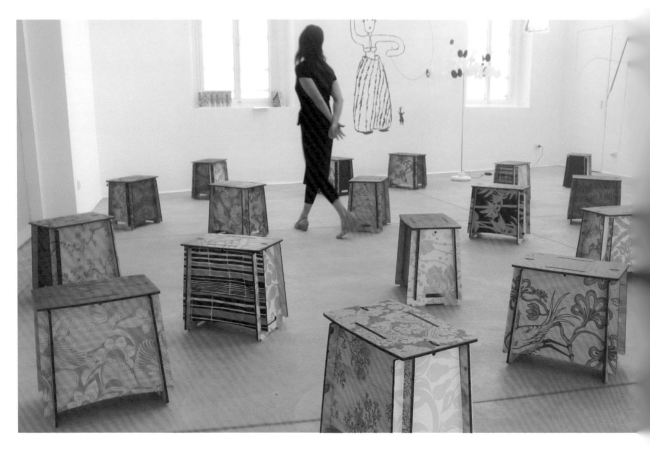

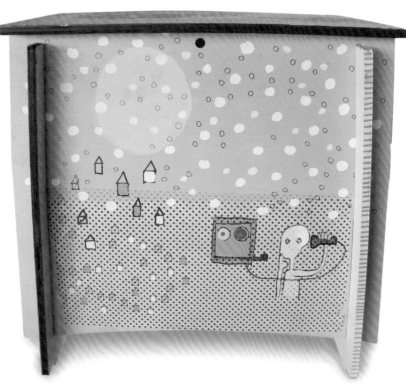

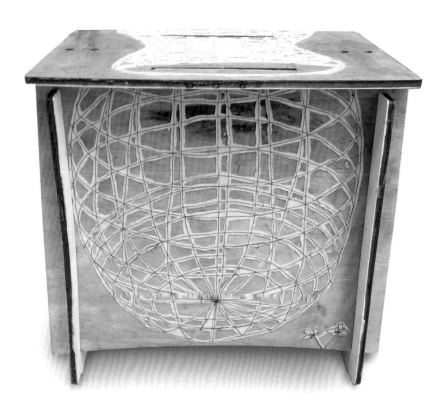

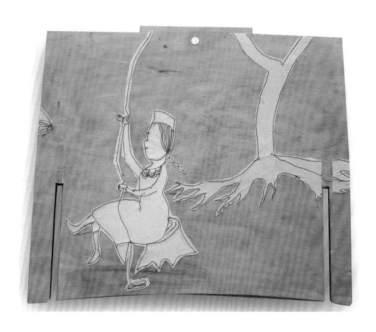

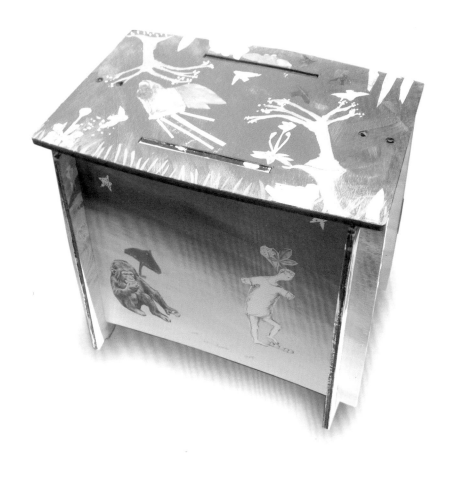

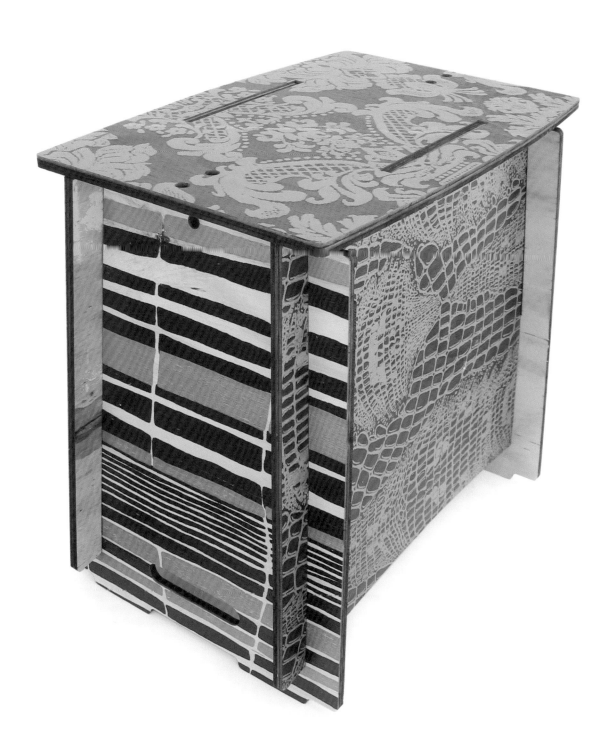

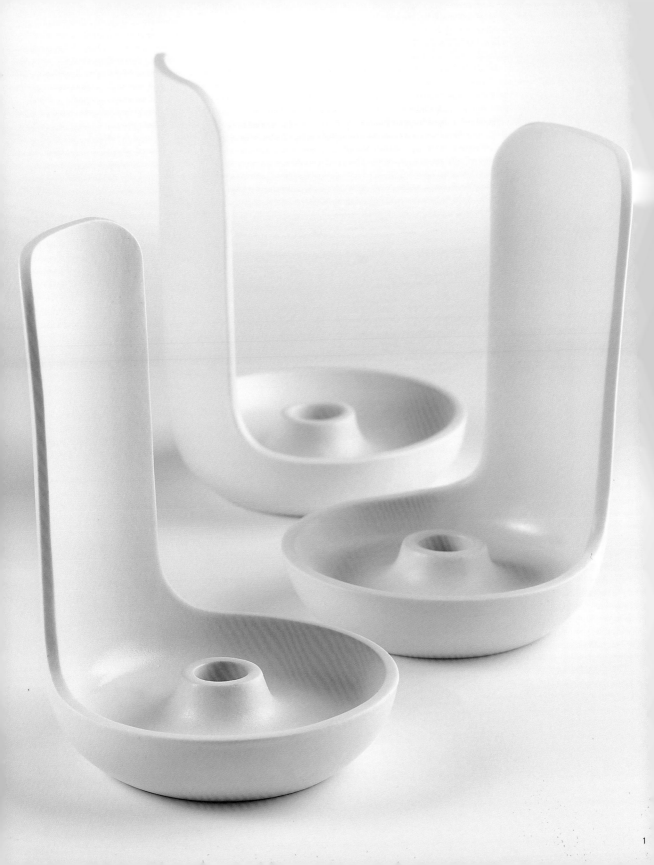

ZUII | MELBOURNE, AUSTRALIA
Marcel Sigel & Alana Di Giacomo

Zuii are establishing their own unique style of design formed out of an interest in the surreal, beauty in form and simple functionality. Their intention is to create pieces that are slightly obscure and enhance the environment.

www.zuii.com

1 Swoon, *candle holder*
2 Trace
3 Skinny
4 Henry's collar, *fruit bowl*
5 Winter, *chandelier*
6 Wall brooch, *coat rack*
7 Carbon
8 Woodland

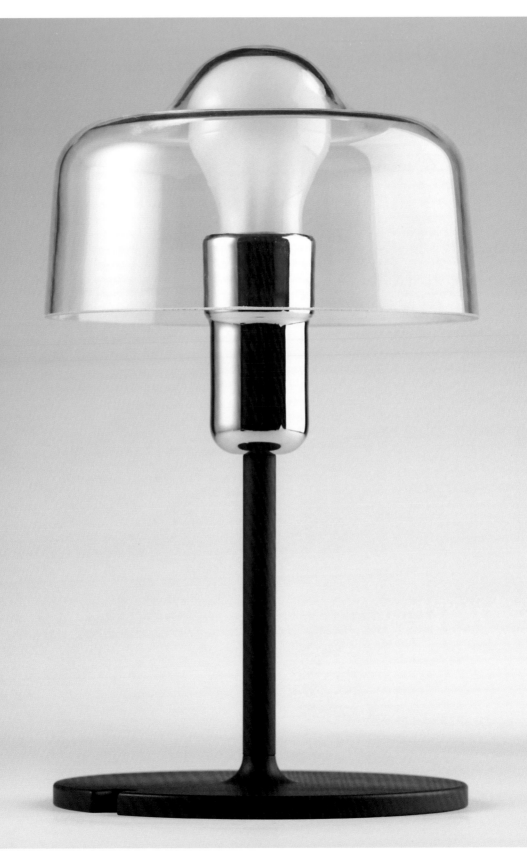

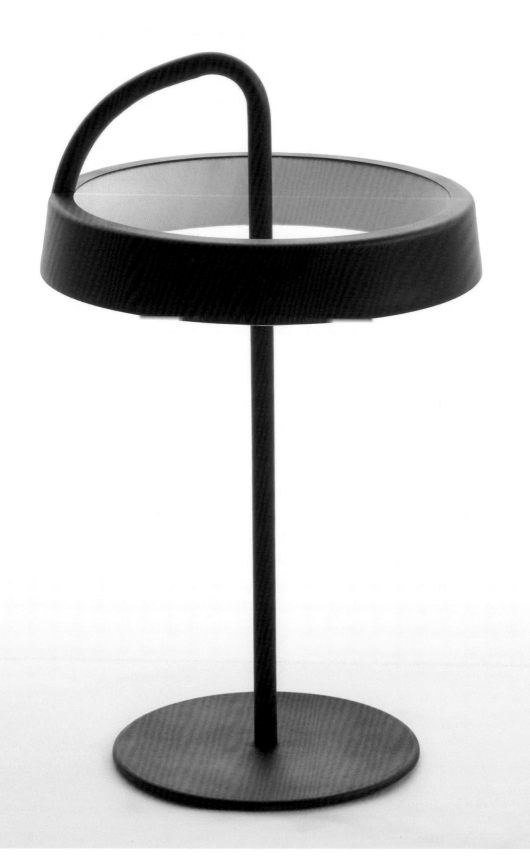

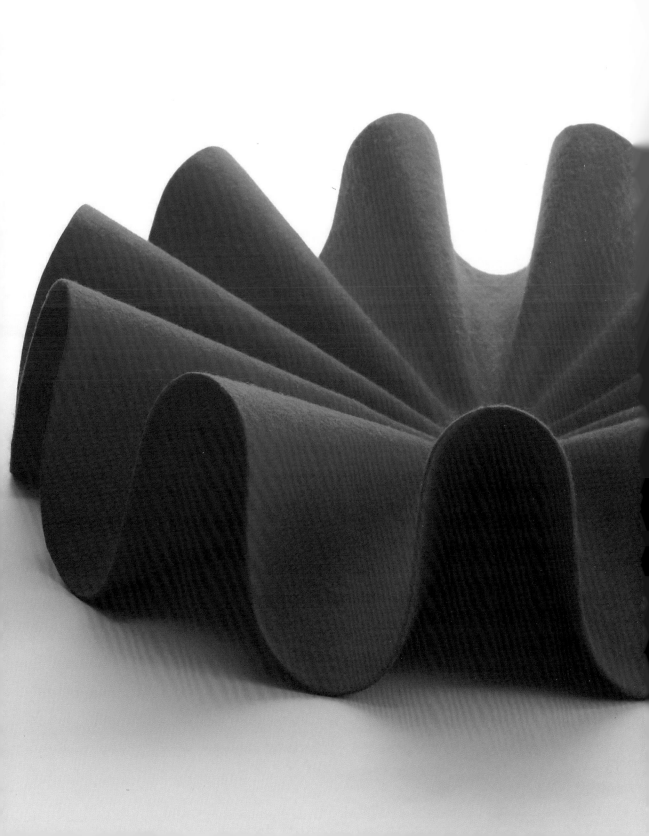

4

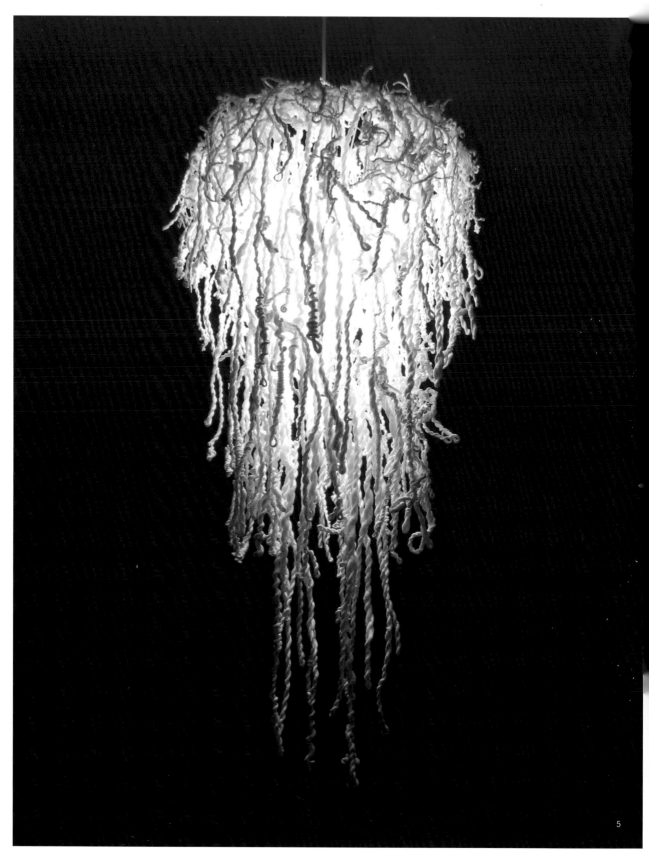

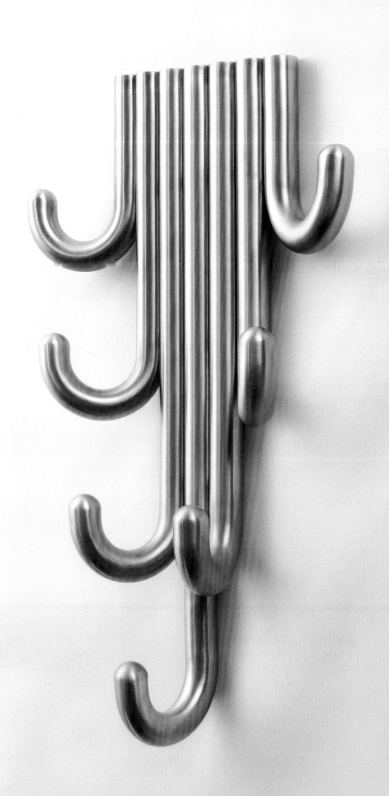

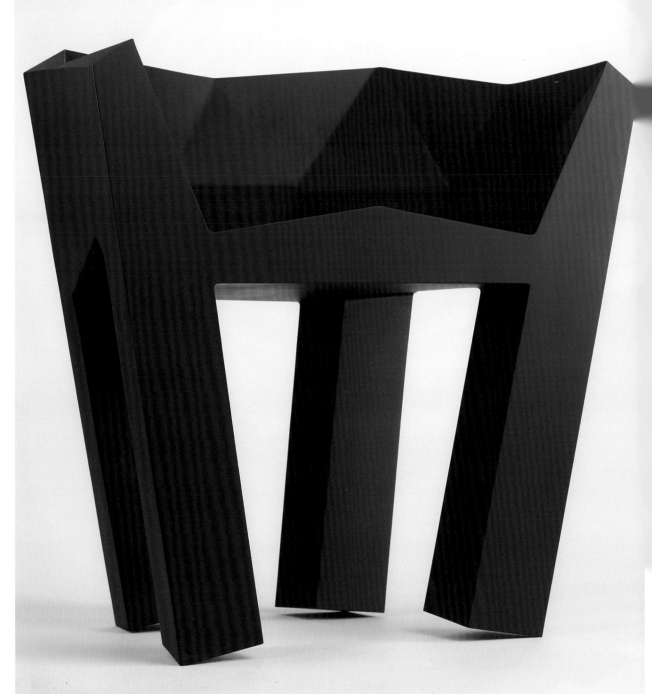

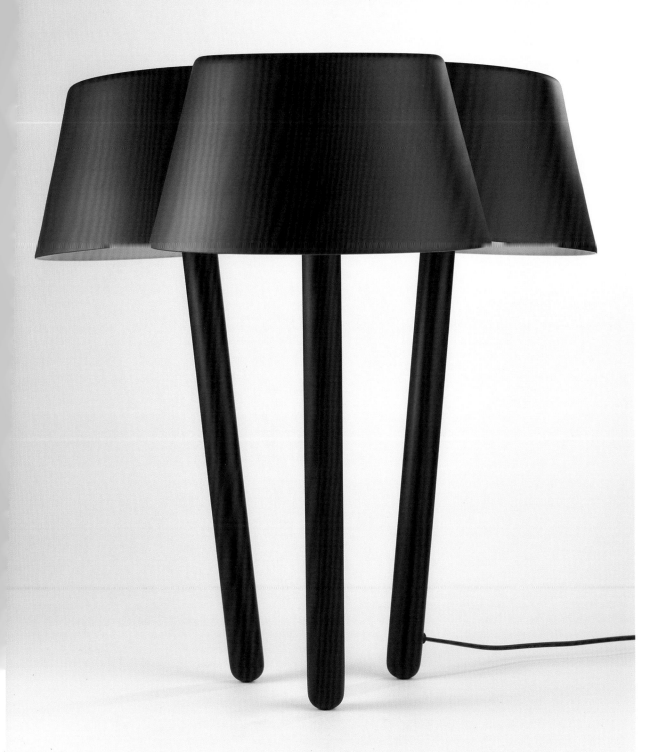

INDEX

© 2005 daab
cologne london new york

published and distributed worldwide by
daab gmbh
friesenstr. 50
d - 50670 köln

p + 49 - 221 - 94 10 740
f + 49 - 221 - 94 10 741

mail@daab-online.de
www.daab-online.de

publisher ralf daab
rdaab@daab-online.de

art director feyyaz
mail@feyyaz.com

editorial project by fusion publishing gmbh stuttgart . los angeles

editorial direction martin nicholas kunz
edited & written by joachim fischer, fischer@brand-affairs.de
translations by saw communications, dr. sabine a. werner, mainz
english translation dr. suzanne kirkbright
french translation micheline funke
spanish translation silvia gomez de antonio
italian translation paola lonardi

layout kerstin graf, papierform
imaging & pre-press jan hausberg

© 2005 fusion publishing, www.fusion-publishing.com

© frontcover photo courtesy sumajin pte ltd, backcover photo: courtesy yamakado
© introduction photos page 7: courtesy mixko, page 9: courtesy marei, page 11: kouji
miura, page 13: masato ozaki, page 15: takahiro ilnoue & studio harada

printed in spain
gràfiques ibèria, spain
www.grupgisa.com

isbn 3 - 937718 - 41 - 9
d.l.: B - 39636 - 2005